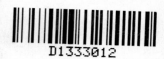

VOGUE

Book of Fashion Photography

VOGUE

Book of Fashion Photography

With 235 illustrations, 25 in colour

Introduction by

ALEXANDER LIBERMAN

Text by

POLLY DEVLIN

Design by

BEA FEITLER

Creative research by

DIANA EDKINS

Thames and Hudson

ACKNOWLEDGMENTS

Special thanks go to the editors of all the *Vogues* and to the photographers whose work
through the years has made this book possible. We acknowledge
with gratitude the great patience, cooperation, and generous contribution of
time which the photographers have given freely on this project.
We wish to thank the following people for their assistance in the preparation of this book:
The Vogue Art Department, New York; Sara A. Foley, Bookings Editor, New York;
Leslie Prouty, Diane Spoto, and Theo Tarter of the Condé Nast Library,
New York, for their patient cooperation; Carl Barile of *Self* magazine
for his attention and assistance; Marcel Guillaume
and Richard Cole for their technical advice and expertise in production.
It is a particular pleasure to acknowledge the friendly cooperation of Jocelyn Kargère,
Art Director, French *Vogue*; and Susan Train, Paris Fashion Editor
for American *Vogue*. Special thanks to Beatrix Miller of British *Vogue*
and Alex Kroll of Condé Nast Books, London.
Several individuals have been extremely valuable in tracking down particular photographs
and information. They are: Julian Bach; Larry Goldman of Photo-Artists, New York;
Susan Kismaric, Assistant Curator, The Department of Photography
at The Museum of Modern Art, New York; Gideon Lewin and Alicia Longwell
of the Richard Avedon Studio; Grace Mayer, Curator Emeritus of the Edward Steichen Archive,
The Museum of Modern Art, New York; Pat McCabe of the Irving Penn Studio;
Xavier Moreau, Congreve Publishing; Marina Schinz; The Sonnabend Gallery,
New York; and Mrs. Joanna Steichen.
For their help in supplying us prints for the following pages, we wish to thank
The Department of Photography, The Museum of Modern Art, New York (p. 104);
The Sonnabend Gallery, New York (pp. 61, 51, 69);
and Mrs. Joanna Steichen (pp. 62-63). D.E.
I acknowledge with thanks the help of my researchers,
Jacky Cattermole, Helen Devlin, and Caroline Baum. P.D.

Associate designer: Carl Barile
Text typeset by Foremost, London
Colour illustrations reproduced by Clichés Lux SA, Neuchâtel
Printed and bound in West Germany by Mohndruck, Gütersloh

CONTENTS

INTRODUCTION

The great interest in fashion photography today is a symptom of the contemporary obsession with power. After a long, slow evolution we have come to a moment when three new forces are converging in the consciousness of the world. The emerging power of the new woman, the unexpectedly all-pervading power of world-wide fashion, and the all-encompassing power of photography with its cloned-image spreaders, television and film. The three power ingredients are inseparable, and their aggressive interplay is the inner dynamic of fashion photography.

When power is present, money cannot be far away; and the growth of fashion photography has depended on the faith of business that fashion sells. But this "fashion imprimatur" would not work without the main power ingredient—sex: the all-powerful and universal human motive for action, the energizer that makes humans love, act, buy, and give. Throughout the visual history of mankind the symbol of sex and love has been woman. Very little has changed today, and the gift of the modern photographer is his Pygmalion-like ability to transform every child of the street into a momentary goddess and object of envy and desire.

In the beginning everything was simple. The basic purpose of fashion photography was just to show women wearing clothes; but, through the years, this elemental need was transformed into a subtle and complex operation that involved art, talent, technique, psychology, and salesmanship.

To achieve its goal, fashion photography needs to seduce—to interest and to transport the spectator into a world of illusion. Our dreams and our imagination are the sources of our desires. Photography, a modern "opium of the people," and fashion photography, as its entertainment branch, have the ability to change our vision momentarily and move us into a more attractive realm of existence. The impetus to action through images is the power of the fashion photograph. The contemplation of a picture of a woman in a dress is an immediate invitation to a vicarious existence. Like an amateur novelist, one can through the signal of clothes project oneself into a life one does not live.

Fashion is a signal and a symbol of class, of education, of taste, of imagination, and sometimes of daring and revolt. It is a visual exhibition of the character of the wearer—and the evolution of clothes from status symbol to personal statement is the measure of woman's growth as a person.

The civilizing power of fashion has produced a more attractive society. Properly packaged and wrapped, men and women can mix more easily in today's overpopulated life. There is a ritual to fashion that marks the hours of the day and suggests appropriate behavior. This bringing of order to existence has protected women, men, and society from the dangers of too much vestmental freedom. Fashion photography has always oscillated between the two poles of conformism and revolt, and the photographs in this book are

a record of this ambivalence; but the power and the fascination with fashion have remained through the years.

A real social change has been recorded in fashion photographs. Throughout its history, ever since its birth as the first illustrated fashion magazine in 1892, *Vogue* has tried to present the most attractive, elegant, and seductive vision of women. In the magazine's earliest days, *Vogue's* editors and photographers wanted to portray ladies and gentlemen. Readers were expected to look up to an aristocracy who had all the advantages of position and education and who set the image of what was proper. These early fashion photographs imitated portrait painting. The authority and the dignity of the wearer and the quality and style of his or her garments were a message of class difference. The stillness of the pose, the haughtiness of the attitude, and the splendor of the clothes created a distance between the image and the spectator. The woman's expression was hermetic, closed; no emotion was permitted.

Progressively, with the disappearance of luxury, with the proliferation of taxes, with the advance of industry and education, the appeal of fashion and the need for fashion broadened. Stores had to sell more. Magazines had to sell more. A wider audience transformed the subject matter of fashion photography, but the magazine continued to show the image of the woman of her time.

Behind it all, there was an ideal of decency, an ideal of furthering the civilizing influence of culture and taste. For the fashion photographs that *Vogue* has chosen to publish, there has been an underlying dream of a world where people act and behave in a civilized manner. This visual portrayal of taste and civilization has changed the customs of America and, perhaps, the world.

Fashion photography, with the post-World-War-II explosion of art forms, began in its own turn to take itself seriously and became involved with the fortunes and joys of creativity. Incredible visual experiments were attempted, always with a close side look at the achievements of the more serious arts. In the process, the egos of the photographers, their desire to express themselves, the longing for an individual style, made fashion secondary and the model herself a dehumanized abstract parody used as a prop to achieve a willful result. The thinner, the less "feminine" the model's body, the more she could act out a graphic grotesque of limbs incredibly quartered in space.

This destruction of woman was not only the photographer's doing; the dress designers created abstract preconceived shapes arbitrarily superimposed on a woman's real form. The makeup and hair went their own way. The fashion editors created, too. Every subdivision became an art in its own right.

Edward Steichen/American Vogue, July 15, 1934/Fashion: Ransohoff/ On the Lurline, Hawaii bound/A color conversion; see p. 50

Toni Frissell/American Vogue, November 15, 1939/Fashion: Himalayan marten jacket with Henry Dreyfuss' aluminum locomotive hood

Irving Penn/American Vogue, October 1, 1950/Regine/Fashion: Balenciaga/Paris

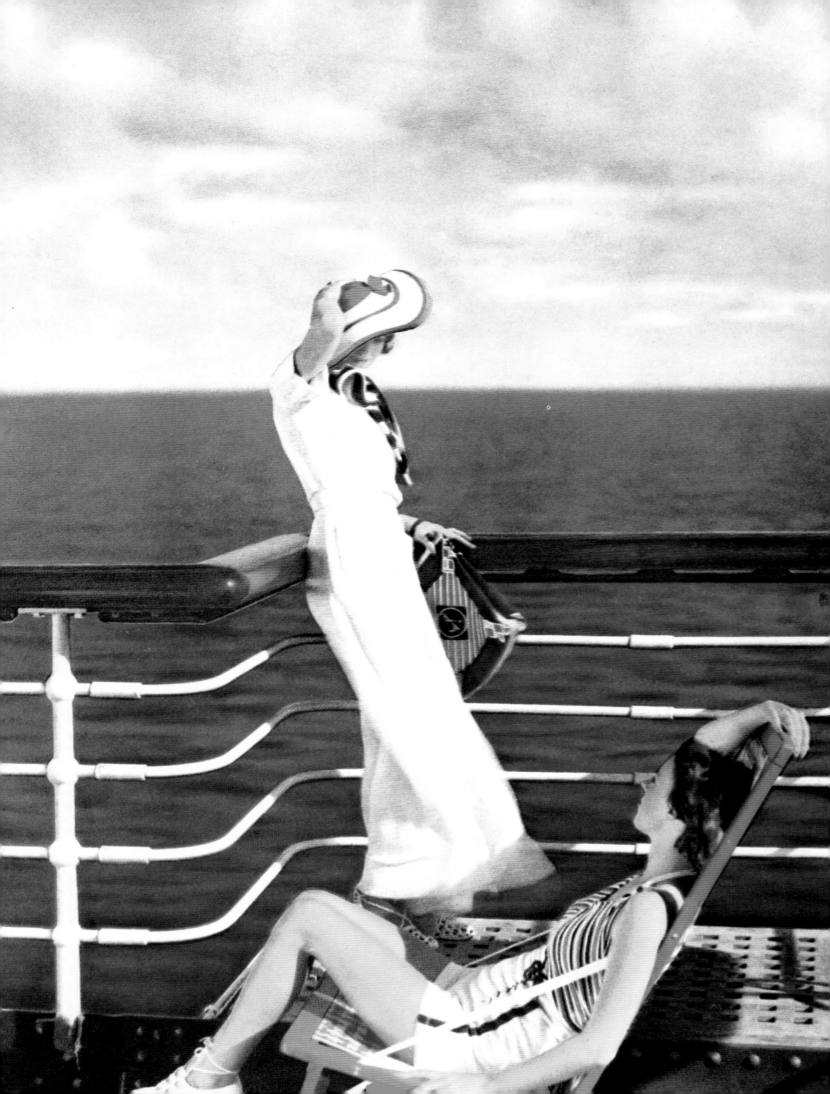

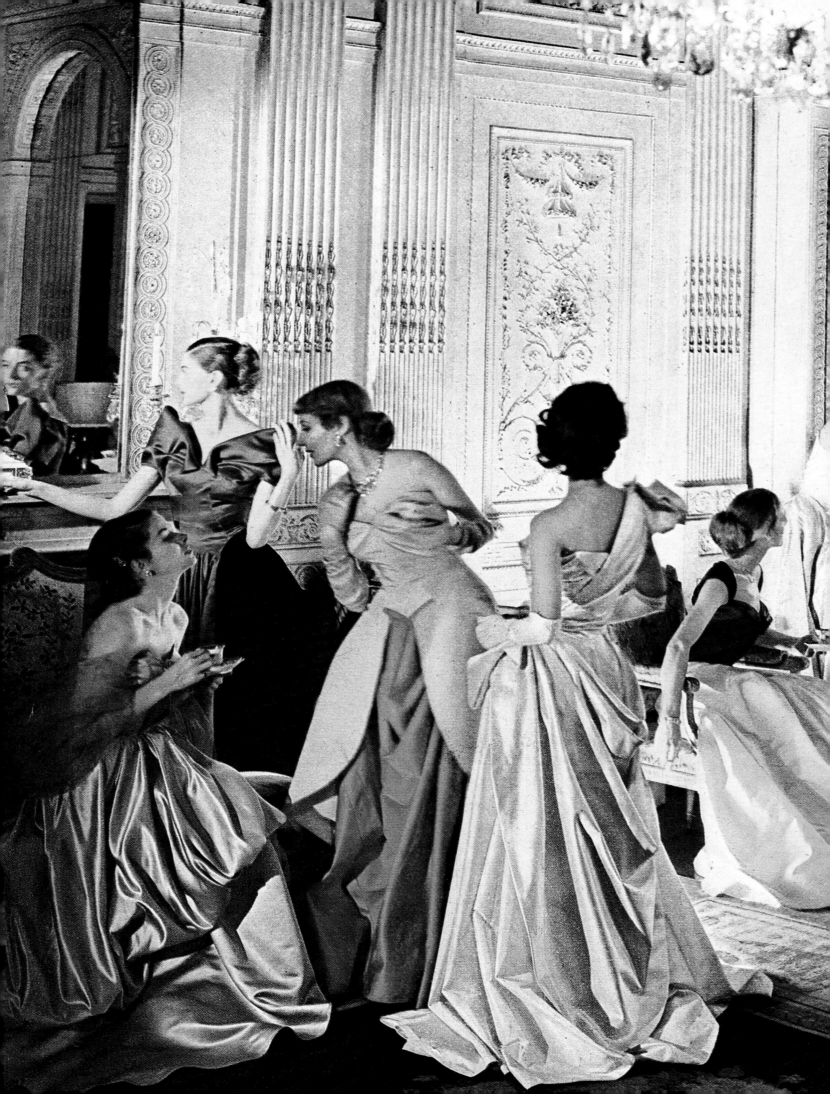

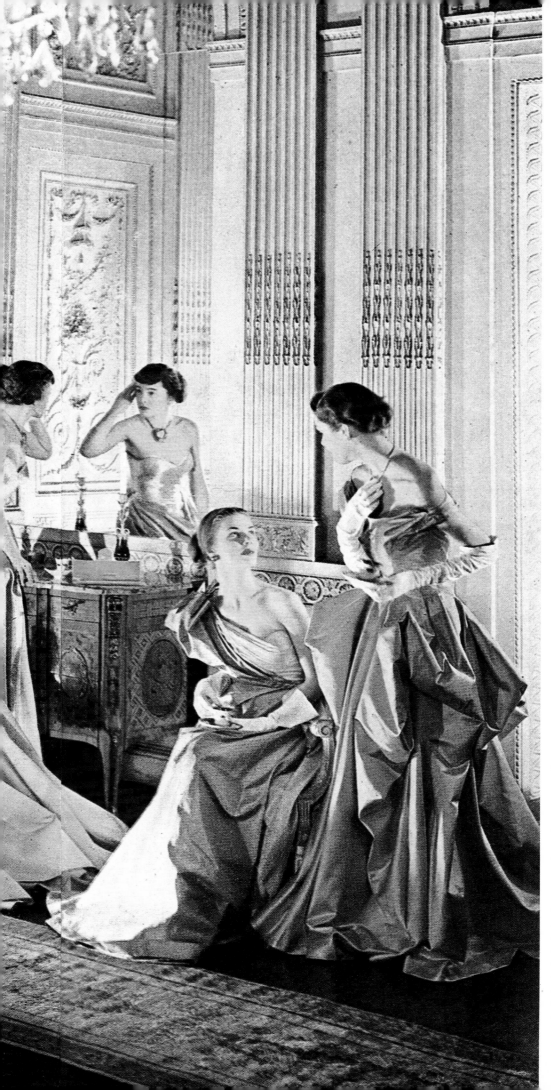

Cecil Beaton
American Vogue, June 1948
Fashion: Charles James
French & Co., New York

Richard Avedon
American Vogue, December 1969
Gloria Vanderbilt Cooper
Fashion: Fortuny
New York studio

Arthur Elgort
American Vogue, June 1976
Patti Hansen
Fashion: Calvin Klein

Helmut Newton
French Vogue June/July 1973
Fashion: Guitare, Dorothée Bis

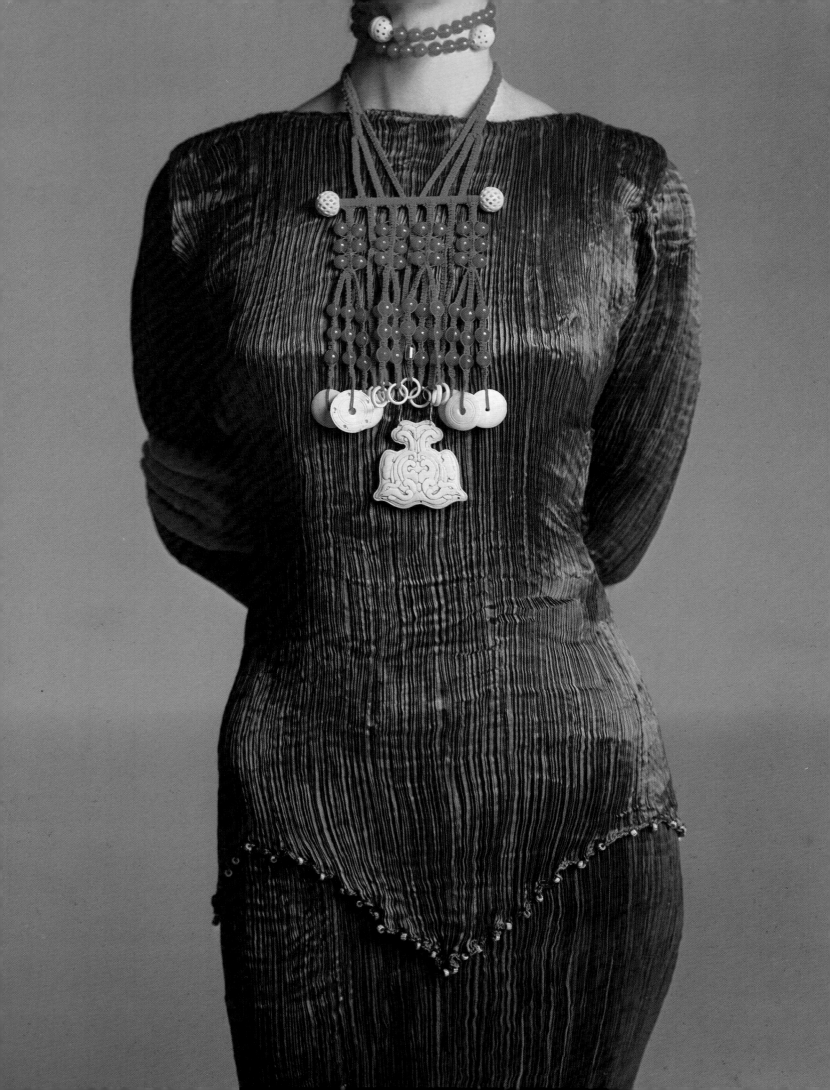

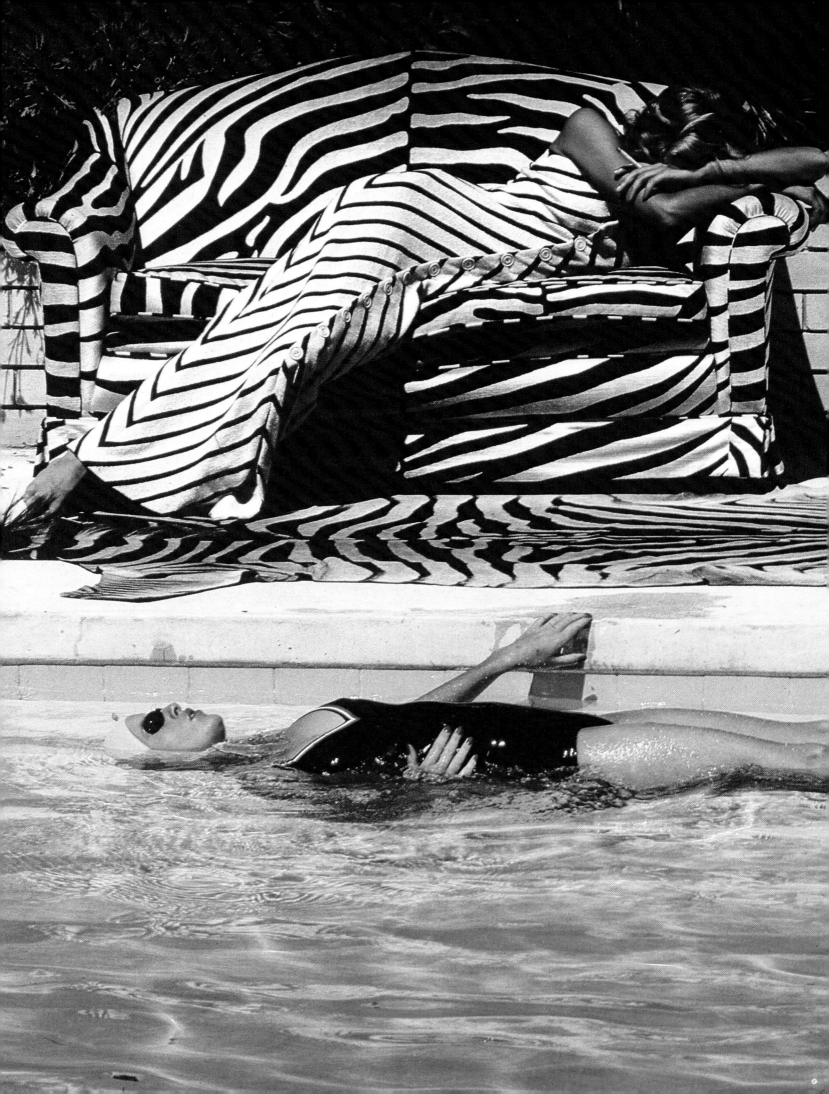

Through this incredible accumulation of minor talents, images resulted on the printed page that in their time were as baroque as Aubrey Beardsley's involved illustrations in his. Games were played using this stylized, unreal image of woman as contrast for the "sordid" everyday reality of life. Grand evening dresses were photographed in slums or against groups of real working people, using their Ensor-like face-masks as foils for the Kabuki-like purified image of the modern geisha in modern clothes. The total image signaled to women: "I am different, my world is not your world; try to achieve this look, it is your ticket of escape from what surrounds you into the heaven of fashion and the unbelievable nirvana of luxe and elegance."

But all excess carries in itself the energy of revulsion and remedy. Women quickly revolted, having found new courage in their economic successes and having made some vital gains against the ridiculous and humiliating restrictions of centuries. They refused to buy and wear fashions that did not suit their lives. This was a vital shift from fashion and makeup imposed by a self-appointed authority to clothes and looks for real women and their needs. Very quickly the economics dictated a surprising about-face by all involved in fabricating *the look*. Clothes became the humble accessories of woman's will.

Bodies in photographs rounded out. Dressing became simplified. The invention of body stockings, of new fabrics, of naturalistic makeup, of do-it-yourself hair all helped to break the visual barrier between fashion and the public. The photographer as the middleman interpreter soon discovered a style that proved seduction could gain from the loss of artifice. In all this transformation, the subconscious image that acted as a control was the look of the reality of the street. All fashion and beauty could be tested against this everyday backdrop. How would this studio or fashion creature look if she were to walk through a crowd? This became a litmus test of modern fashion creation and photography. It changed the thinking of designers, editors, advertisers, and of course the women who now knew better.

The humanization of fashion photography forced photographers to find new ways to express seduction. Less became more, and the simple portrait of a woman in clothes—but this time with a real focus on the woman herself—established the true relationship and scale of importance of clothes, of fashion, of ornament to the woman wearing all of these necessary or unnecessary accoutrements.

Fashion photography has played an extremely important role in the emancipation of women. No other group of human beings has been portrayed so extensively and so publicly; and no other medium has reproduced as many varying images of women as women's magazines. If one puts together all the advertising photographs that have been published with all the editorial photographs

of fashion and of personalities, the total is staggering.

The images of women accumulated through the years since photography began have left their imprint on the collective unconscious. The question of whether a photograph is art or is not art has very little meaning. The real achievement of photography is its ability to create a memory bank of the way women at a given moment in certain societies have looked and cast their power spell.

Today, fashion photography has to portray "real" women with a purpose to their lives; it has to show—by the woman's expression, by the movement of her body—that she is involved in an active, intelligent life. The new awareness of the modern woman has to show through in the new fashion photography. A stupid beauty has no appeal.

Women who work no longer have time to go to a couture house for five or six fittings. There are no lady's-maids to button a hundred tiny buttons. The whole process of washing and ironing by hand had to change in a busy working world. Women wanted to free themselves from a do-nothing concept of life, and the fashion industry had to face the elimination of much that stood for luxury and elegance.

Elegance is an intensification of fashion. It is the ennobling ingredient that makes wearing clothes a form of culture. It is the tangible measure of the admiration that a woman has for herself and the admiration of the creator of the clothes for his unknown-to-him heroine. Elegance may be natural and inborn or artificial and imposed. More and more, in a healthier world, the physical beauty, the grace of a coordinated moving body triumphs and forces on fashion the primeval elegance of nature. To sense and to express these values and to translate them into pictures demands tact and taste that are very special and rare. It is through the sensitive subtlety of the good fashion photographer that these visions are best entrapped.

There are in the history of fashion photography unforgettable images created by the few extraordinary artists of the camera who have put their visual stamp on the whole periods of fashion—de Meyer, Steichen, Beaton, Huené, Horst, Frissell, Penn, Avedon, Klein, Bourdin, Newton, Elgort, Turbeville, Lartigue. These are men and women who are able to develop a unique personal style and a certain personal manner of seeing that, through the repeated publication of their work, became linked forever with their names. Photography in general is an anonymous medium; and the achievement of the few greats is a triumph of obsessive, unshakable persistence in expressing and creating a personal style and vision.

Photography is an expensive, squandering process and demands enormous financial outlays. Film, cameras, electronic lighting, studios, staffs—all are prohibitively costly. The photography of fashion and the pro-

18

liferation of advertising in women's magazines have created an immense opportunity for work and money. Many photographers have supported their creative nonfashion work through these new outlets, and a creative interchange has enriched their double activities.

As opportunities for photographers grew, a big change in the history of fashion photography came about: the appearance of a star system—star photographers and star models. The photographer of talent assumed a vital role. To insure his exclusivity, he was signed up by a magazine or advertiser, put under contract. Large sums were guaranteed; and, from one in the role of an editorial illustrator, an employee of the magazine, the photographer became a semi-free powerful entity who dealt from strength with his now equals, the editors.

This change sometimes transformed magazines into showcases for the creative whims of the photographer. But the danger of loss of control could be averted by judicious choice of the photographer in the first place and finally by the veto retained by the editors to publish or not to publish. Nevertheless, a tension always remains; and, out of this wary relationship, very often unexpectedly striking essays and individual pictures result.

In the ancient tradition of the Chinese, the true artist remained an amateur. With fashion photography as well as with art, it is the "amateur" who retains a certain naïveté and freshness in his response to any given assignment. Faced with a woman and a fashion, he may take an approach that is more subjective and more intimate than that of the professional. This approach allows him to come closer to the personality of the wearer; he will not concentrate, as a fashion professional might, on merely documenting the clothes. He may have the inspired courage to risk the throwaway picture. The professional seeks perfection. The amateur may through accident achieve the yet unseen. This gamesmanship of art is a gamble with oneself against all restraints and the ability to surmount a sometimes pedestrian assignment.

The photographers who have achieved the most interesting results in fashion have been the men and women who have been able to bring the enrichment of their other work as nonfashion photographers to a fashion photograph, the ones for whom the fashion became a part of their larger experience as photographers involved and aware of the world around them. The discipline of serious portraiture, the respect given and observed in contact with personalities, has made many photographers see the fashion model as a human being and not only as a mannequin.

With the evolution of women's attitudes, the tricks of old-fashioned seduction are slowly disappearing from the fashion photograph. A healthy, energetic, flirting image has replaced that of the hypnotizing seductress. The modern temptress has created a new sex symbol and a stronger bond with the spectator.

In communicating with the reader, in revealing intimacy, women fashion photographers have played a vital role. Men are more concerned with structure, composition, strength, form. Women are sensitive to form, but they are able to see beyond the appearance of strength toward an inner strength that is deeper and more in harmony with the essence of femininity. The emergence, today, of a great number of women fashion photographers comes at a time when fashion itself is more fluid, less structured.

Women, in their active lives, want to move; and modern clothes are no longer the straitjacketed, corseted, presketched garments that once entrapped women into an idle and passive life. This revolt of women against the dictates of a man-imposed image has been caught by women photographers who know how to portray the multiple moods of woman. Through their work, a new image is emerging: an image not only of the triumphant, all-happy woman but of a contemplative, intelgent, meditative, sometimes happy but also sometimes suffering and bewildered being. These women photographers also know the secret of tenderness, that God-given power to soothe and to love. And these images are the answer to the great subconscious longings of both men and women.

The whole question of visual appeal has never been deeply studied. What interests a woman in a picture of another woman? Should the model in the photograph be calmly absent, so that the woman spectator can take her place in the dress? Should she be visually stimulating, so that the woman reader will want to look like her in order to achieve the model's aura of success?

There is now a newer approach: one that expresses the model's awareness of realities that are more serious than just the wearing of clothes. In modern fashion photographs, all stylization, mannerisms, or abstractions are but quaint, superficial approaches working around the essential; and that essential is the human being with whom the spectator can identify.

Today, because of their involvement and awareness and of their new technical means, photographers are able to catch a reality that has brought the fashion image closer to a new form of art. Moments are caught that are unseen or barely seen by the human eye, and this fixation on paper of the everyday invisible—perhaps more beautiful than the everyday visible—has created a new experience. Hair is now caught in a glorious moment of abandon in space. Bodies flying, running, or just moving unexpectedly within the frame of a camera have made a new imagery, one that has revealed women at their most intense moments of being.

Photography is a voyeuristic medium. Men and women have a built-in psychological urge to observe and glorify the beauty of women; and a part of women's eternal role has always been to stimulate erotic desire.

This can be achieved, in a fashion photograph, through the model, through clothes, through makeup and hair and all the artifice of fashion. The photographer, in a sitting, is concerned with intensifying these areas of appeal. A good model is also involved in provoking the photographer—by her movement, her expression, her attitude—to fall in love momentarily and to capture this fleeting seduction. It is not an accident that cameras have a phallic association; and this teasing relationship between photographer and model —this attempt to show the noncontact rape of a given woman—sometimes brings out the unforgettable, and orgasmic, picture.

Many great fashion photographs have been created out of the very special bond that existed between photographer and model; and many of the great models who stamped the work of key male photographers lived with or married the men under their spell. There is a special image that can be caught if a man is in love with the women he is photographing, for he sees her more vividly through the magnification of desire. His photograph becomes more than a document of fashion; it is a lasting trace of a moment of "blind" passion.

Fashion photography attempts to portray the archetypal woman. This image varies superficially at different moments of history; just as fashion changes, our taste in feminine beauty also evolves, and each era has its own demands. The modern model is very young. The camera ages people quickly; a model of sixteen or eighteen is seen through the eye of the camera as a glorious thirty. Youth, energy, and an inner dynamic quality are essentials for a great model. So, too, is the ability to shed professionalism and to become herself.

The model today brings into the studio the reality of a modern young woman's life. Her body has been moving in a discothèque. She has been jogging. She has been exercising. She has been making love. She has been living an active life. She often arrives in the studio dressed in blue jeans and then, like an actress, assumes her role. The enrichment of the photographer's vision is the link that makes clothes part of the image of the moment. The photographer no longer dictates a pose; he catches a glimpse of life that connects him to a physical reality outside the deadness of the studio.

Modern photography—with the liberation of mental and social restraints, with the freeing of modern dress—has dared to suggest more explicitly erotic situations and to present more nudity. Some photographers today have attempted a visual breakthrough by an individual style based on shock. Scenes of terror and violence have crept into the photography of clothes; but it is as if each magazine page were a stage and everything on the stage were pure make-believe. Nothing is to be taken seriously; all is theater. But the attention-getting value of the resulting strangeness keeps

clothes that could otherwise be quickly forgotten imprinted on a reader's memory.

These attempts to shock stem from the success of contemporary art. To startle the spectator has always been the desire of the avant-garde artist. But with this type of subject matter, national tastes, cultures, and religious barriers play an important role. France and Italy will accept a greater visual freedom than will England or America. Europe accepts readily photographic images of a sophisticated, luxurious, "decadent" world. On the other hand, the American photographer, bred in a more puritanical and idealistic culture, faces a much wider audience. The imitation of an avant-garde group and its kinky fantasies is not a goal for the American public. A respect for moral values, happiness within the daily reality of life, and well-being within a working society are still the American ethos.

Contemporary fashion photography gives pleasure to the reader, and this is achieved more easily by a smile. The smiling syndrome is one of the new standbys of fashion presentation and primarily an American phenomenon. In advertising, nothing sells better today than a product that is stamped by the smile and the seductive appeal of a beautiful woman. And the most unexpected products seem to need not only that human appeal but also the glamor, the confidence, and the stamp of approval that fashion can give. The modern escape is into the illusion of all-pervading happiness. The model signals to the reader that she is happy in what she is wearing, that she is happy in her world. But maybe this standardization of communication through happiness is one of the reasons creative fashion photography is sometimes swamped in a sea of banality and sameness.

In the relatively unique and still special environment of *Vogue*, the smile is not a must but is present when its charm expresses a moment of relaxed pleasure and fun. The hard sell is left to the tough commercial pressured world. But fortunately all is not greatness and seriousness in our fashion photography. The world needs a sense of play, of entertainment. To provoke the noble, one needs the contrast of the trivial and amusing. Women know how to use lightness and charm to achieve success through delight.

This light touch is in the spirit of the young of our age. They are building a shield of happiness against the terror that surrounds us. This exuberance and nonrestraint in fashion are an affirmation of faith in the survival of the individual through repeated exercise of freedom of choice. This choice of look is the visible proof of a nonconformist democracy—and the real moral ingredient of fashion today.

What still is missing from most fashion photography is a sense of the sacred. We are in the realm of the ornament of the profane, and this lack is the reason why fashion and its documentation are often considered frivolous, nonessential elements

in the human puzzle. Sometimes, as if seeing through and beyond the fashion, a photographer reaches the real being inside her cocoon of fabric and there is a glimpse of a touching humanity. Perhaps this kind of unique and noble fashion photograph stems from the realization on paper of a sense of awe and worship—the respect and admiration not for the superficial vestments but for the expression of an ideal of life and the eternal beauty of a woman's face and body. Unless they achieve this climactic level, thousands of photographs are but foreplay that teases us to expect the unique revelation—the unexpected picture that will add to our mental image-file an unforgettable idea.

If one puts together the millions of photographs printed in the *Vogues* through the years, a very human—and noble—concept of woman emerges. The respect for the person and the visualization of life through that person is what great fashion photography is all about. It is through these values, and through the collaboration of editors, art directors, models, and photographers who try to express them, that the group of *Vogues* exists today as a unique phenomenon.

This book gives the reader the rare opportunity to study the evolution of dress, behavior, and custom. Whatever their pictorial or creative value, *Vogue's* photographs retain a vital historical importance. This documentary value is one of the unique contributions of fashion photography to the memory of civilization. Because of the extra-ordinary continuity of the *Vogues*, it is possible to look back through their pages and to assemble a unique visual history that illustrates and makes visible our yearning for roots in an attractive past.

Photographers who through the years thought they were performing a humble, necessary task of showing what clothes existed for the needs of a given moment, in spite of themselves, unknown to themselves, were involved in a much grander scheme. They have shown that there is a possibility of achieving beauty, happiness, and progress, that through liberation from superficial restraints and mannerisms a better and more attractive life is possible. Their visual panorama is in reality a record of the freeing of human beings.

This total image of progress and hope is perhaps the most worthwhile reason for assembling these photographs. Another is to pay homage to the creativity and the inventive talents of the designers and photographers who have lavished their lives on portraying, ornamenting, nourishing, and protecting the sometimes delicate and more often strong and willful female creature who has maintained through the centuries an unbreakable spell on the imagination of mankind.

ALEXANDER LIBERMAN

1920s

PHOTOGRAPHERS FOR *VOGUE*
IN THE 1920S WERE JAMES ABBE, CECIL BEATON, HUGH CECIL,
BARON ADOLPHE DE MEYER, ÉMILE OTTO HOPPÉ,
GEORGE HOYNINGEN-HUENÉ, NICKOLAS MURAY, BERTRAM PARK,
MAN RAY, MATSY WYNN RICHARDS,
SEEBERGER FRÈRES, CHARLES SHEELER, EDWARD STEICHEN.

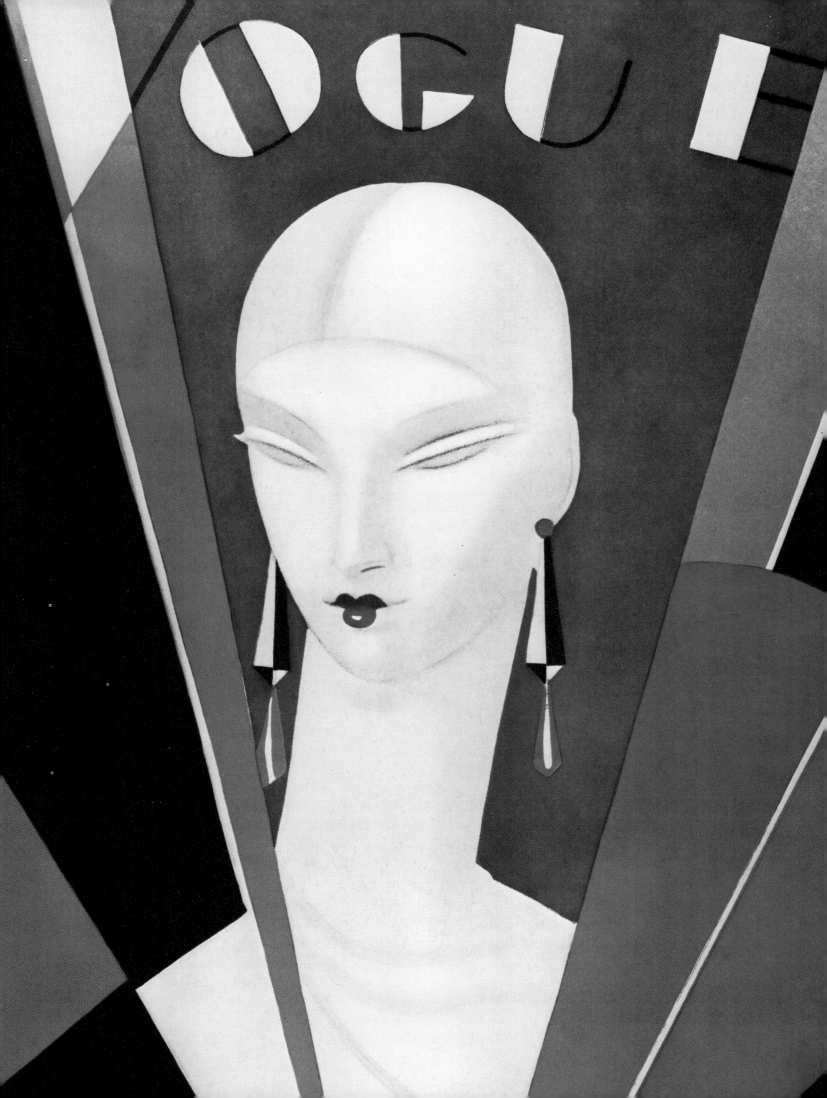

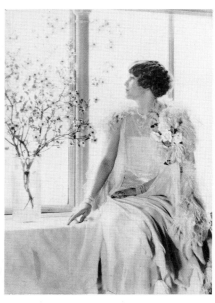

James Abbe/American Vogue, before 1920/ Ida Rubenstein

Photographer unidentified/American Vogue, July 1, 1913/Lady Paget and Duchess of Marlborough/Longchamp

Matsy Wynn Richards/American Vogue, July 1, 1923/Claire Windsor/Fashion: Francis

1920s

"The development of fashion photography moves with
that of the twentieth century; and ever since Condé Nast, an ambitious young
American publisher, bought *Vogue* in 1909 when it was a weekly
society magazine and set about making it into the foremost fashion magazine
in the world, *Vogue* has chronicled and energized fashion as it happens.
Looking back at fashion photography we see that
the world in which women have moved, worked, socialized, and become

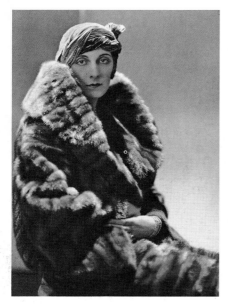

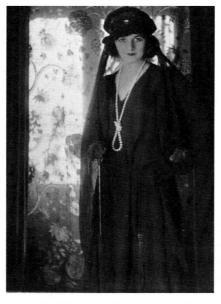

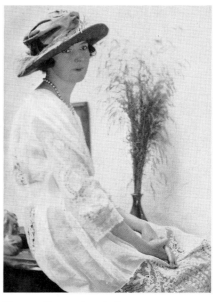

George Hoyningen-Huené/American Vogue, September 15, 1928/Fashion: Suzanne Talbot, Maison Max/

Bertram Park/American Vogue, c. 1921/Doris Keane

Photographer unidentified/American Vogue, c. 1920s/Viola Tree

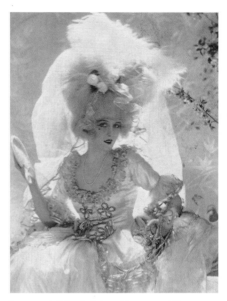

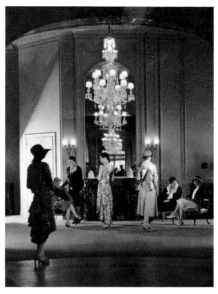

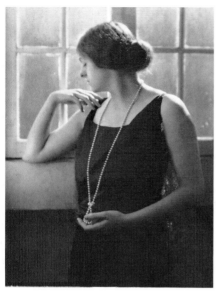

Baron Adolphe de Meyer/American Vogue, September 1, 1920/Helen Lee Worthing

Edward Steichen/American Vogue, May 1, 1928/Tippin Pero, Hannah Lee Sherman, Marion Stone, Rita Wilg, Gertrude Clark, Jule André and Mme Lassen/Fashion: Bergdorf Goodman

Nickolas Muray/American Vogue, July 15, 1923/Helen Gahagan

increasingly liberated, is chronicled—although sometimes inadvertently—almost as assiduously as fashion itself. Through fashion photography we collect a unique and valuable record of the society of the time, its moods and its manners, and can perceive the current cultural preoccupations— artistic influences, theatrical styles, social trends, the changing styles of salon and news photography.''

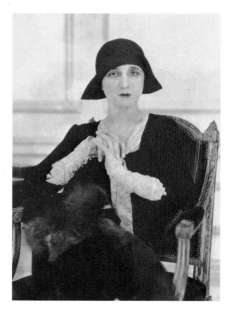

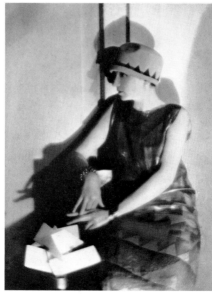

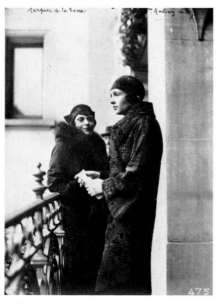

Charles Sheeler/American Vogue, September 29, 1928/Mme Lassen/Fashion: Reboux

Man Ray/American Vogue, May 15, 1925, and French Vogue, May 1925/Madame Agnès/Fashion: Chéruit

Seeberger Frères/American Vogue, December 21, 1929/M. Martinez de Hoz and Marquise de la Torre/Paris

Baron Adolphe de Meyer
American Vogue,
July 1, 1919
Ann Andrews
Fashion: Jonas

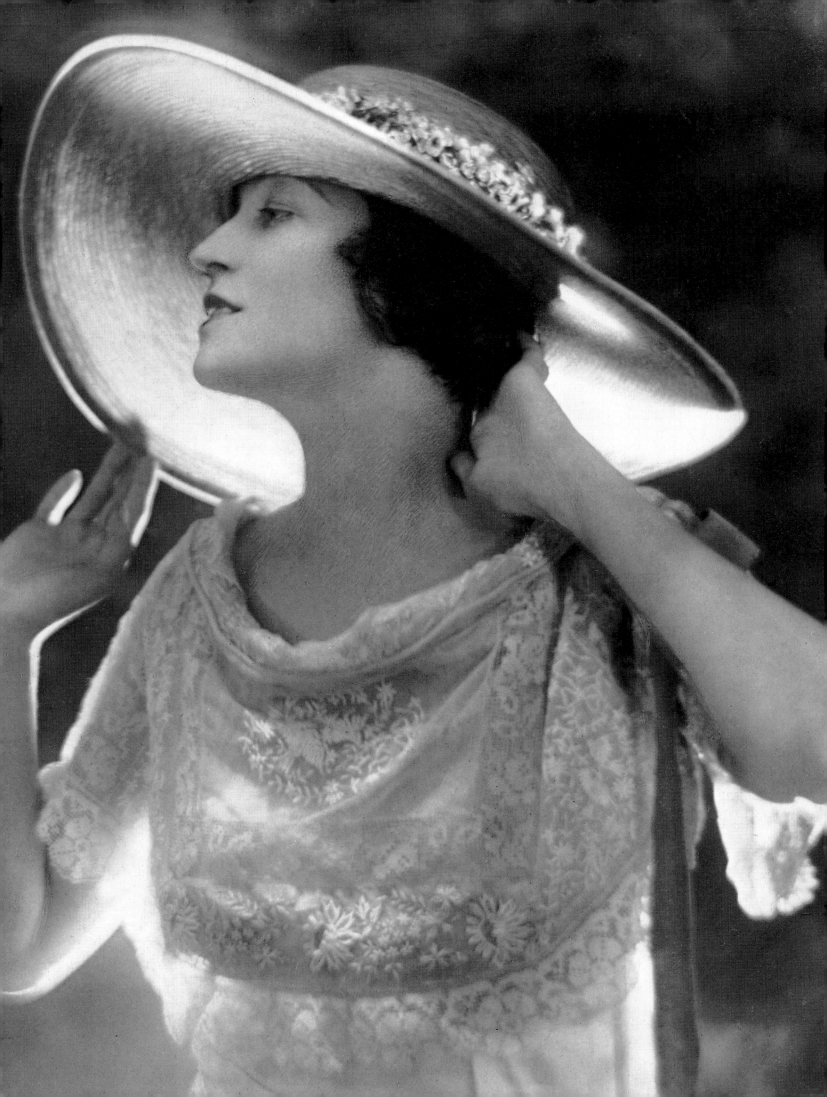

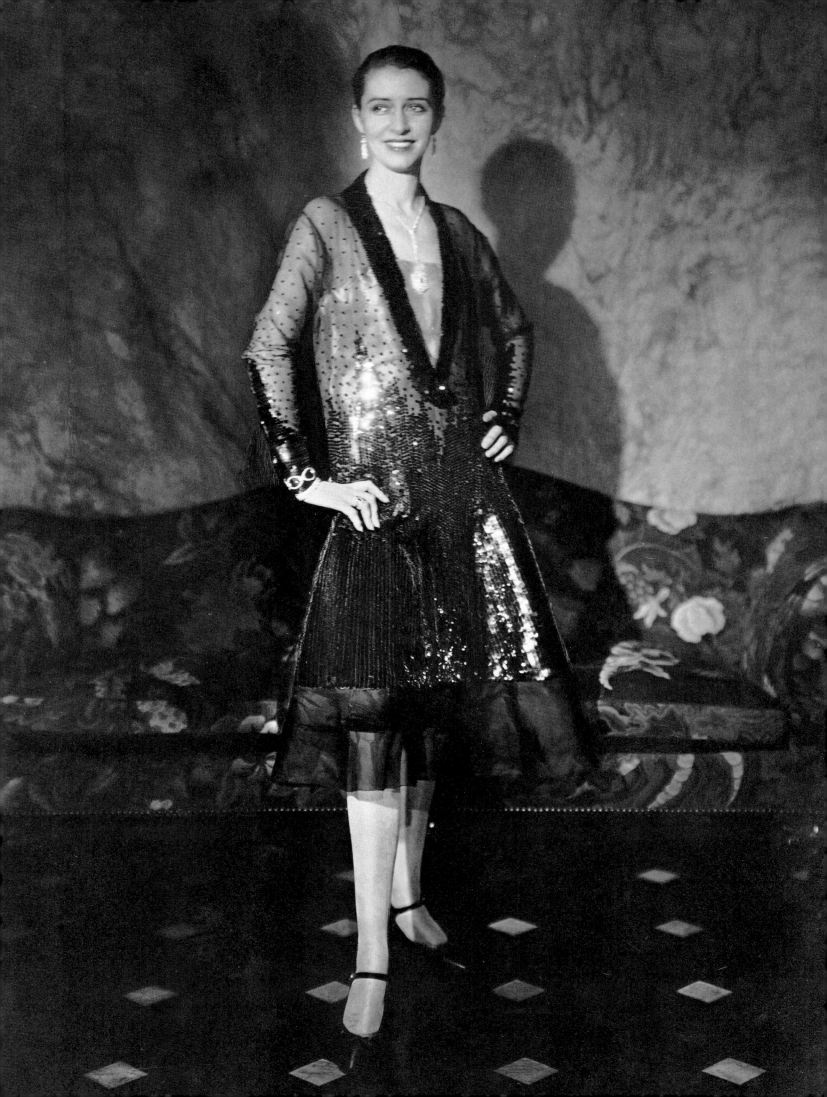

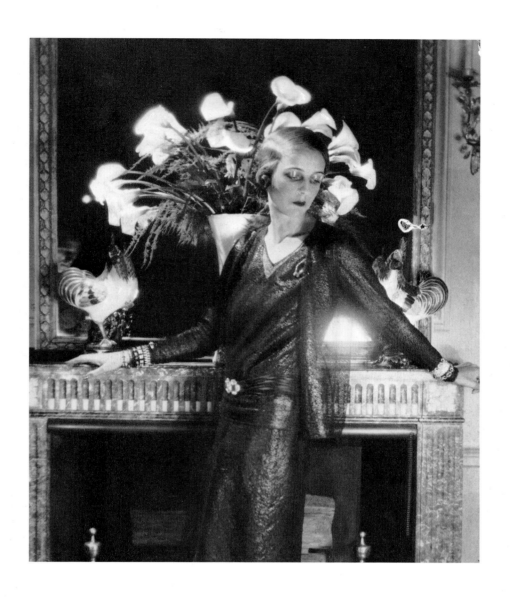

Edward Steichen
American Vogue, May 1, 1927
Marion Morehouse
(Mrs. e. e. cummings)
Fashion: Chéruit
Condé Nast's apartment, New York

Cecil Beaton
American Vogue, March 16, 1929
Marquise de Casa-Maury

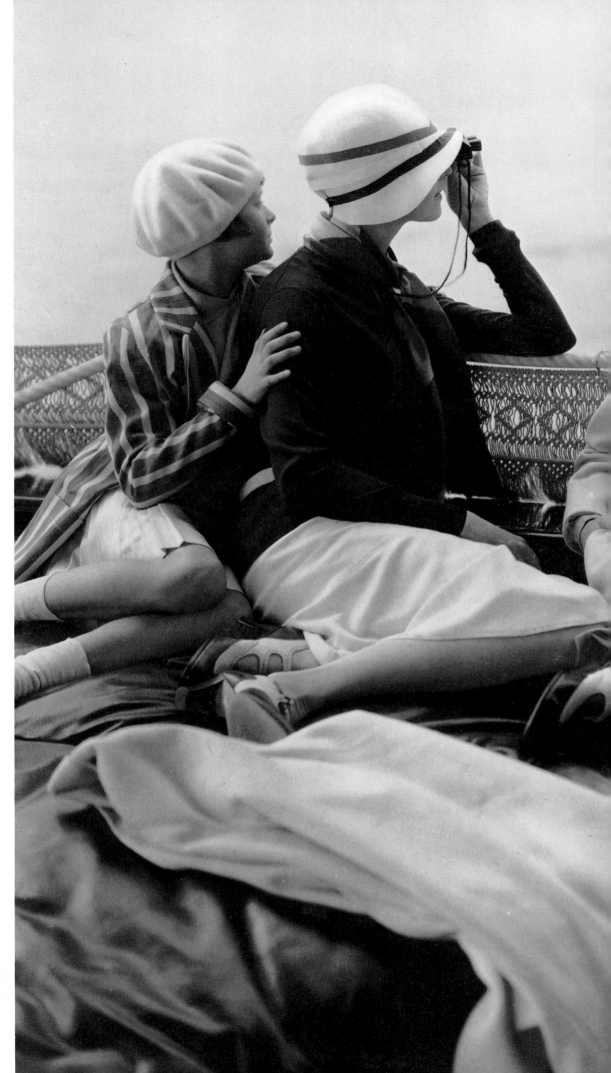

Edward Steichen
American Vogue, July 15, 1928
Fashion: L-R Chanel, Reboux, Mae
& Hattie Green

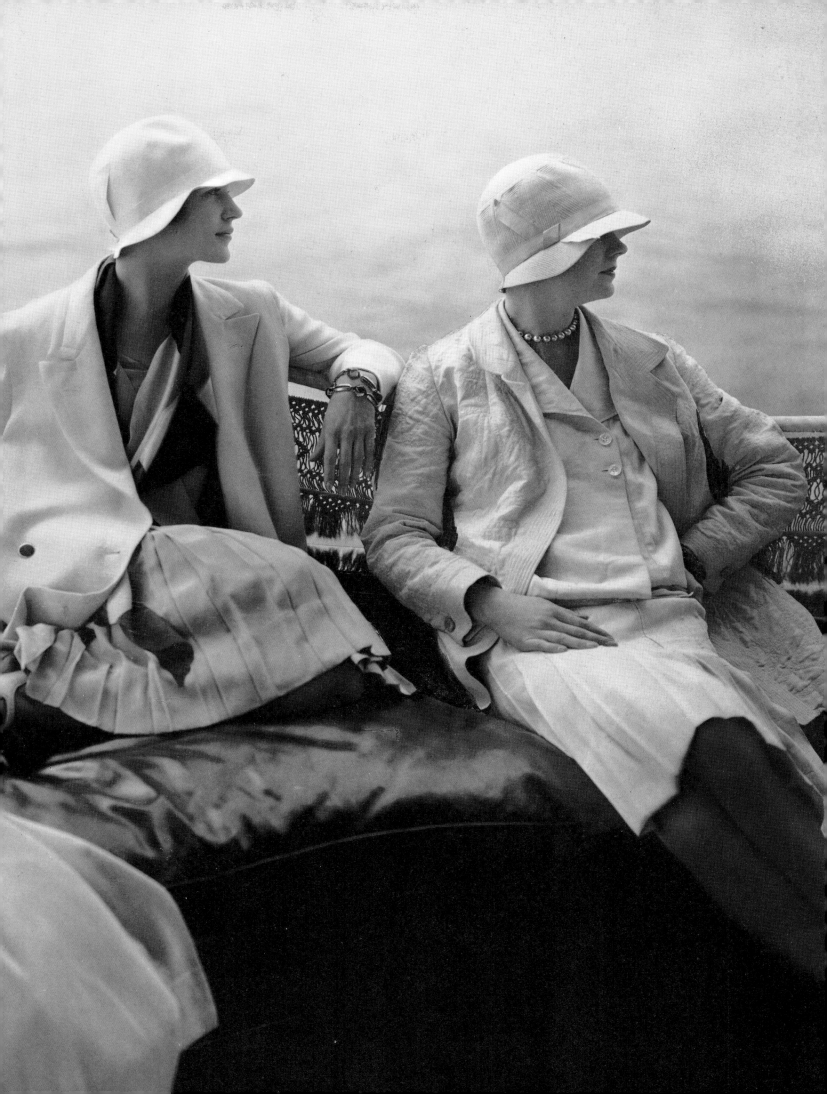

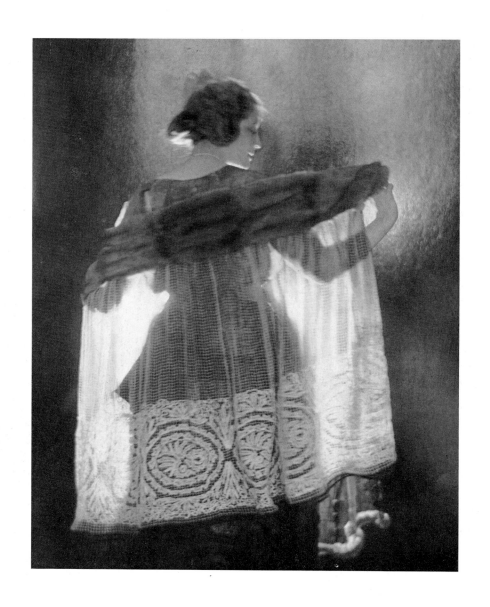

Baron Adolphe de Meyer
American Vogue, April 15, 1921
Ann Andrews
Fashion: H. Jaeckel & Sons

Baron Adolphe de Meyer
American Vogue, December 15, 1919
Dorothy Smoller
Fashion: Jenny

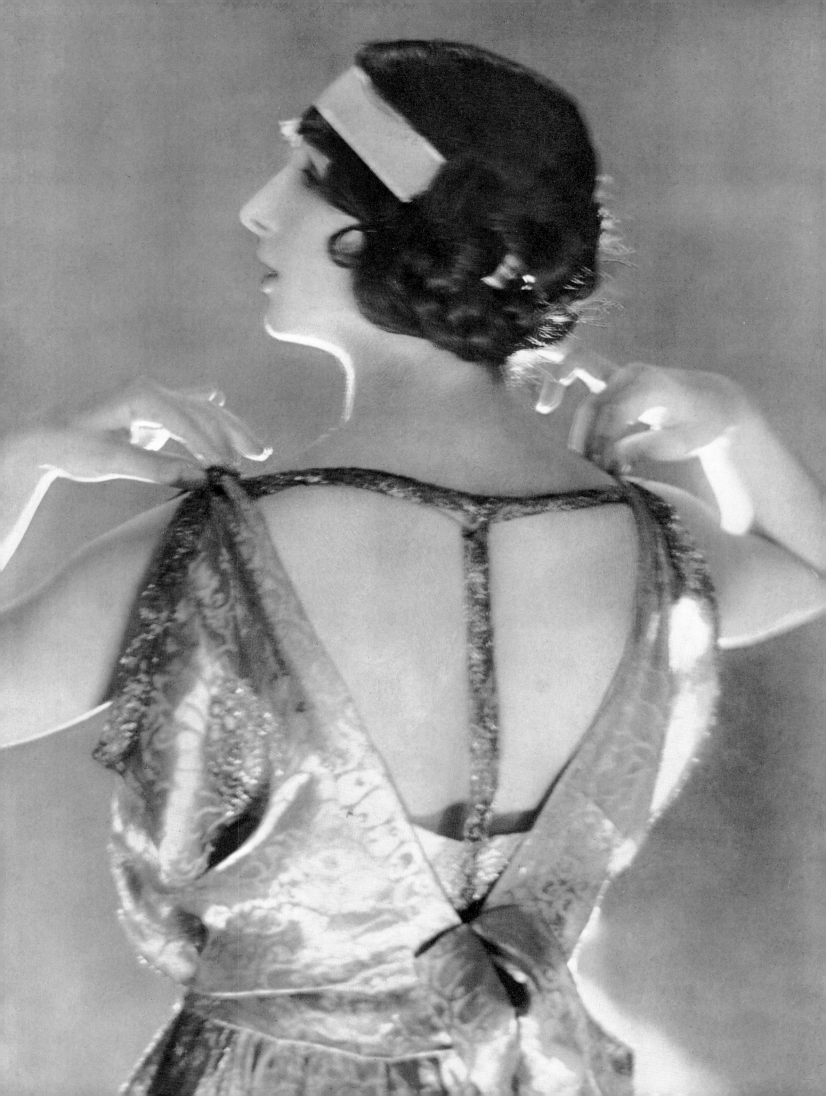

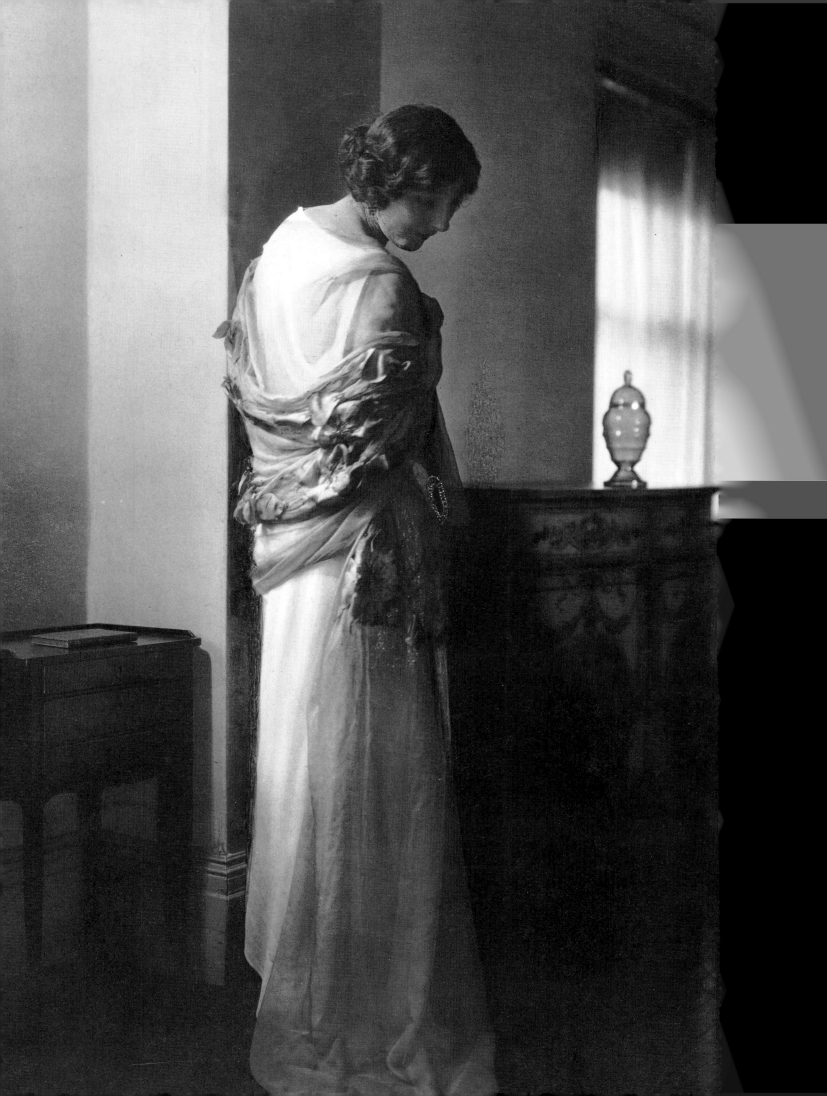

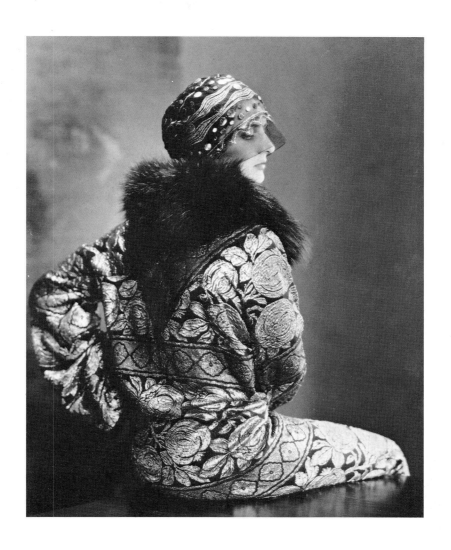

Edward Steichen
American Vogue, August 1, 1923
Florence Fair
Fashion: Chéruit

Edward Steichen
American Vogue, November 15, 1925
Fashion: Suzanne Talbot

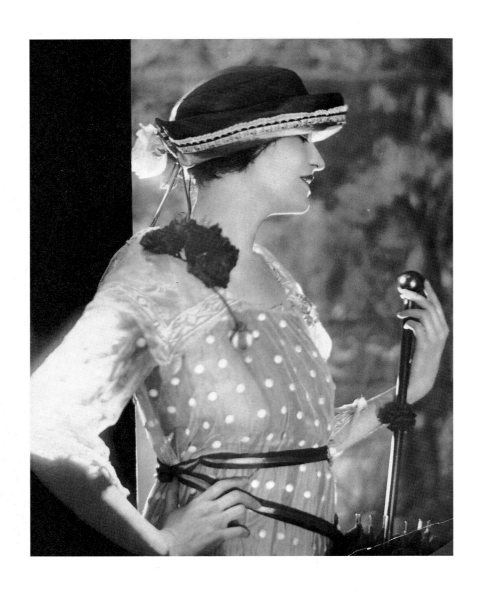

Baron Adolphe de Meyer
American Vogue, July 1, 1919
Fashion: Reboux

Edward Steichen
American Vogue, December 15, 1926
Fashion: McAffe Oxfords

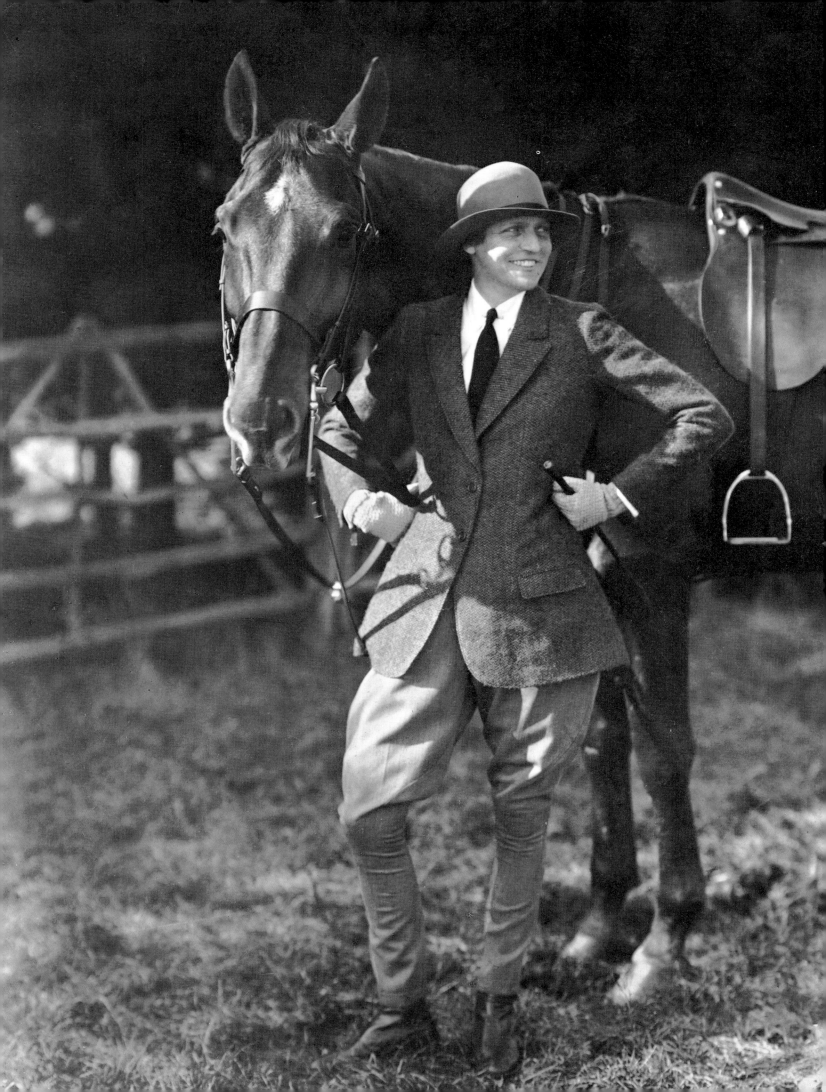

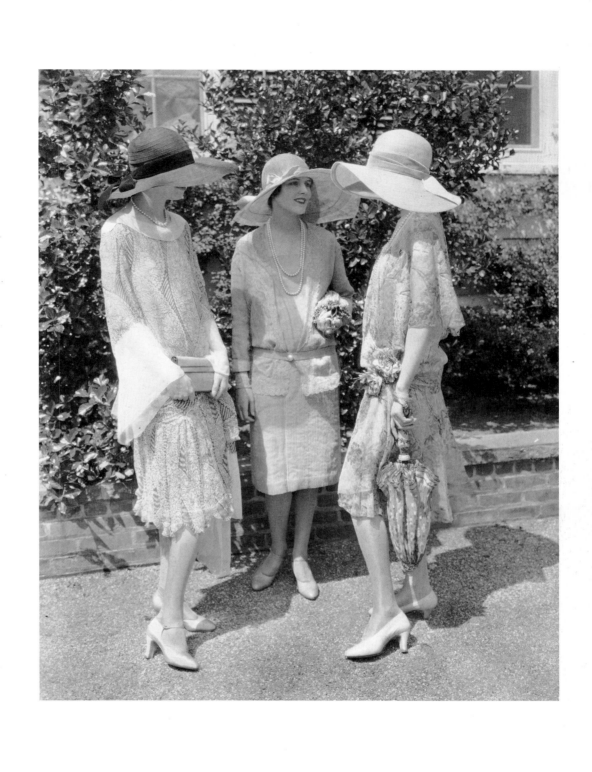

E dward Steichen
American Vogue, May 1, 1927
Kitty Penn Smith

Edward Steichen
American Vogue, July 15, 1927
Fashion: Madame Frances, Jay Thorpe

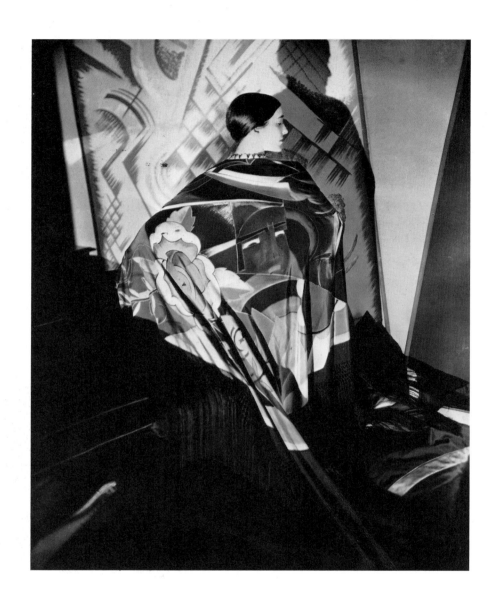

Edward Steichen
American Vogue, June 1, 1925
Anita Chace
Fashion: Colour Studio,
New York

Baron Adolphe de Meyer
American Vogue, January 15, 1913
Gertrude Vanderbilt Whitney
Fashion: Persian costume

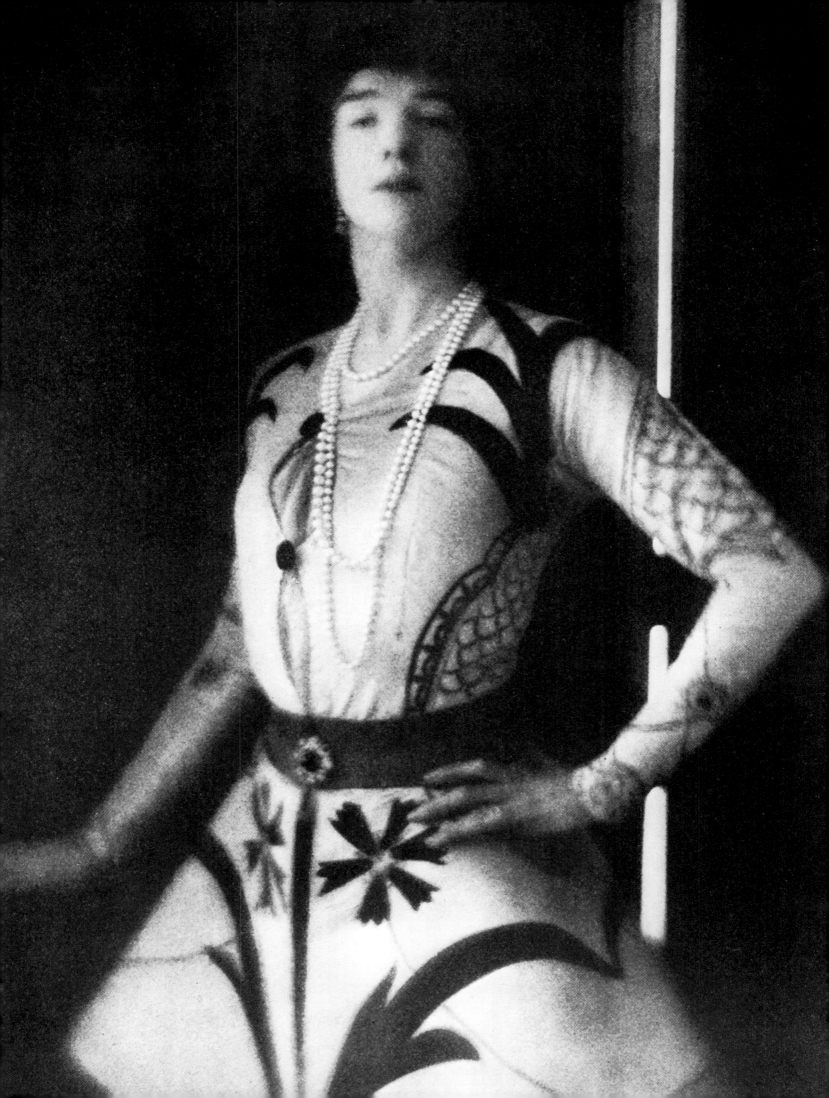

1930s

P HOTOGRAPHERS FOR *VOGUE*
IN THE 1930S WERE CECIL BEATON, ERWIN BLUMENFELD,
ANTON BRUEHL, ANDRÉ DURST,
TONI FRISSELL, HORST P. HORST, GEORGE HOYNINGEN-HUENÉ,
ANDRE KERTESZ, HERMAN LANDSHOFF, REMIE LOHSE,
LUSHA NELSON, JOHN RAWLINGS,
ROGER SCHALL, EDWARD STEICHEN, DR. PAUL WOOLF.

E dward Steichen
American Vogue, July 1, 1932
First color photographic cover

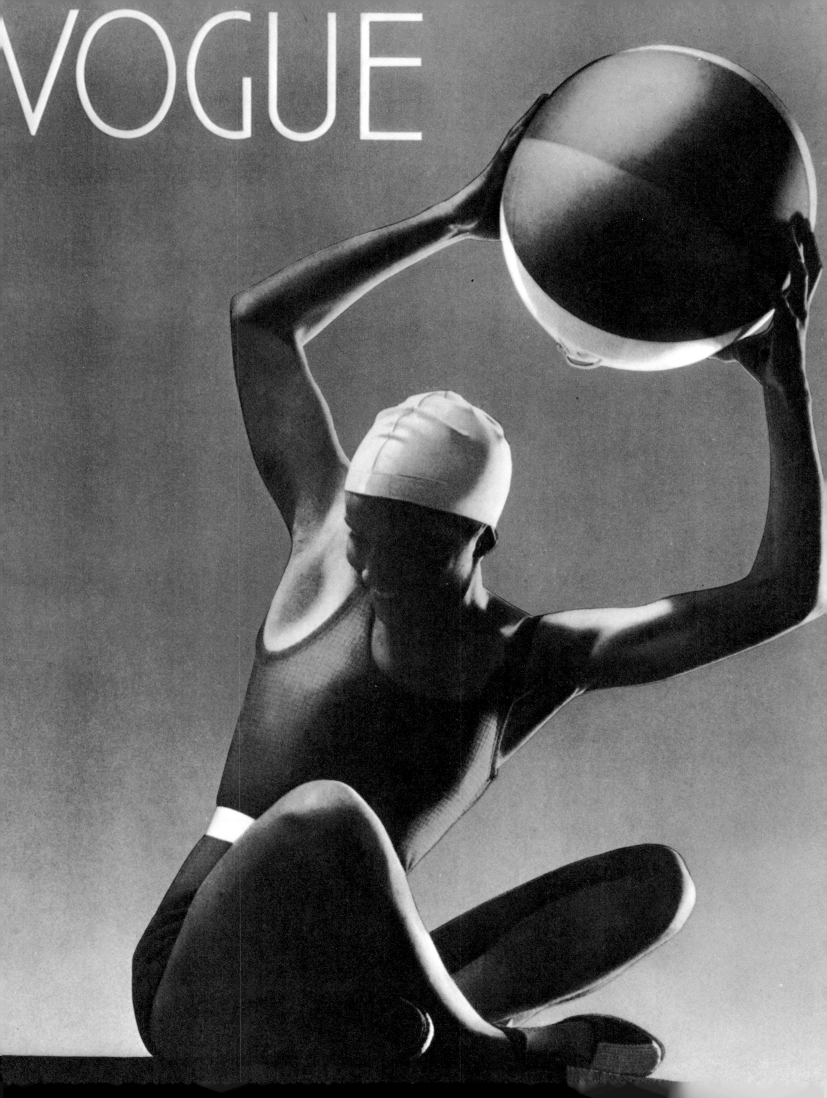

Cecil Beaton/American Vogue, August 15, 1933/The Marquise de Paris/Fashion: Reboux, Augustabernard/

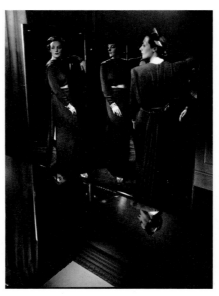

Edward Steichen/American Vogue, November 1, 1935/Muriel Maxwell/Fashion: Rose Amado, Madame Pauline/

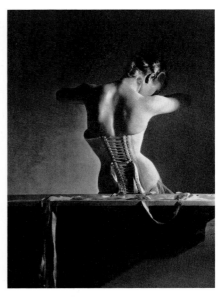

Horst P. Horst/American Vogue, September 15, 1939/Fashion: Detolle/Paris

1930s

"Vogue was now an important instrument and
arbiter of fashion. One thing was constant: to be a well-dressed
woman in the 1930s was a time-consuming
business involving serious dedication, endless fittings,
and infinite changes of hat and costume.
In 1933 *Vogue* came to the conclusion that fashion ideas sprang

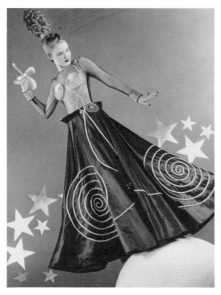

Anton Bruehl/American Vogue, February 1, 1939/Fashion: Henry Dreyfuss

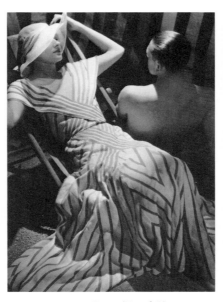

George Hoyningen-Huené/French Vogue, August 19, 1933/Fashion: Chanel

André Durst/American Vogue, January 15, 1936/Fashion: Schiaparelli

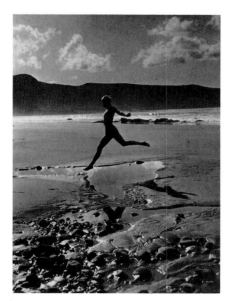

Dr. Paul Woolf/American Vogue, July 15, 1935

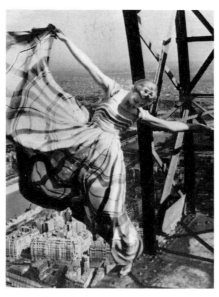

Erwin Blumenfeld/French Vogue : May 1939/Lisa Fonssagrives

Roger Schall/American Vogue, April 1, 1936/ Fashion: Chanel

from Hollywood and Paris by spontaneous combustion.
The pages were changing radically in look
and layout, as well as in content. A unique collaboration
of talent, circumstance and opportunity lifted
fashion photography in the 1930s into its distinctive place as a
separate visual genre in the arts of the twentieth century.''

Remie Lohse/American Vogue, May 1, 1936/ Tea Dance, Plaza Hotel

Lusha Nelson/American Vogue, December 1, 1936/Lisa Fonssagrives/Fashion: Talbot, Paquin/Paris Studio

André Kertész/American Vogue, January 1, 1932/Mrs. Cavendish-Bentinck/Fashion: Lelong, Louise Bourbon/Paris

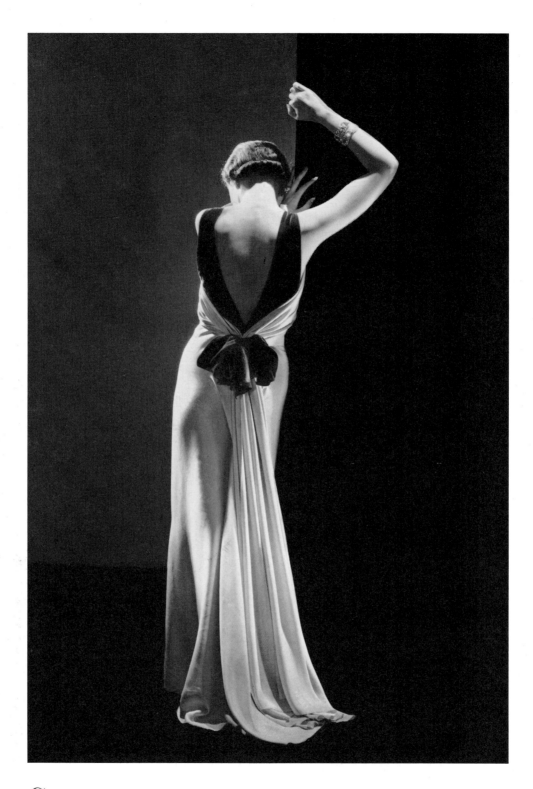

G eorge Hoyningen-Huené
American Vogue, September 15, 1933
Mademoiselle Koopman
Fashion: Augustabernard

Edward Steichen
American Vogue, March 15, 1935
Mary Heberdeen
Fashion: Arthur Falkenstein

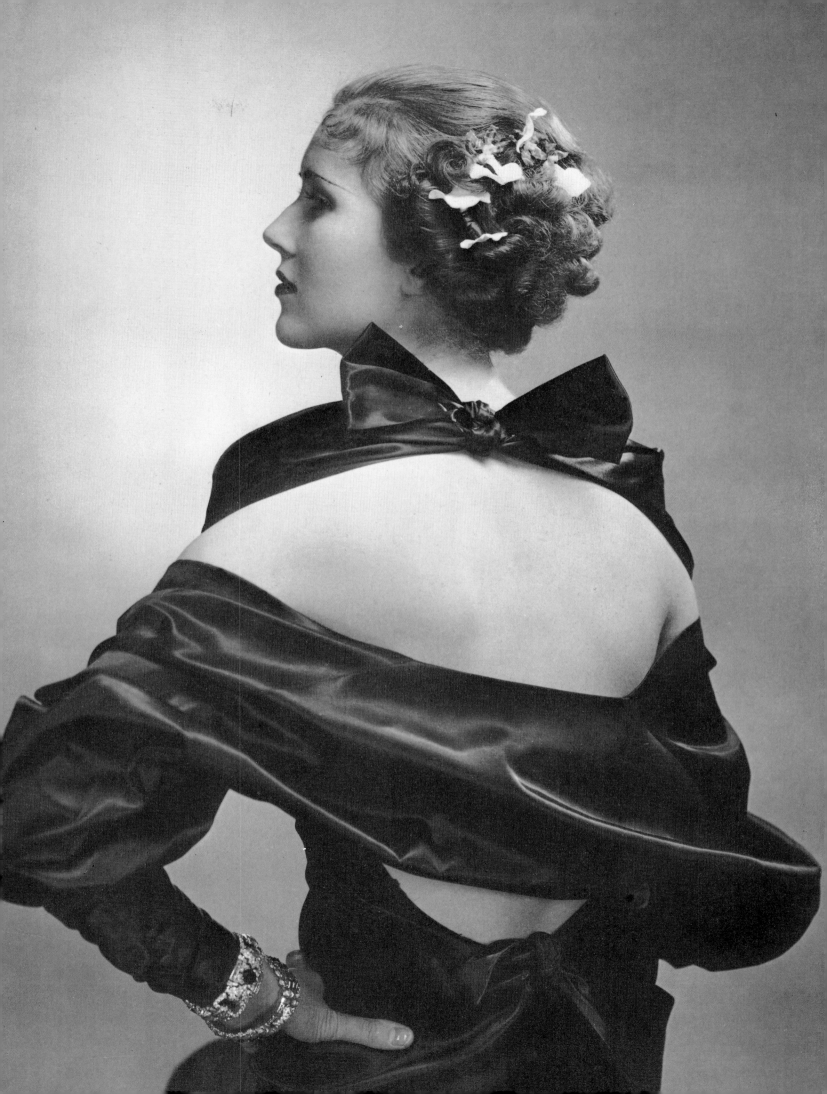

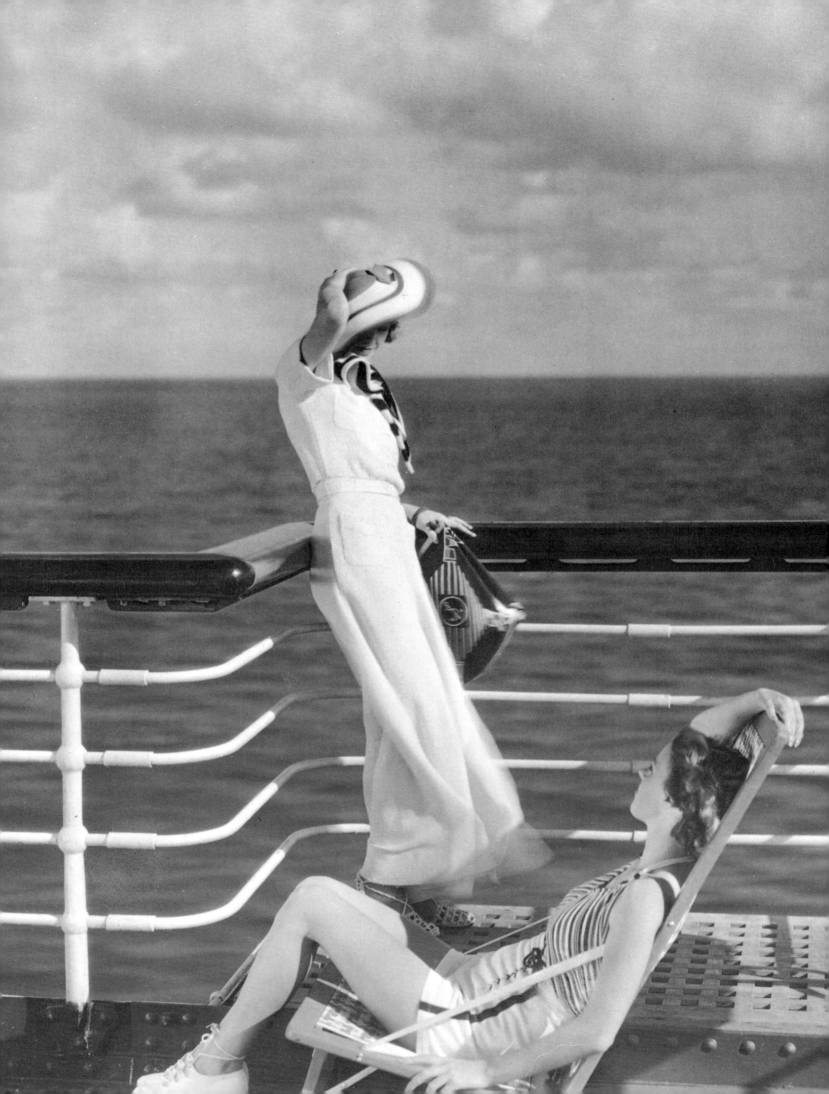

Edward Steichen
American Vogue, July 15, 1934
Fashion: Ransohoff
On the Lurline, Hawaii bound
Used in Vogue as a color plate (see p. 9)

George Hoyningen-Huené
French Vogue, July 30, 1930
Agneta Fischer
Fashion: Schiaparelli
Vogue's Paris studio

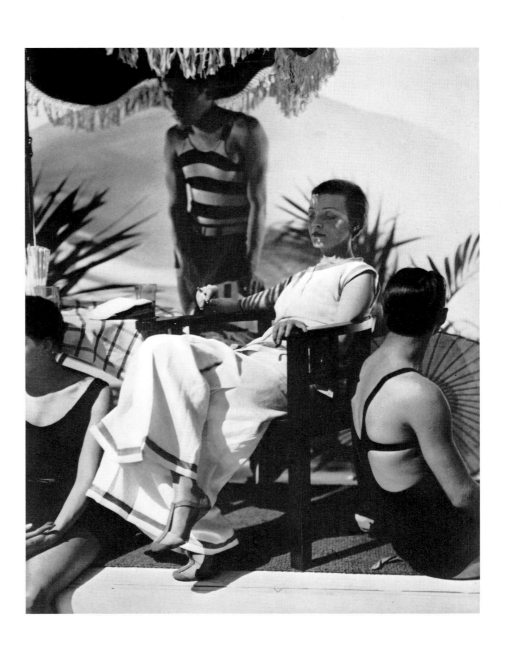

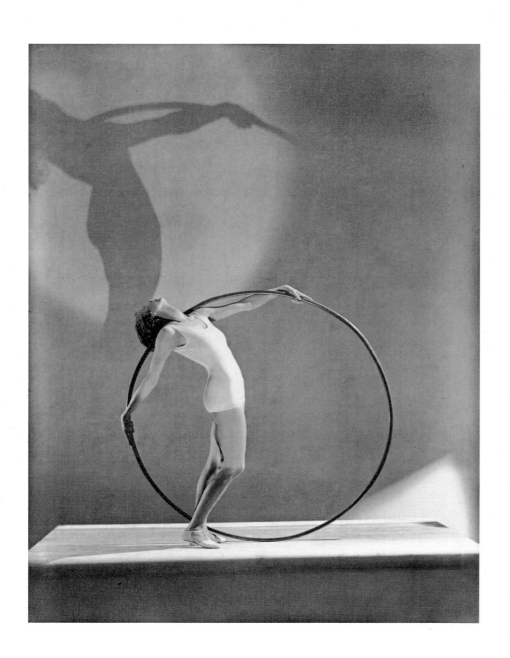

George Hoyningen-Huené
American Vogue, July 5, 1930
Ernor Carise
Vogue's Paris studio

George Hoyningen-Huené
American Vogue, December 15, 1934
Miriam Hopkins
Fashion: Travis Banton

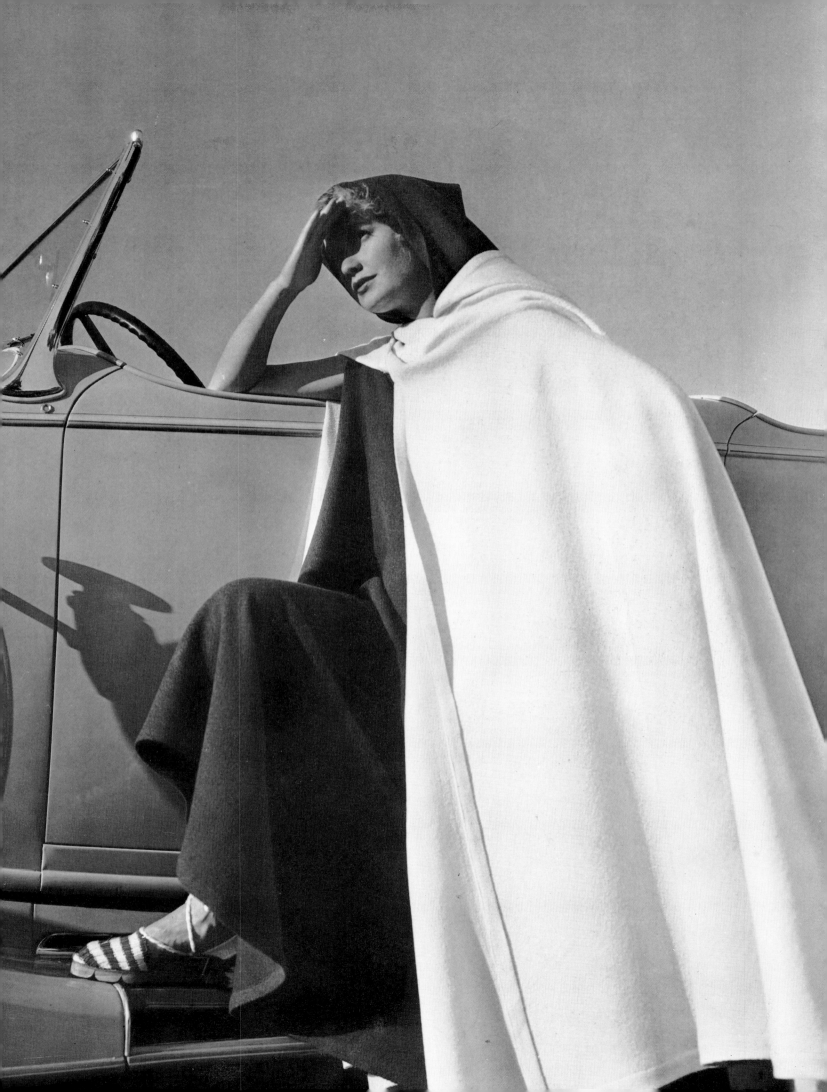

E dward Steichen
American Vogue, October 15, 1933
Mrs. Metmore
Fashion: Augustabernard

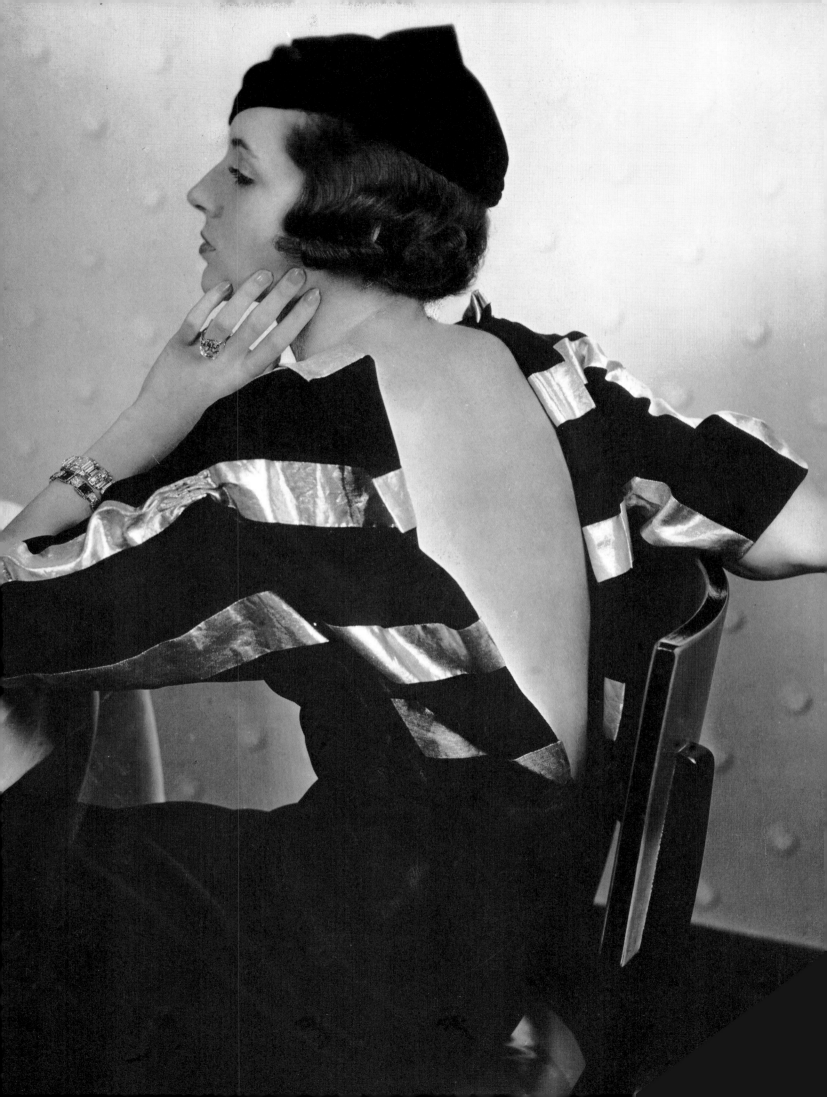

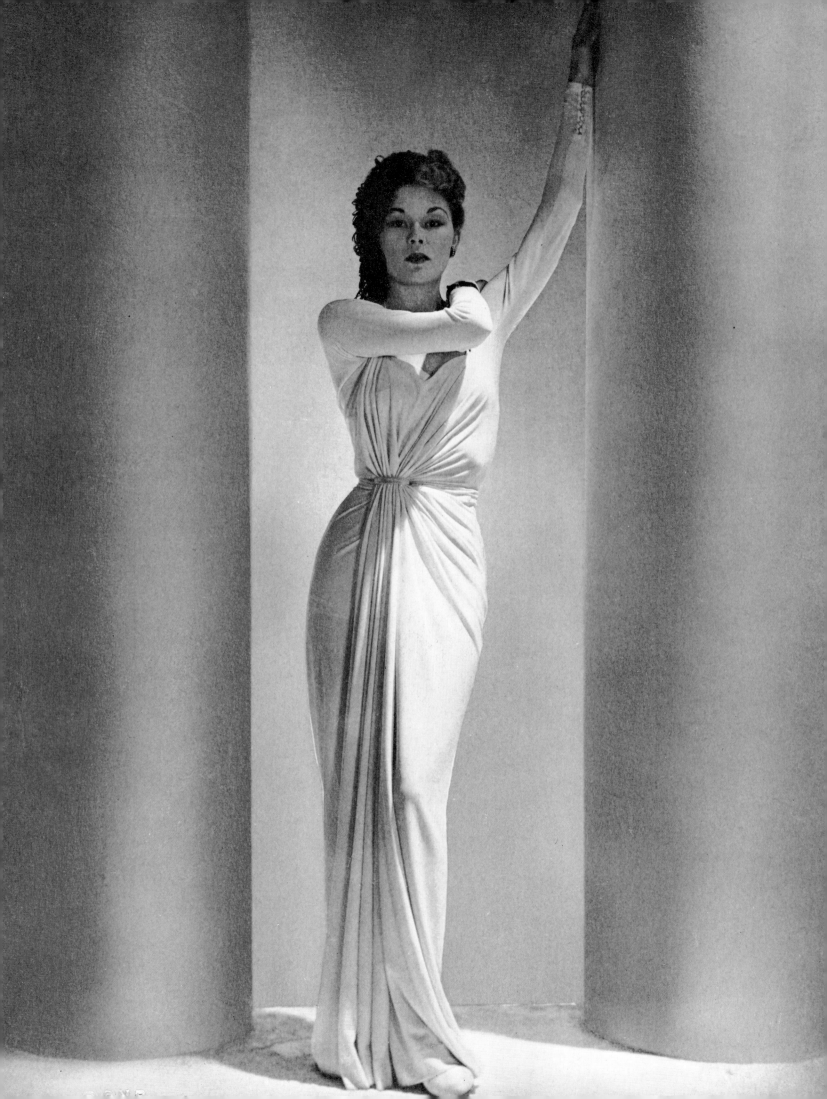

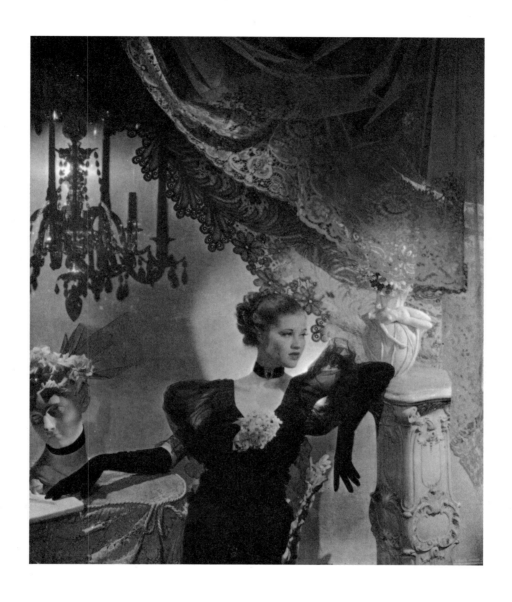

Horst P. Horst
American Vogue,
March 15, 1938
Lud
Fashion: Alix

Cecil Beaton
American Vogue, May 15, 1935
Mary Taylor
Fashion: Chanel

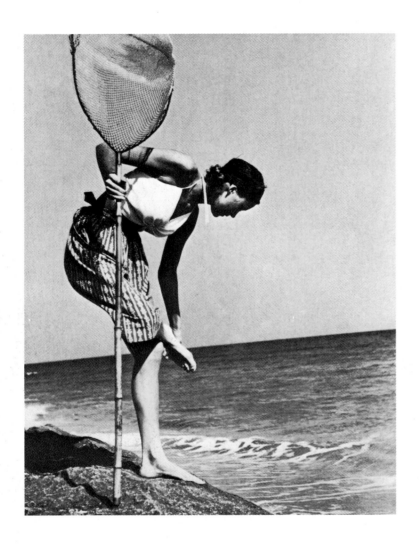

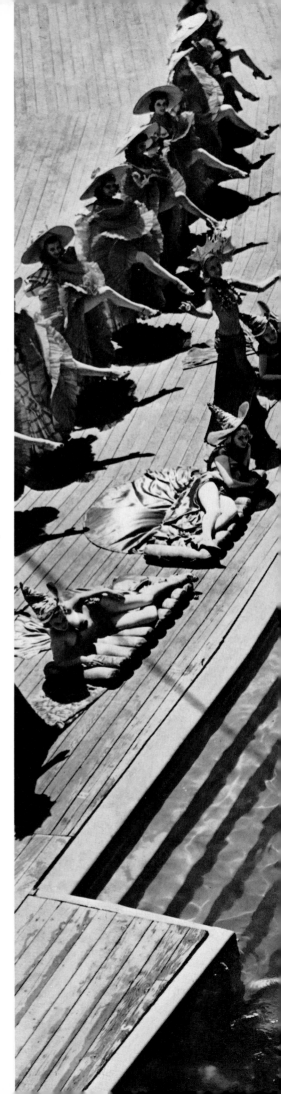

T oni Frissell
American Vogue, May 15, 1937
Fashion: from peasants and fishermen

Anton Bruehl
American Vogue, September 1, 1939
Billy Rose's original Aquacade

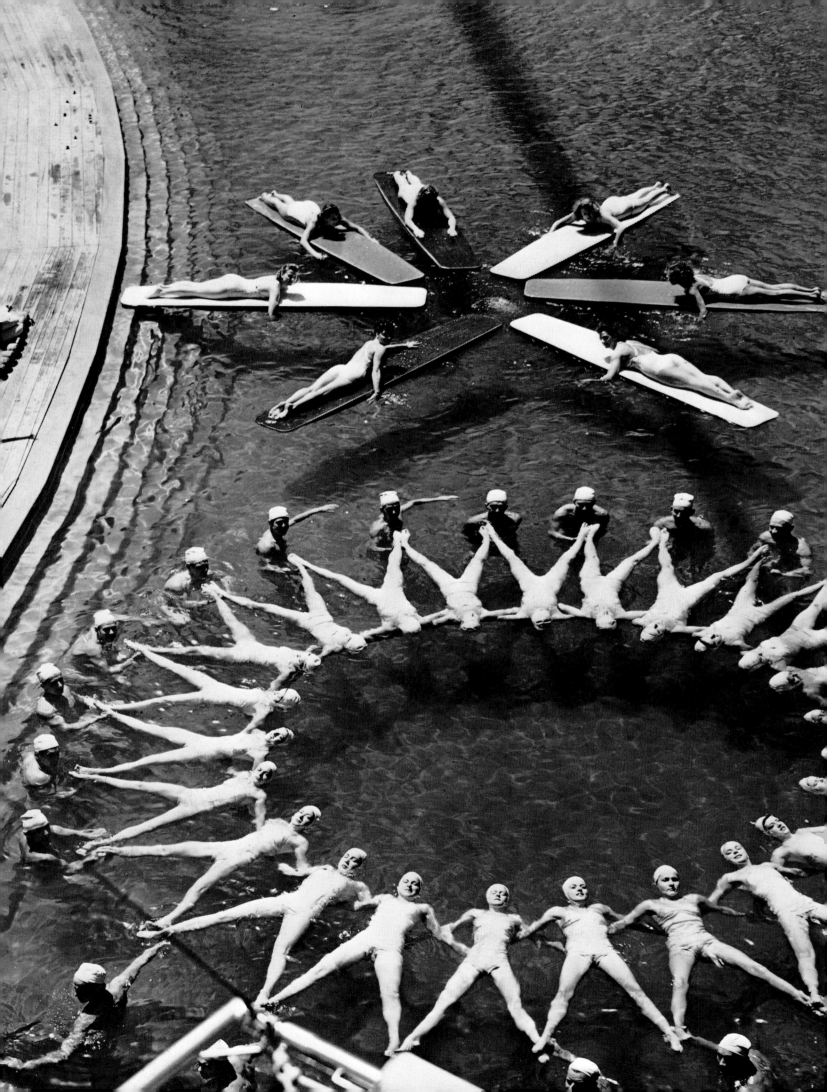

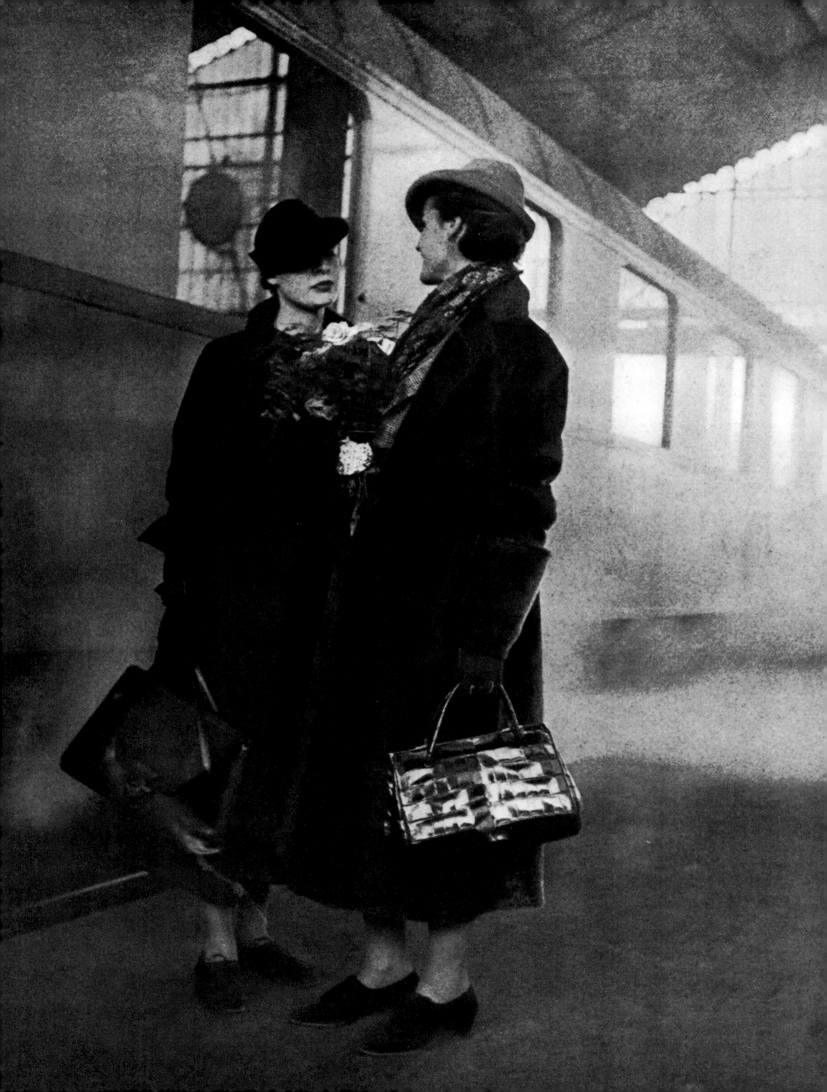

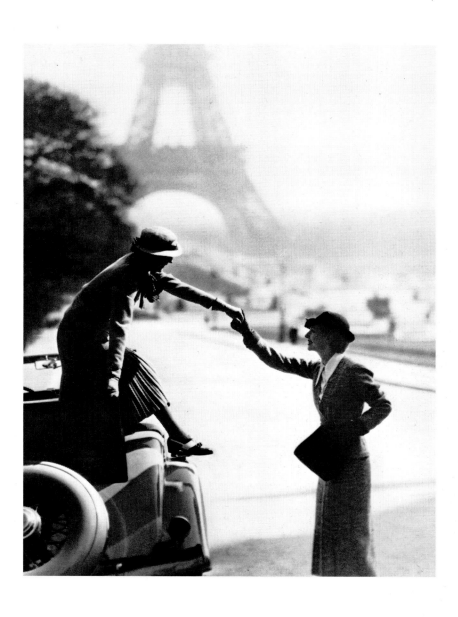

R oger Schall
French Vogue, January 1935
Fashion: Andrébrun, Weil Furs
Gare de Lyon, Paris

George Hoyningen-Huené
French Vogue, May 1934
Fashion: Lelong

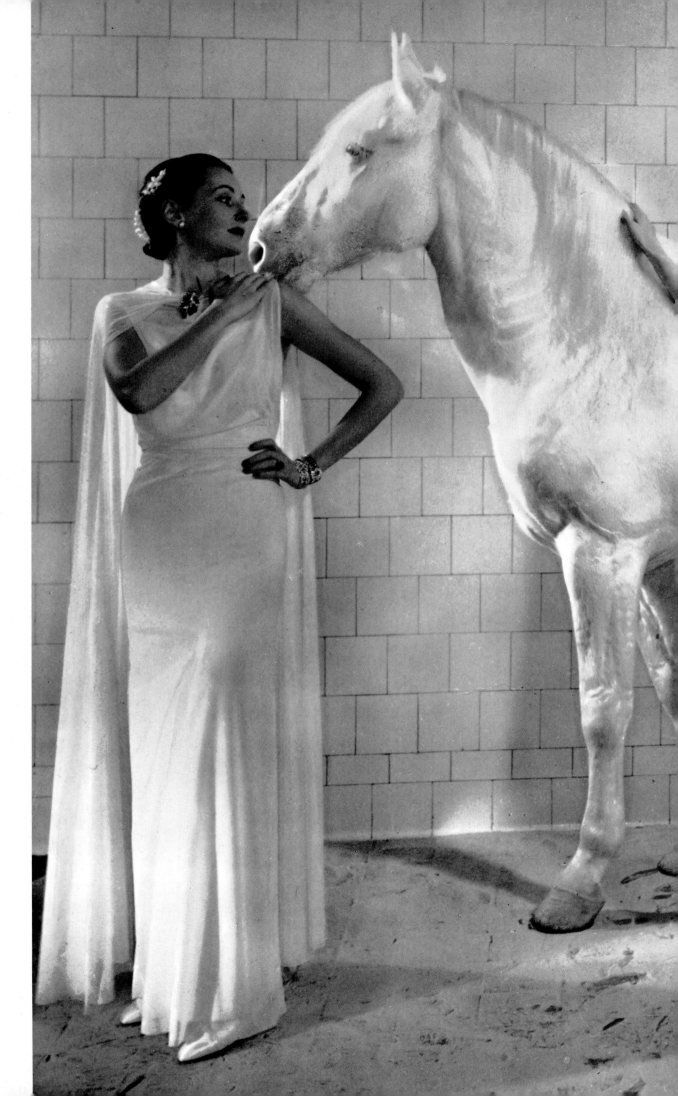

Edward Steichen
American Vogue,
January 1, 1936
"White" Center,
Gwili André
Steichen's New York
studio

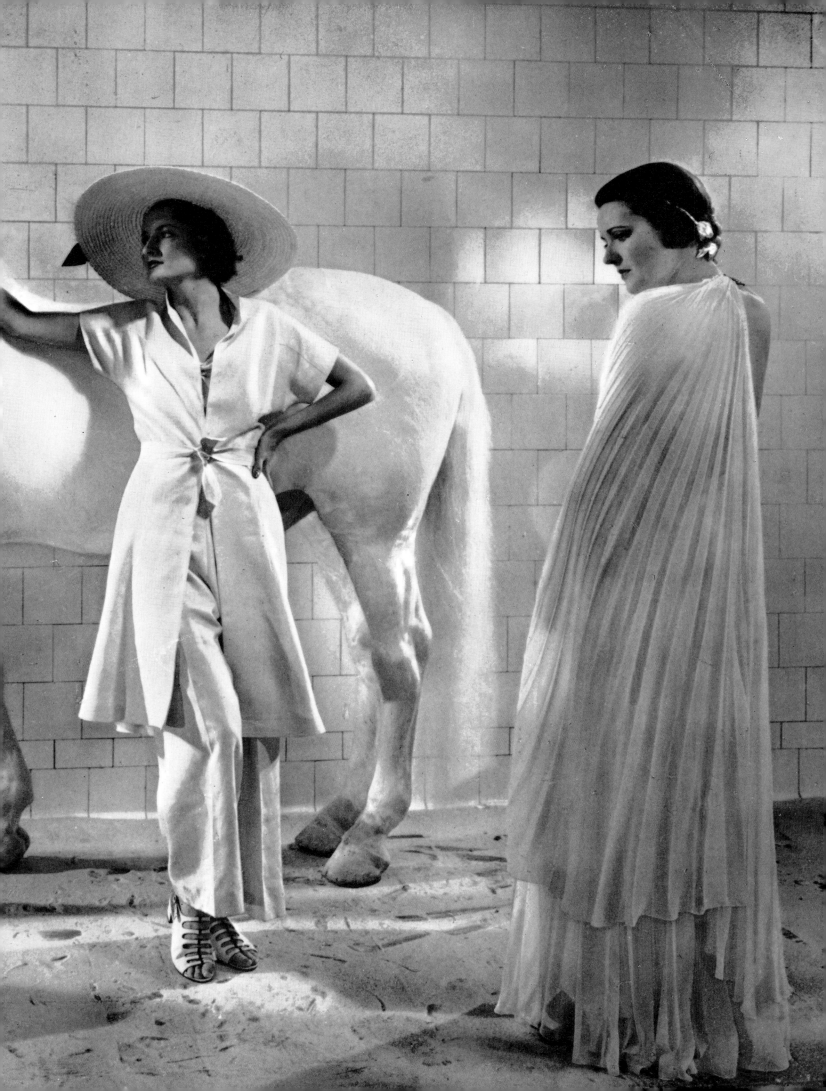

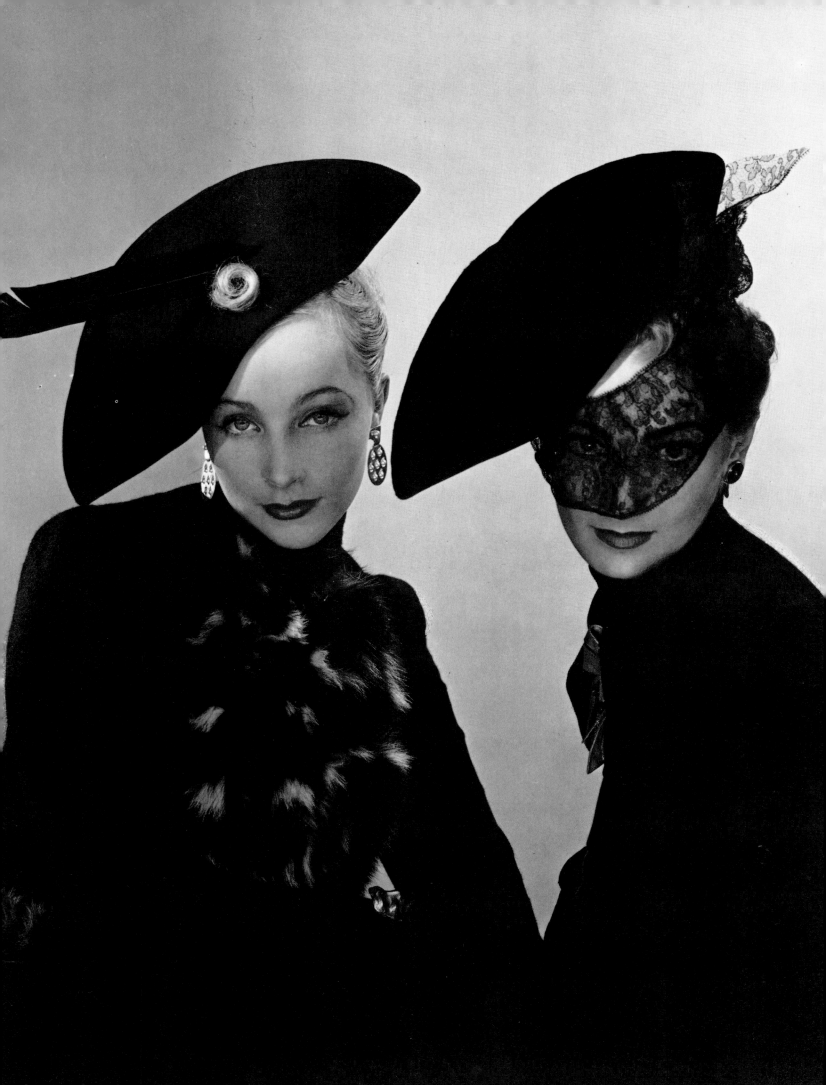

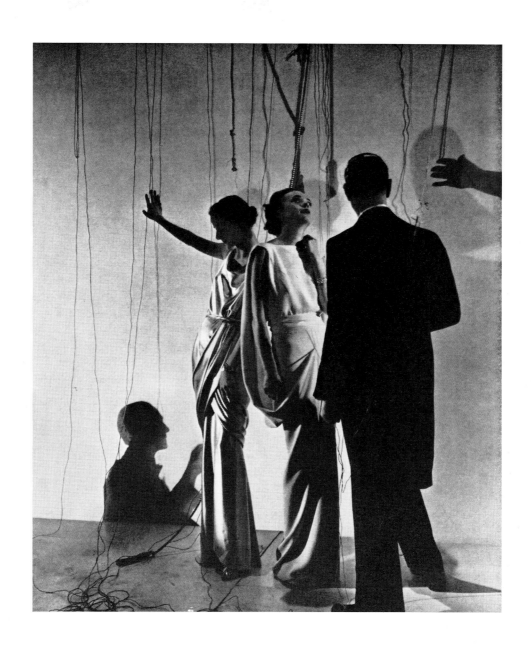

Erwin Blumenfeld
American Vogue, December 1, 1938
Fashion: Schiaparelli

Cecil Beaton
British Vogue, January 1938
Fashion: Piguet

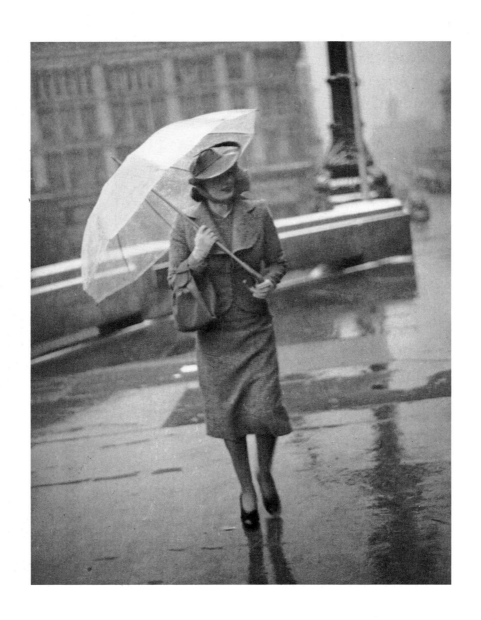

Toni Frissell
American Vogue, February 1, 1938
Mrs. C. Ruckelshaus
New York

Toni Frissell
American Vogue, January 1, 1939
Joan Dixon
Fashion: Brigance
Through a glass at Marineland's
Oceanarium, Florida

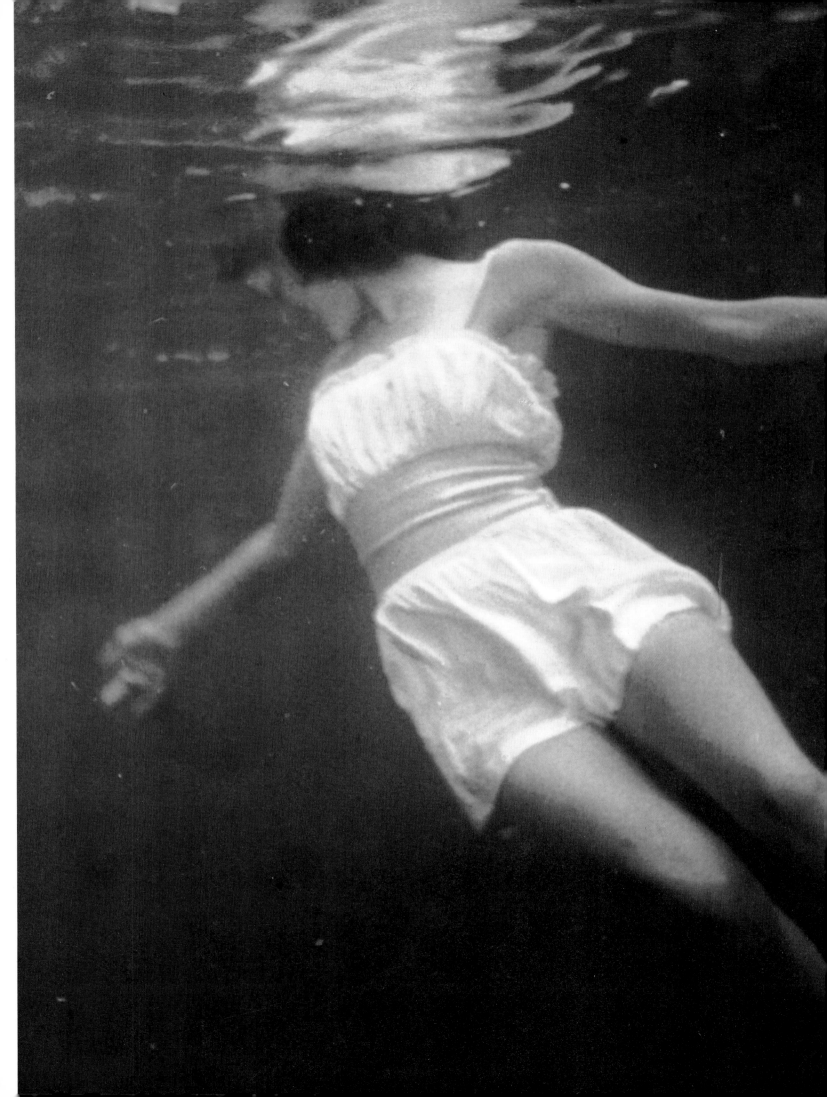

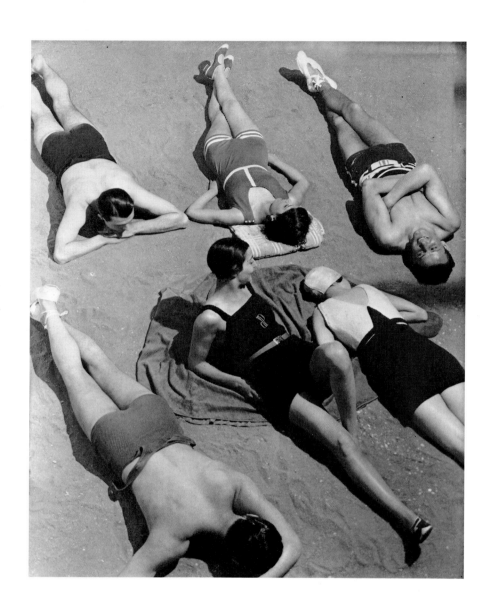

George Hoyningen-Huené
American Vogue, July 5, 1930,
and French Vogue, July 1933
Fashion: L-R Jean Patou, Molyneux,
Hélène Yrande; the men's by Jantzen
Vogue's Paris studio

George Hoyningen-Huené
French Vogue, September 1927
Mademoiselle Colette Salomon

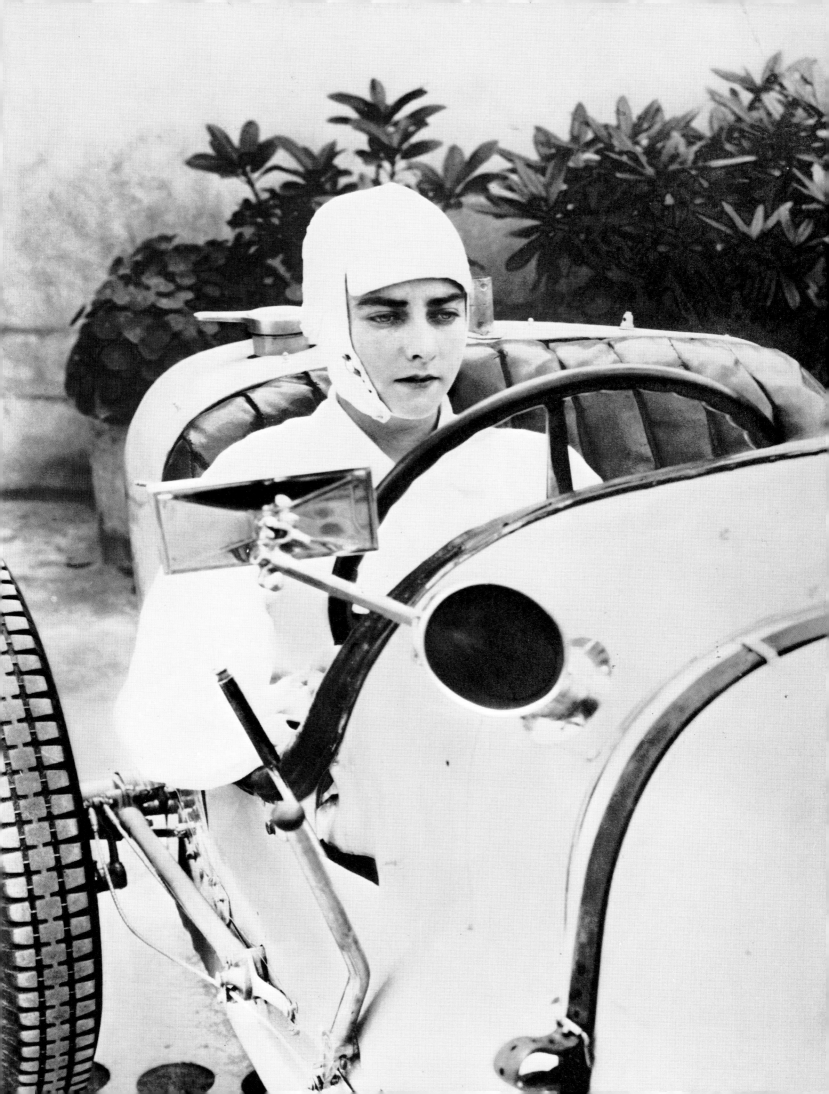

1940s

PHOTOGRAPHERS FOR VOGUE

IN THE 1940S WERE ALLAN AND DIANE ARBUS, SERGE BALKIN,

CECIL BEATON, KAY BELL, ERWIN BLUMENFELD,

CLIFFORD COFFIN, TONI FRISSELL,

HORST P. HORST, CONSTANTIN JOFFÉ, JACQUES-HENRI LARTIGUE,

LUIS LEMUS, GEORGE PLATT LYNES, HERBERT MATTER,

FRANCES MCLAUGHLIN, LEE MILLER,

GJON MILI, NORMAN PARKINSON, IRVING PENN,

JOHN RAWLINGS, RICHARD RUTLEDGE.

Horst P. Horst
American Vogue, June 1, 1940
Lisa Fonssagrives
Fashion: Brigance

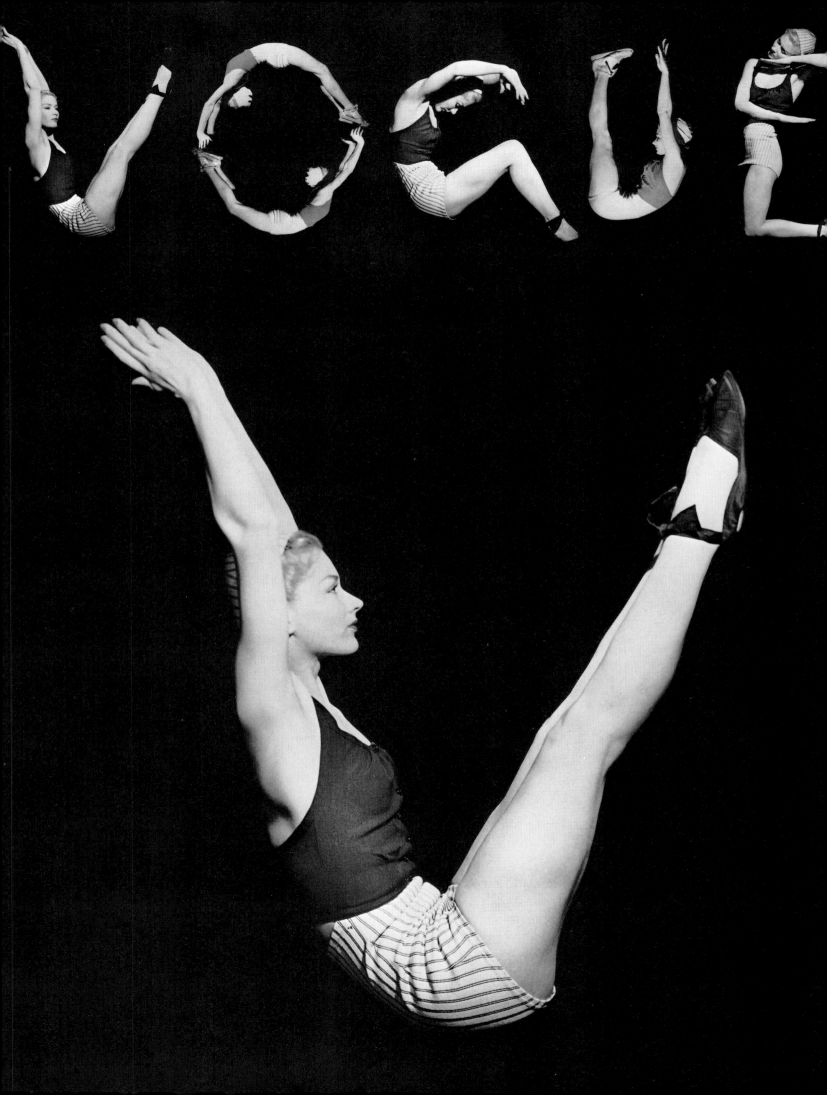

Erwin Blumenfeld/French Vogue, November 1938

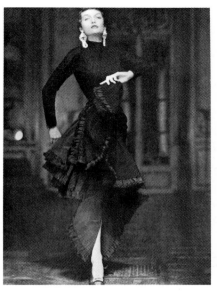

Horst P. Horst/American Vogue, September 15, 1949/Countess Alain de la Falaise/Fashion: Paquin/Paris

Richard Rutledge/July 1, 1947/Fashion: Paulette

1940s

"Vogue's readership soared during
the war. Its photographs of women still managing to look
marvelous while making do, the conviction that
fashion was an essential part of life,
war or not, the refusal of its editors to be
disheartened by new restrictions and
regulations, supplied not only guidance and
glamor but also a reassuring sense of continuity
and civilized living.

Toni Frissell/American Vogue, July 1, 1942

Gjon Mili/American Vogue, June 15, 1943

Herbert Matter/American Vogue, May 15, 1949

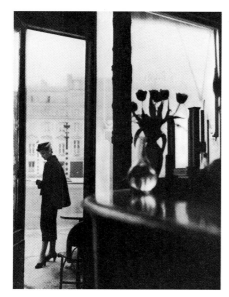

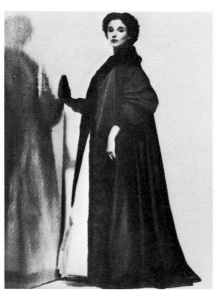

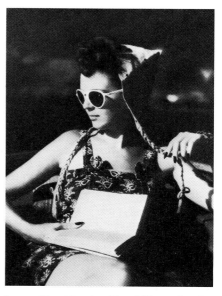

Clifford Coffin/French Vogue, April 1948/
Fashion: Schiaparelli/Paris

John Rawlings/American Vogue, October 1,
1946/Fashion: Lelong/First color photographic
radio transmitted image

Jacques-Henri Lartigue/French Vogue, June/
July 1974/Florette, 1943/Lac d'Annecy

Paris was isolated. A new American look
in fashion was created, totally confident, self-contained, with
a spirit of its own. New York and Los Angeles
became independent centers. In 1942 the
American garment-makers' union, the ILGWU, raised a
million dollars to promote American fashion through an advertising
campaign with *Vogue* at its center. And yet fashion, although
much more accessible and easier to follow,
was still rooted in the business of haute couture."

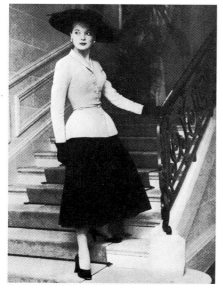

Serge Balkin/American Vogue, April 1, 1947/
Fashion: Dior/Paris

Cecil Beaton/American Vogue, June 1948

Allan and Diane Arbus/American Vogue,
May 1, 1949

Clifford Coffin
American Vogue, December 15, 1946
Princess Cyril Troubetskoy
Fashion: Pierre Balmain
Paris

Cecil Beaton
American Vogue, December 15, 1945
Fashion: Pierre Balmain
Paris

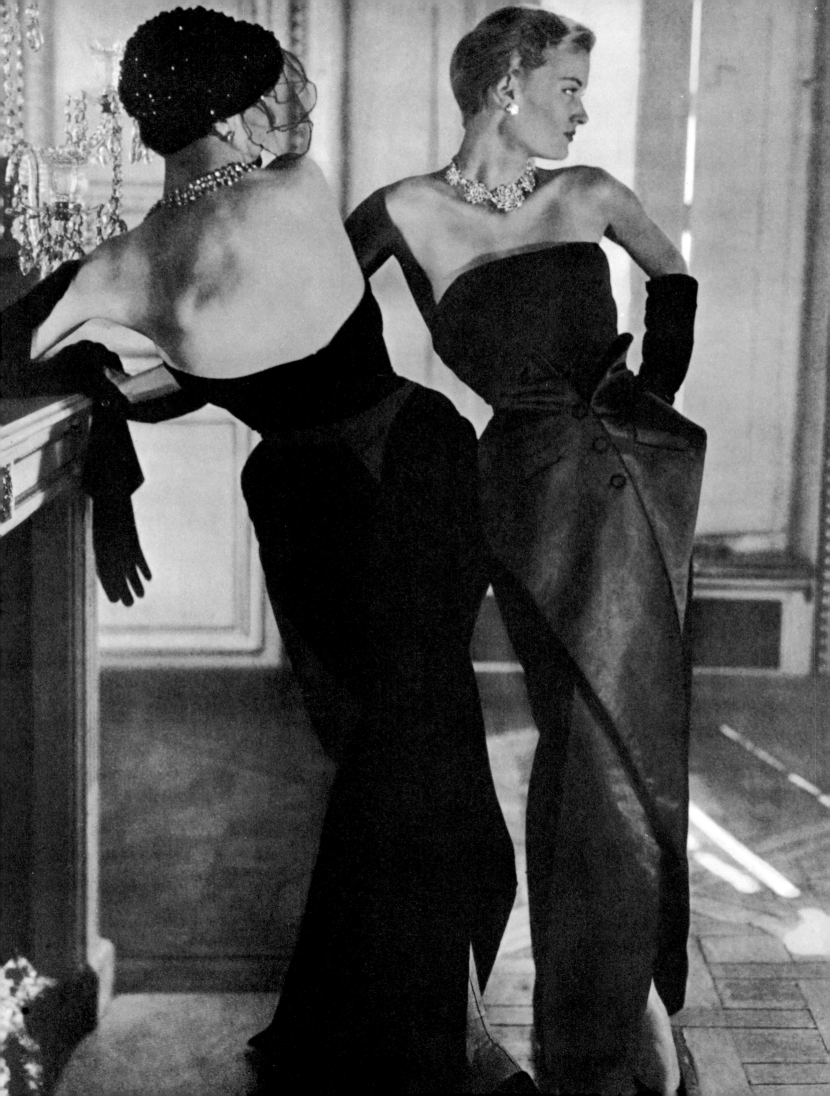

Horst P. Horst
American Vogue,
September 15, 1949
Fashion: Dior

Horst P. Horst
American Vogue, April 1, 1946
Bettina Ballard
Fashion: Pierre Balmain
Paris

John Rawlings
American Vogue, January 1949
Fashion: Omar Kiam of Ben Reig

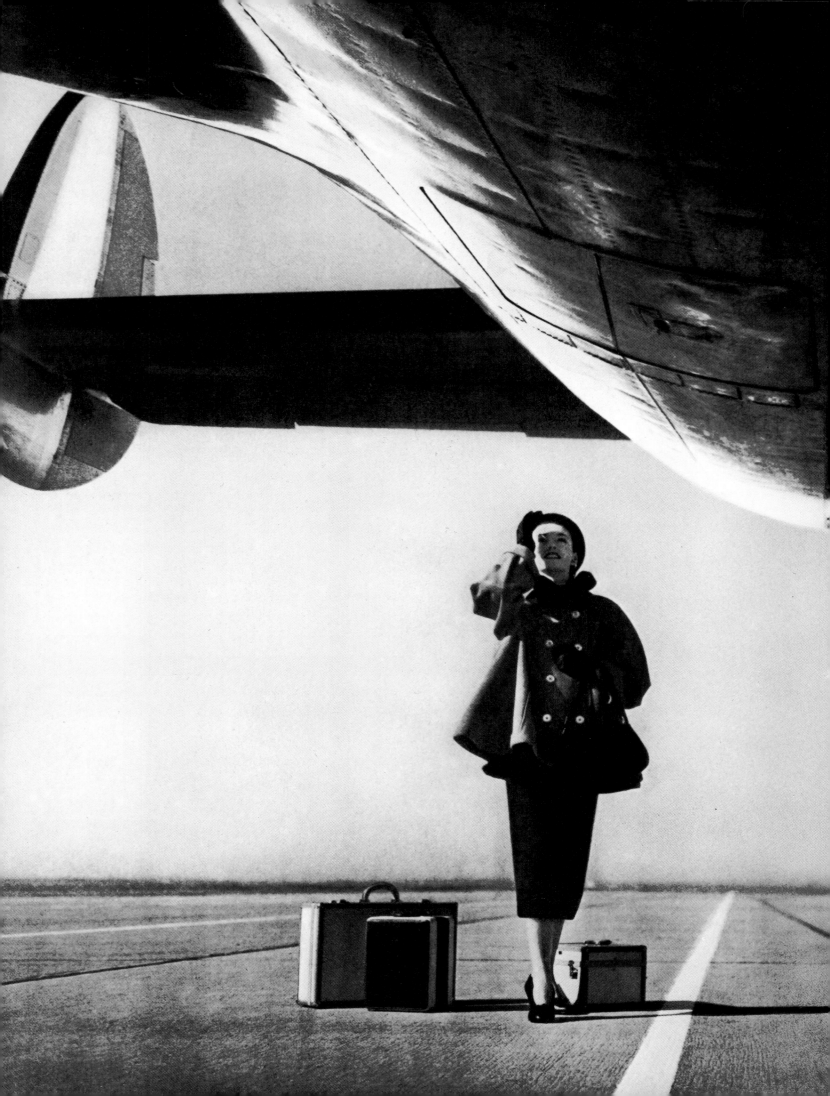

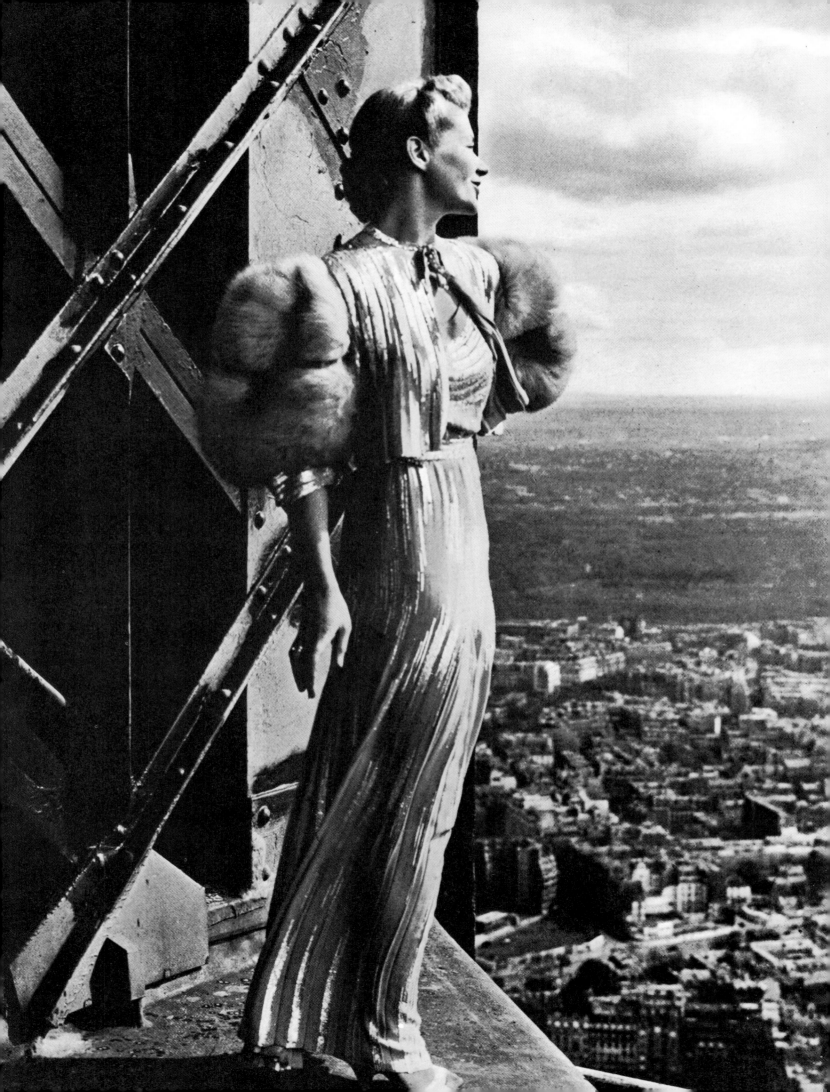

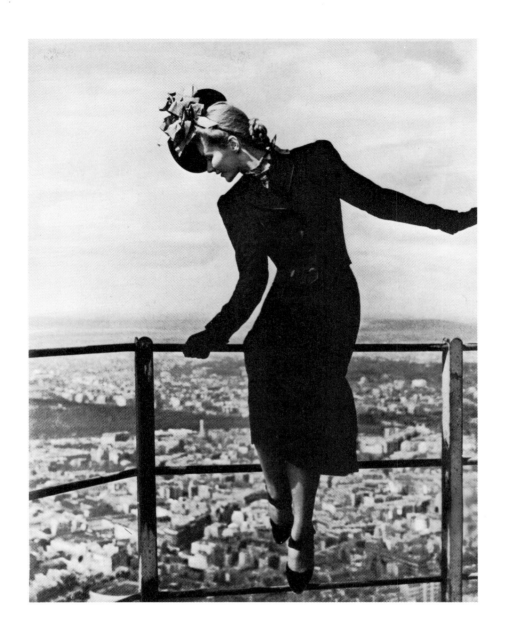

Erwin Blumenfeld/French Vogue,
May 1939
Lisa Fonssagrives/Paris

Erwin Blumenfeld/French Vogue,
May 1939
Lisa Fonssagrives/Paris

Irving Penn
"Twelve Beauties." The most
photographed models in America for the
past decade in their first
group portrait.
Left, L–R
(Seated) Marilyn Ambrose, Dana Jenney
Fashion: Claire McCardell, Hattie
Carnegie

(Standing) Meg Mundy, Helen Bennett,
Lisa Fonssagrives
Fashion: Traina-Norell, Nettie Rosenstein,
Hattie Carnegie
(Background) Betty McLauchlen
Fashion: Ceil Chapman
Right, L–R
(Foreground) Dorian Leigh/Fashion:
Ceil Chapman
(Seated) Andrea Johnson/Fashion:
Mark Mooring
(Standing) Lily Carlson, Elizabeth
Gibbons, Kay Hernan/Fashion: Ceil
Chapman, Henri Bendel, Charles James
(Background) Muriel Maxwell
Fashion: Ceil Chapman
Vogue's New York studio

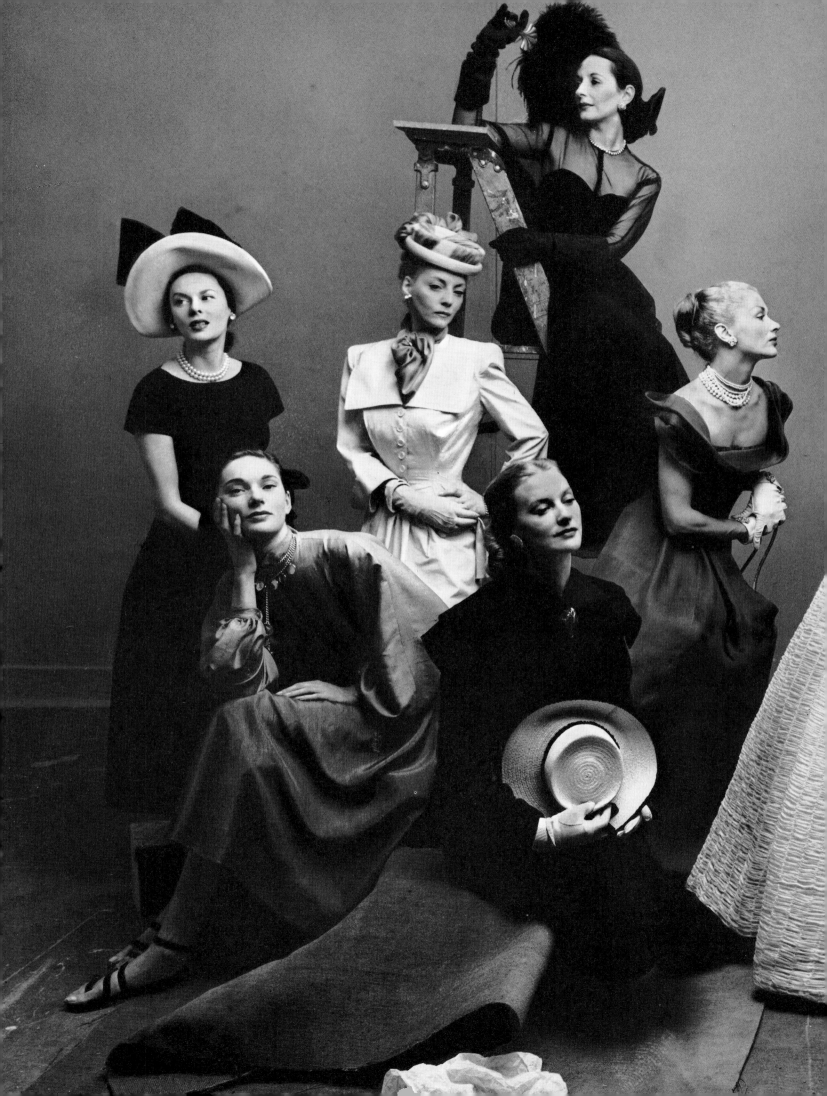

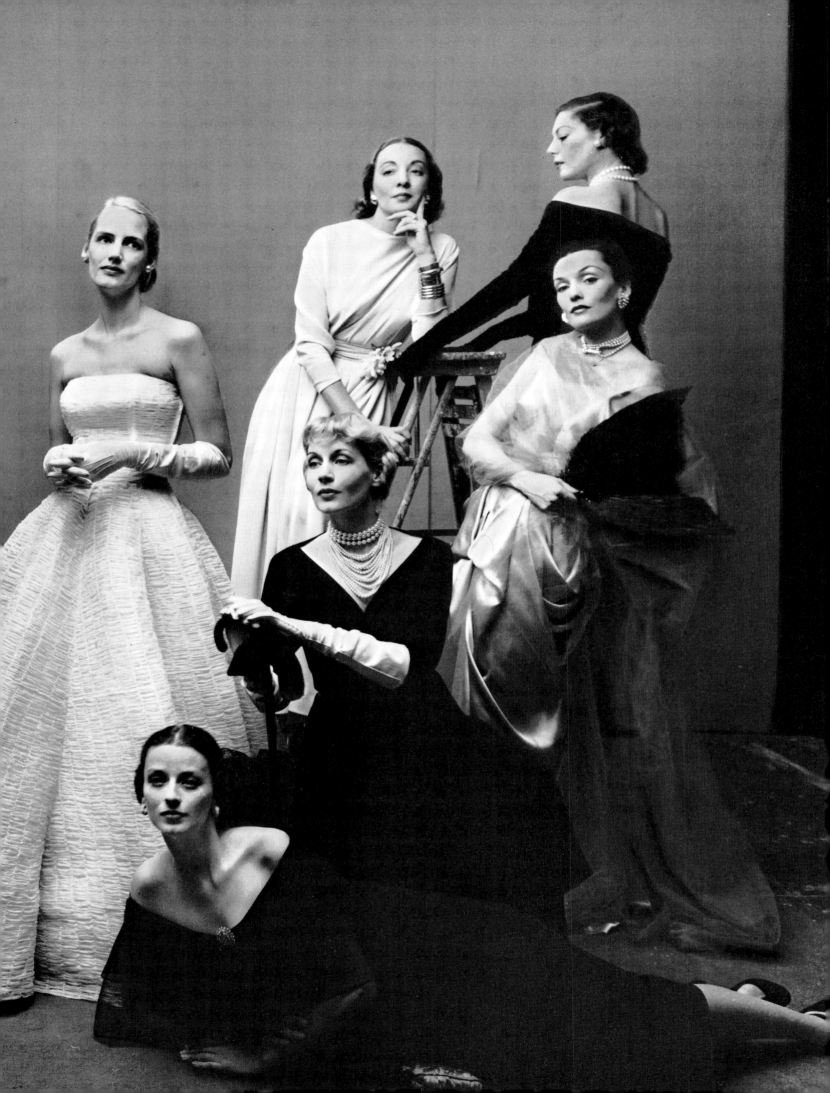

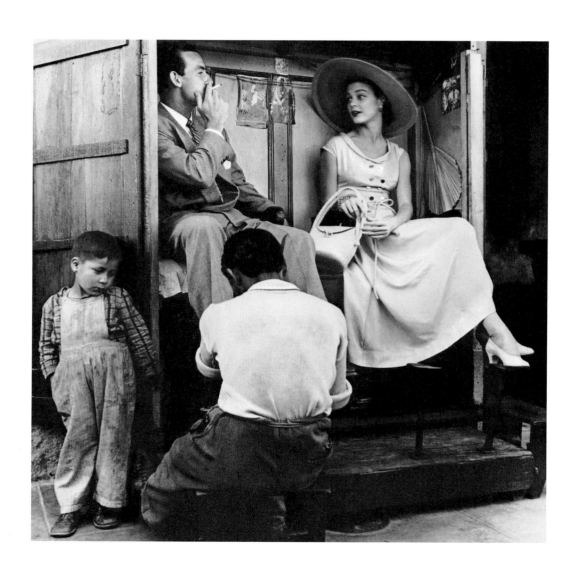

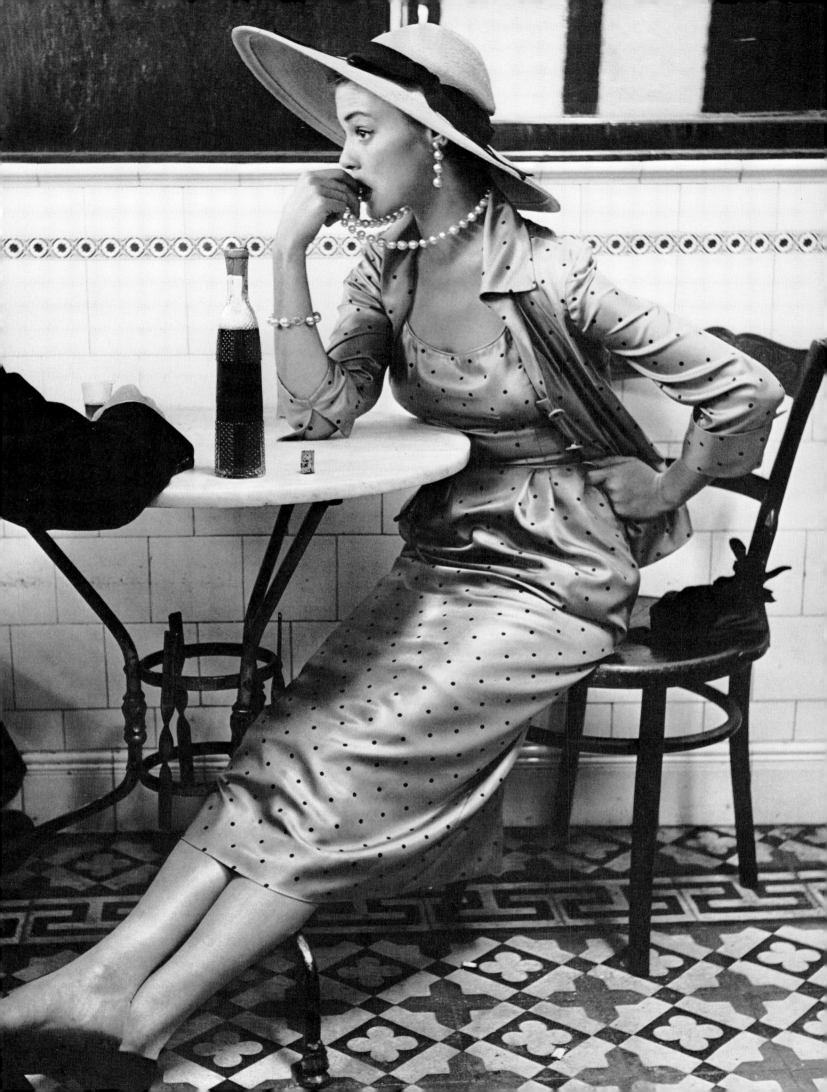

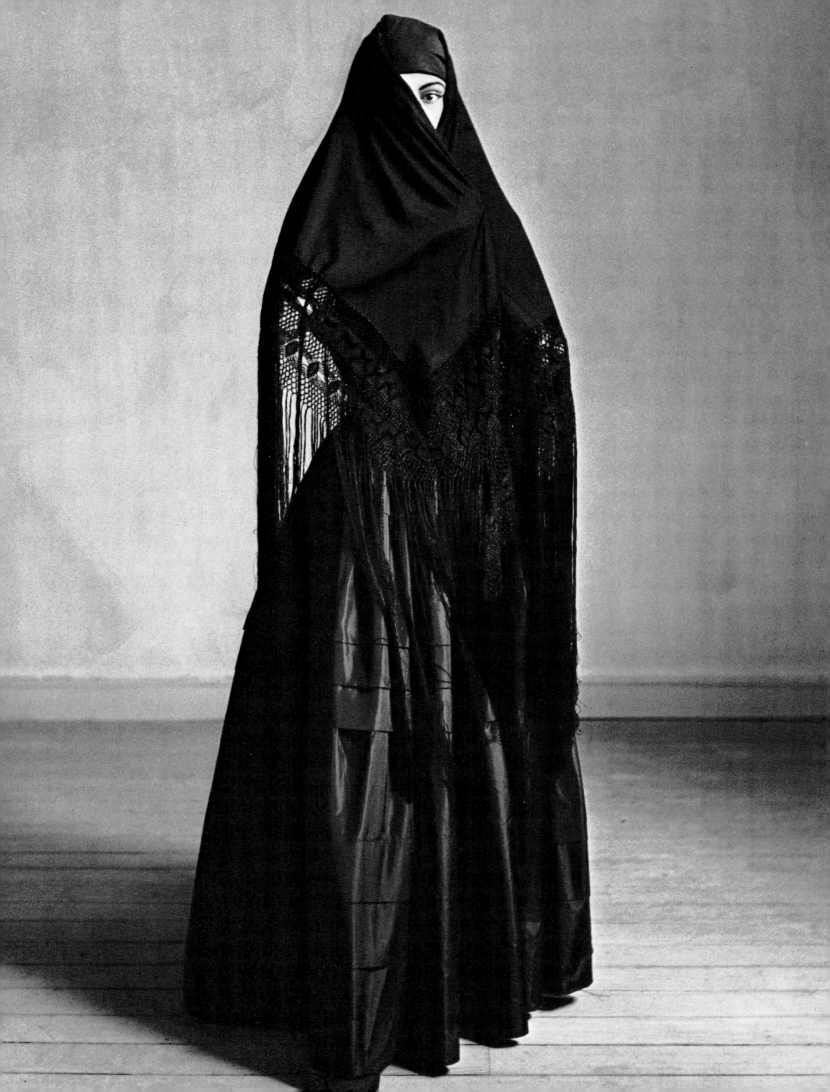

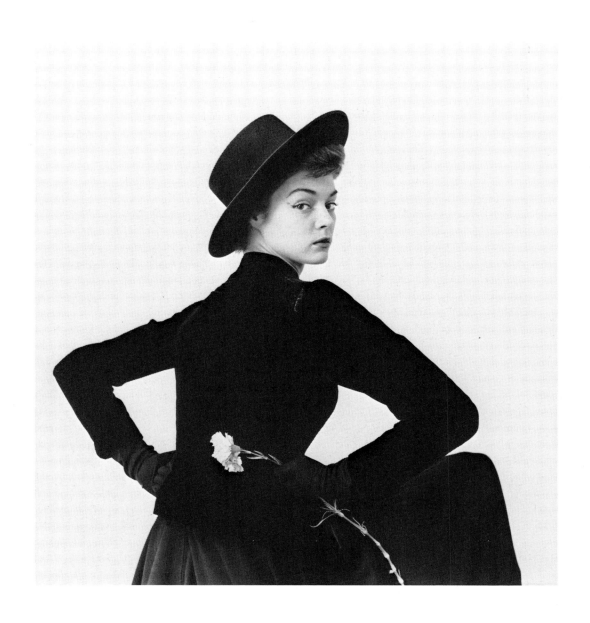

Irving Penn
American Vogue, February 15, 1949
Jean Patchett
Fashion: two Peruvian modes of dress,
(left) the Tapada, the street headdress, and
(right) a bullfighter's costume.

Toni Frissell
American Vogue, May 15, 1942
Fashion: L–R Kleinert, Brigance, Sacony

Toni Frissell
American Vogue, June 15, 1943
Sandy Rice/Florida

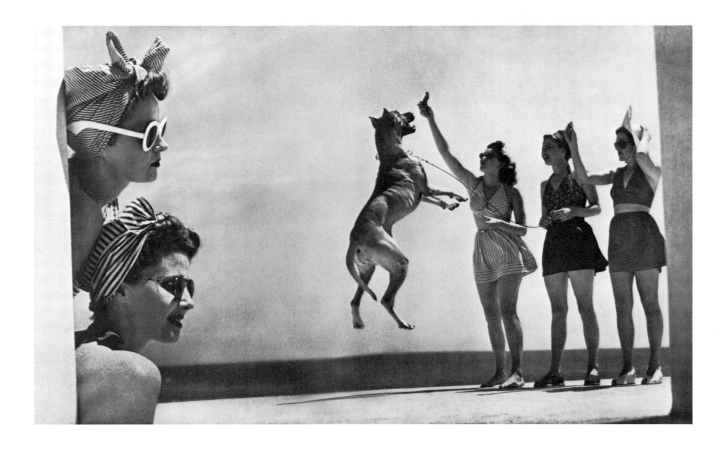

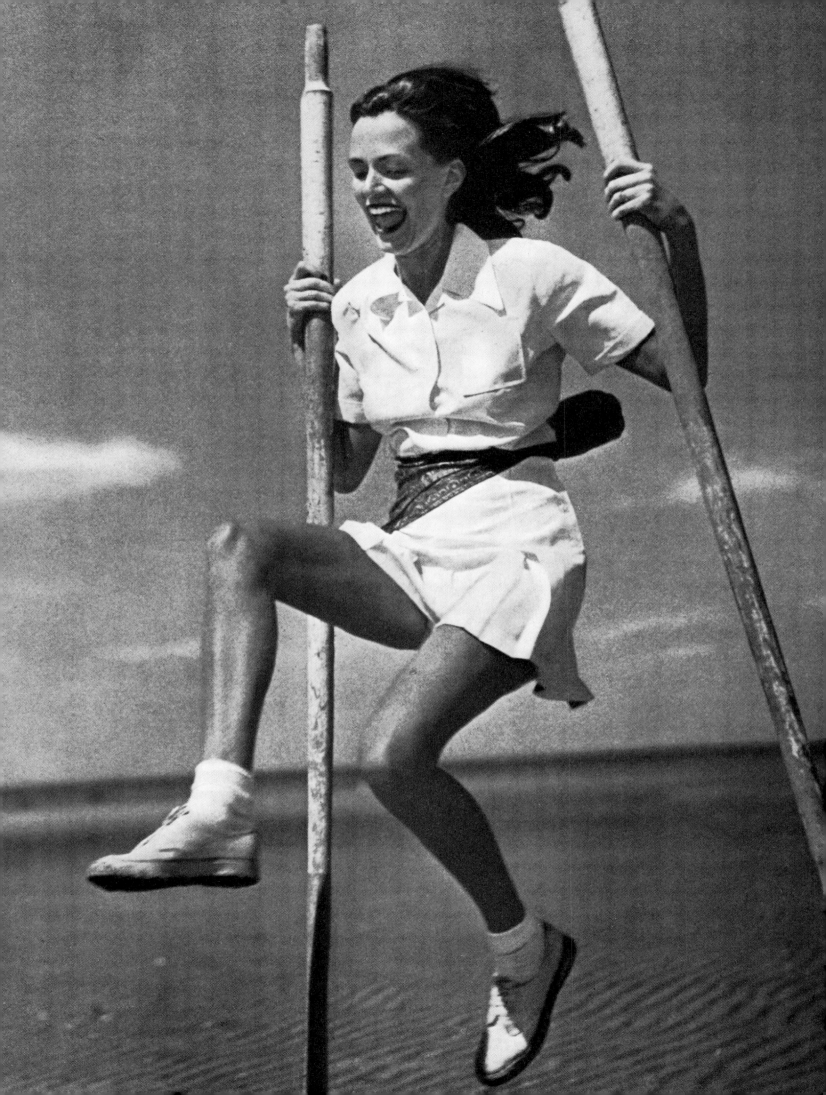

1950s

Photographers for Vogue

IN THE 1950S WERE ALLAN AND DIANE ARBUS, ANTONY ARMSTRONG-JONES,

SERGE BALKIN, KAY BELL, ERWIN BLUMENFELD, GUY BOURDIN,

HENRY CLARKE, CLIFFORD COFFIN,

LOUIS FAURER, HORST P. HORST, CONSTANTIN JOFFÉ,

WILLIAM KLEIN, LEOMBRUNO-BODI,

GEORGE PLATT LYNES, FRANCES MCLAUGHLIN, NORMAN PARKINSON,

GORDON PARKS, IRVING PENN, KAREN RADKAI,

JOHN RAWLINGS, RICHARD RUTLEDGE, JERRY SCHATZBERG.

Irving Penn
American Vogue, April 1, 1950
Jean Patchett
Fashion: Larry Aldrich

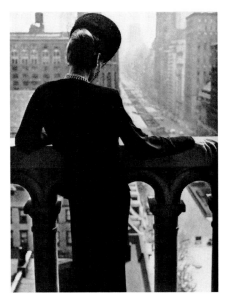

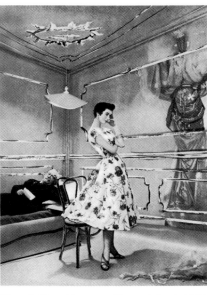

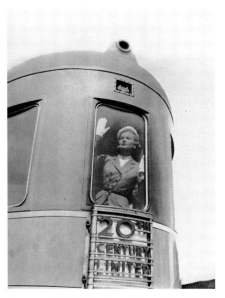

Kay Bell/American Vogue, August 1, 1945/
Fashion: Ben Reig by Omar Kiam

Horst P. Horst/American Vogue, May 1, 1953/
Fashion: Clare Potter

Constantin Joffé/American Vogue, June 1951/
Fashion: Harry Frechtel/Santa Fe Super Chief

1950s

"The 1950s were a time of new beginnings,
of recovery and discovery. Years of rationing were over, and a
deprived population, on both sides of the Atlantic,
set about becoming consumers,
reaching out eagerly towards a prodigal future.
Many changes that the war had brought had become
permanent. Aspirations to self-awareness and
self-fulfillment, which were to become real quests in the following
decades, were already evident, and traditional standards

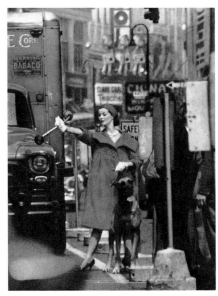

William Klein/American Vogue, July 15,
1958/Fashion: Tiffeau-Busch, Lilly Daché/
New York City

John Rawlings/American Vogue, April 15,
1950/Fashion: Mildred Orrick

Jerry Schatzberg/American Vogue, December
1958/New York City

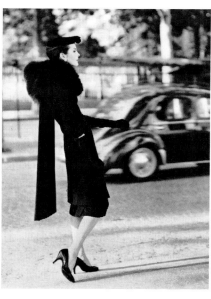

Karen Radkai/American Vogue, August 15, 1954/Fashion: Ritter Brothers

Erwin Blumenfeld/American Vogue, February 15, 1954/Fashion: Sally Victor, Henri Bendel

Henry Clarke/American Vogue, September 1, 1955/Fashion: Balenciaga

were being questioned and discarded.
In the fashion world, however, traditional standards
died hard. The only kind of statement about women that could be
made in fashion photography had a kind of absurd
conventionality, and the model perpetuated
an enshrined prewar image of the untouchable lady.
Then, almost overnight, as it seemed, the 1950s
became the decade of the affluent young.
Fashion taboos were broken with relish.''

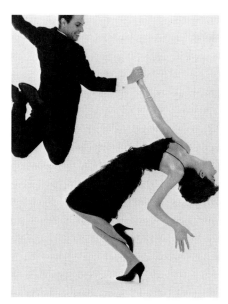

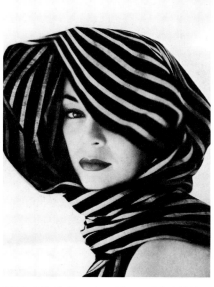

Antony Armstrong-Jones/British Vogue, November 1959/Gay Steele/ Fashion: Atrima at Cresta

Clifford Coffin/American Vogue, July 1951/ Jean Patchett/Fashion: a rebozo

Frances McLaughlin/American Vogue, November 15, 1951/Countess Corti/Fashion: Visconti/Capri

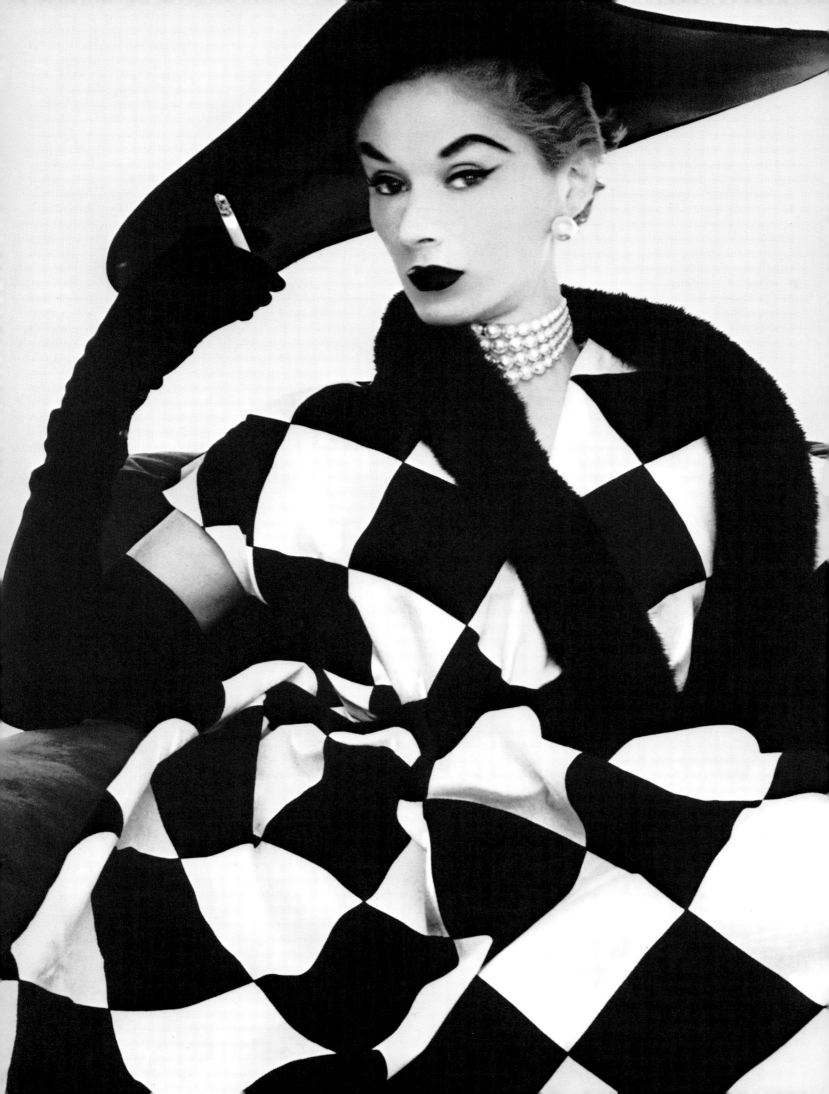

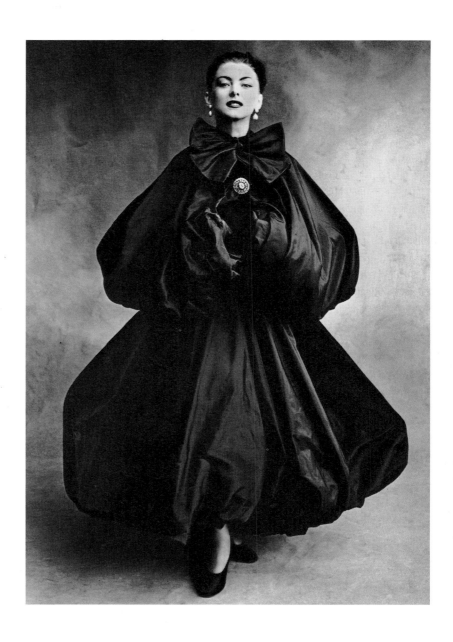

I rving Penn
American Vogue, April 1, 1950
Lisa Fonssagrives
Fashion: Jerry Parnis

Irving Penn
American Vogue, September 1, 1950,
and French Vogue, October 1950
Fashion: Balenciaga
Paris

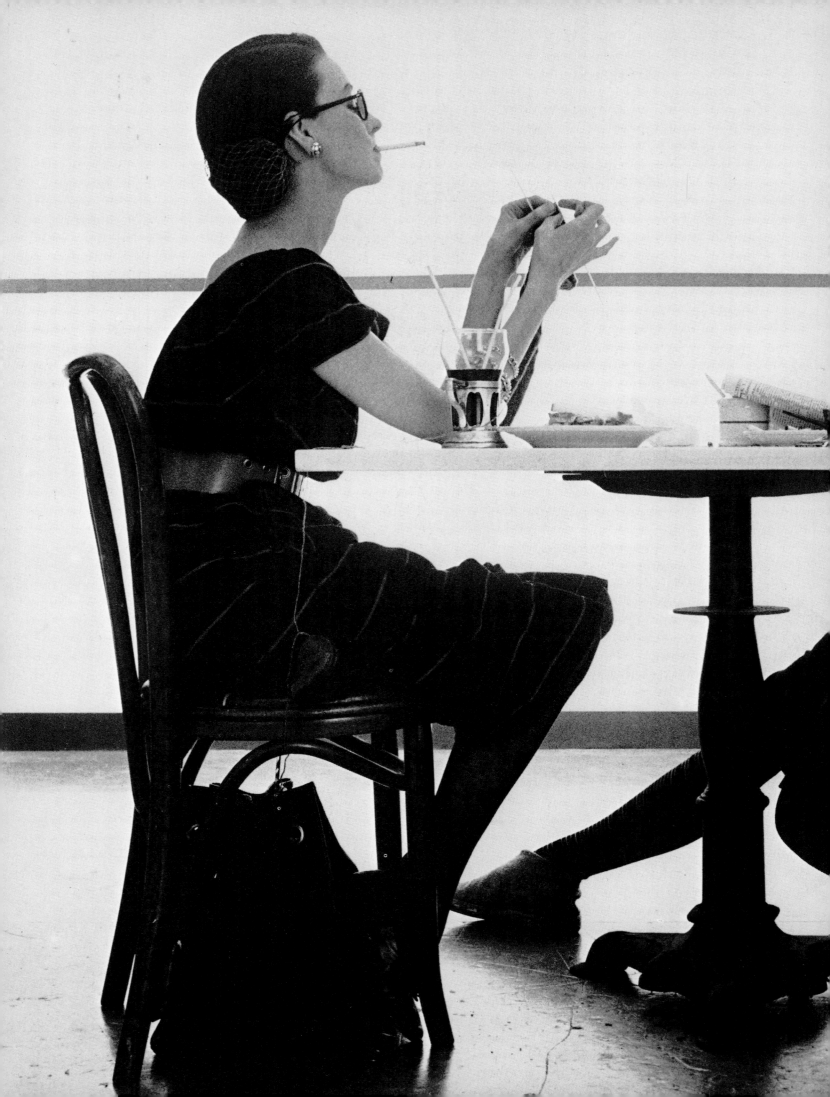

Irving Penn
American Vogue, January 1, 1950
Dorian Leigh and Evelyn Tripp
Fashion: wartime costumes from the
Metropolitan Museum's Costume Institute

Irving Penn
American Vogue, April 1, 1951
Mary Jane Russell
Fashion: Traina-Norell, John Frederics

Irving Penn
American Vogue, January 1950
Dorian Leigh
Fashion: Dior

97

Leombruno-Bodi
American Vogue, May 15, 1954
Mrs. Marion Hargrove

Frances McLaughlin
American Vogue, November 15, 1951
Countess Corti
Fashion: Myricae/Capri

Antony Armstrong-Jones
British Vogue, January 1959
Fashion: Rima Casuals
A BOAC Comet,
Idlewild Airport, New York

Constantin Joffé
American Vogue, October 1, 1950
Mrs. Hugh C. Wallace and her son,
Edward Owen, Jr.
Philadelphia

Frances McLaughlin
American Vogue, May 15, 1955
Fashion: Will Steinman

W illiam Klein
American Vogue,
September 15, 1957
Fashion: Dior
Opera, Paris

Irving Penn
American Vogue, April 1, 1951
Sunny Harnett
Fashion: Ben Reig
Vogue's New York studio

Irving Penn
(Left) American Vogue, September 15, 1950
(Right) American Vogue, September 15,
1950, and French Vogue, October 1950
Lisa Fonssagrives
Fashion: (left) Balenciaga,
(right) Marcel Rochas

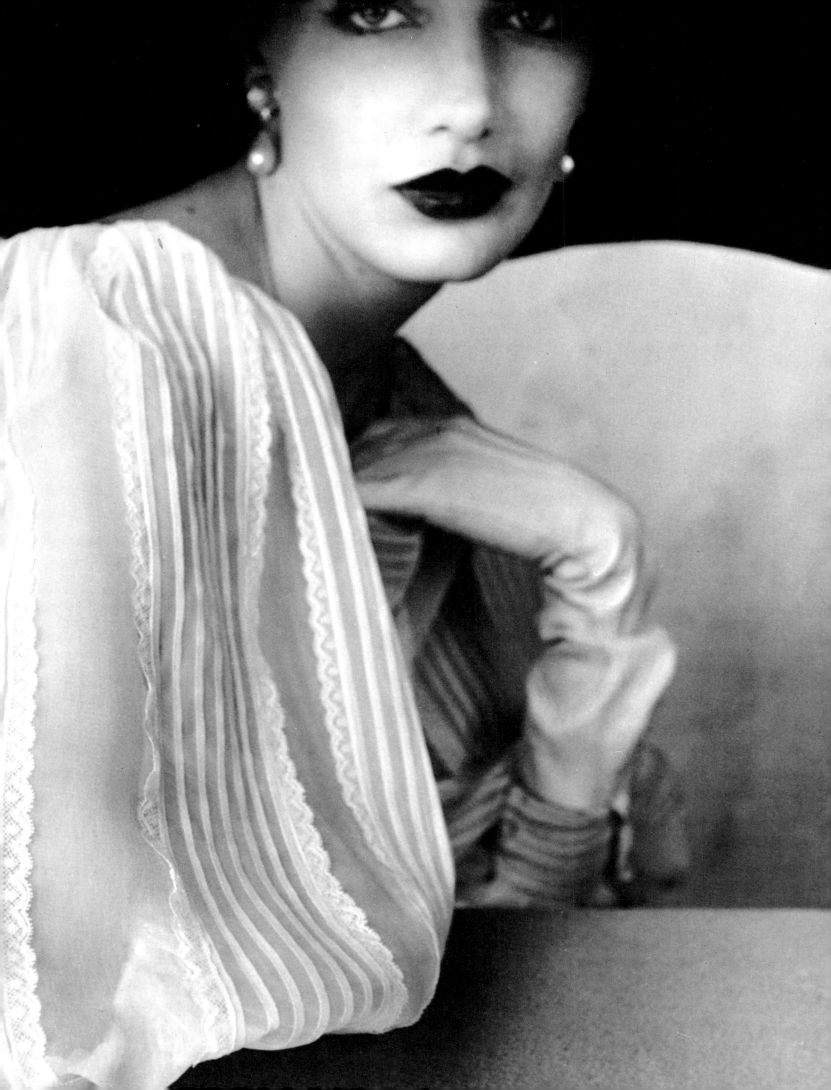

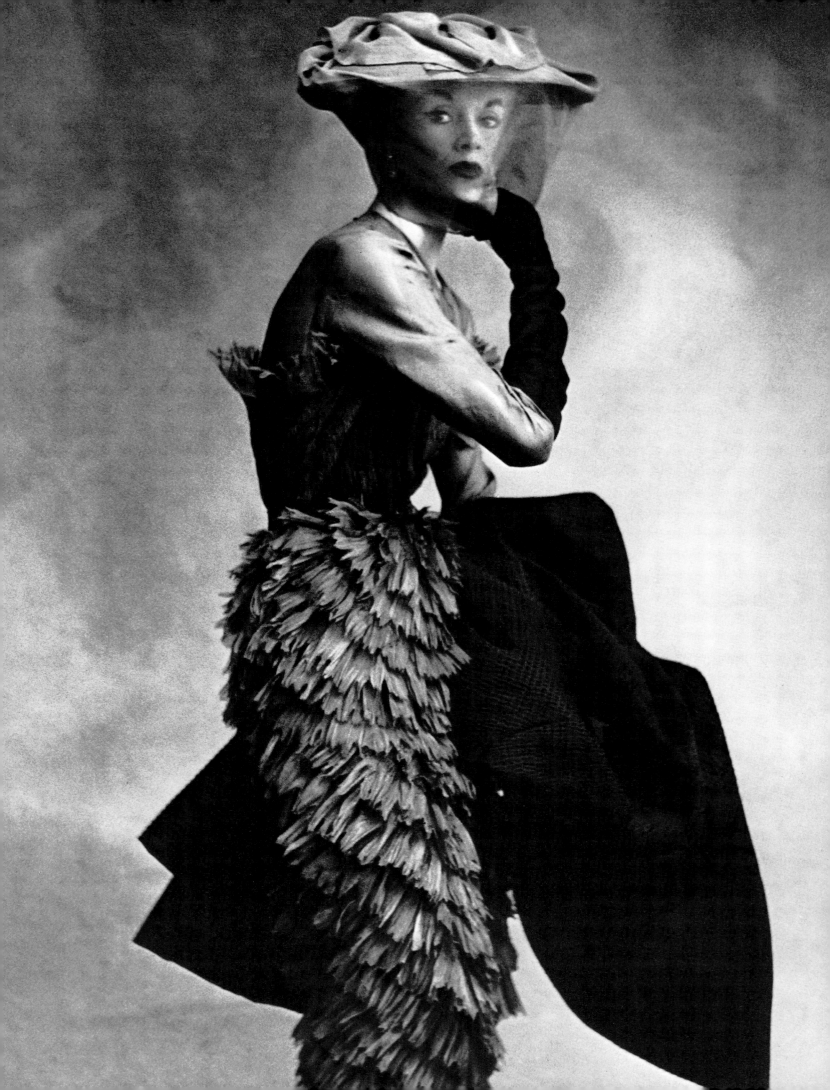

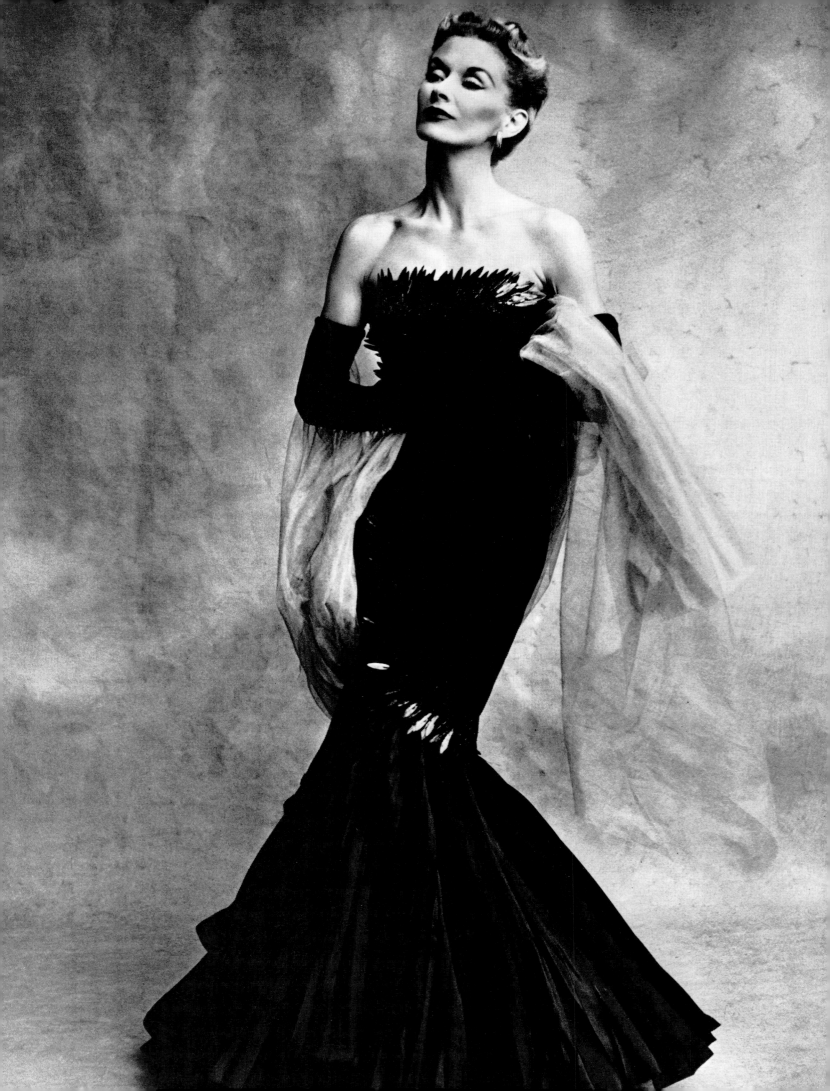

Irving Penn
(Left) American Vogue, May 1, 1949
(Right) American Vogue, June 1950
Jean Patchett

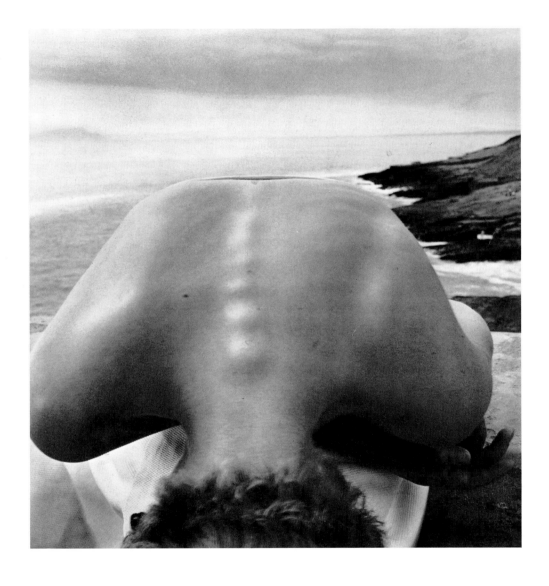

Baron
Adolphe de Meyer/
American Vogue,
c. 1920/Jeanne
Eagels

"PHOTOGRAPHY AND FASHION"
POLLY DEVLIN

A fashion photograph is a news photograph about the way we look and the way we live, dispatched from the reconnoiterers beyond the front, back *to* the front and thence down the line. Even when the information has been assimilated and acted upon, and has become history, great fashion photographs do not simply sink and fade into historical reports or relics of a vanished world. They contain a message additional to the original and urgent one about a fashion of life. They convey the flavor of their moment; and these flavored moments together constitute the taste of their age.

The development of fashion photography moves with that of the twentieth century; and ever since Condé Nast, an ambitious young American publisher, bought *Vogue* in 1909 when it was a weekly society magazine and set about making it into the foremost fashion magazine in the world, *Vogue* has chronicled and energized fashion as it happens. In the pages of its various editions the work of certain great photographers stands out, with an ageless and vivid validity.

On passing fancies, on the most frivolous components of fashion, these photographers brought to bear skills and sensibilities tempered by the age and society in which they moved.

The particular function of a fashion photograph is to show clothes and *how* they are worn at a certain time; but this apparently simple aim contains inbuilt complexities and ambiguities. The clothes have to be photographed ahead in order to be on time. ("A bit of every woman's autobiography in advance," is how it has been described.) The fashion photograph thus influences fashion by its very previousness. Another aim is to describe a certain reality about fashion, and about women; but in general the model used to portray this facsimile of reality is an idealized version of a fashionable woman, and her clothes have been carefully chosen by skilled fashion editors. For all this inherent exclusivity, the image must have a wide appeal.

Fashion photography aims to be timely, but must, by its nature, also be timeless. It is primarily meant for instant scrutiny, yet continues to bear re-examination. Its subject is a product with built-in obsolescence—and the result may be an amusing, ephemeral picture or a monumental statement. Fashion photographs do not show an intimate slice of life, although they may be in the style of photographs which do so. Essentially they are concerned with surfaces and effects, and with revealing the details of those surfaces. They are documents about fashion.

How women look and what women wear is at the very center of these photo-documents; but the periphery is valuably revealed too. Looking back at fashion photography we see that the world in which women have moved, worked, socialized, and become increasingly liberated, is chronicled—although sometimes inadvertently—almost as assiduously as fashion itself. Through fashion photography we collect a unique and valuable record of the society of the time, its moods and its manners, and can perceive the current cultural preoccupations—artistic influences, theatrical styles, social trends, the changing styles of salon and news photography. Photographers sometimes revealed this extra, although integral, information about their particular world almost unconsciously, because they were of their time and simply used whatever was on hand to convey some immediate message. But some did it explicitly—by copying trends, by using special lighting effects, by introducing props which pertained

to the spirit of the new movements in art, by constructing theatrical settings as backdrops, by introducing new artefacts or new inventions into their photographs. Fashion photographs reflect the growing interest in travel, as photographers went further afield for settings.

1920s

The most important thing we get from fashion photography is a unique, valuable and extraordinarily detailed view of women, which reveals itself, after anything more than a cursory study, to be multifaceted. We see very clearly how women looked; not just how they dressed, but how they desired to look, and were expected to look, and how they were looked at. We can discern how they behaved, and how they were expected to behave. We can see what was found shocking, and how repetition of that shock lessened its impact. We can see what roles women played and how these roles have changed, trace how long it took for one stereotype to take over from another, and finally perceive the reality of the women behind their images, even in the most fantastic of guises or in the most unreal settings.

And yet we rarely see in these pages the face and body of what might fairly be called "the average woman." The model must almost be an icon if she is to be successful in her role as a representative, i.e. she will usually conform to certain requirements and conventions of beauty, proper to the time and women she represents; but usually she will also be taller, thinner and more striking than the majority.

The role and the status of the model—or mannequin as she was first called, after the seventeenth- and eighteenth-century wooden fashion dolls sent around the capitals of Europe to show the fashions of Paris—have undergone profound changes in this century. The first professional mannequin worked for the couturier Worth a century ago, and was in fact his wife. It was Baron Adolphe de Meyer who gave modeling a social status by using society beauties or famous actresses in his photographs, and also by projecting his own personality, by making people want to be photographed by him. De Meyer was a famous photographer in Europe before coming to New York in 1913 to work for Condé Nast. Although Nast continued to use fashion illustrators like Lepape, Vertès and Benito in Vogue, he was certain that the future of the magazine lay in photographs and he wanted the best. As re-established by Condé Nast, Vogue was virtually the only link between the worlds of fashion, art, and commerce, and Nast was completely single-minded, both about establishing its authority and about attracting the people he wanted to read it. The first to formulate the theory of "class magazines," he intended to exclude all but the one particular group of society to which the magazine was directed.

De Meyer fitted perfectly into Nast's plans. He was a startlingly exotic addition to the rigid world of New York fashion, and his European connections gave him a considerable cachet. Born Adolphe Meyer Watson in 1868, he dropped the Watson when he married Olga Carriciolo (who was reputedly the daughter of Edward VII) and established his reputation as a photographer in Paris and London: his photographs of members of the Ballets Russes still convey their splendor and dazzling impact. Before his arrival in New York in 1913 both Vogue and Vanity Fair (another Condé Nast magazine) published a series of introductions, informing readers of his fame and prestige in Europe, and of what an exclusive and expensive coup it was for Vogue. De Meyer transformed fashion photography from being a sideline for photographers into being a full-time *artistic* occupation and a fashionable way of life. There was a feeling of social intimacy between him and the women he photographed. No matter how haughtily they stare out from the pages, no matter how self-regardingly they gaze into the proffered looking glasses, no matter how disdainfully

Baron Adolphe de Meyer/ American Vogue, July 1, 1919/Ann Andrews

they stare down the camera, beauties like Miss Ann Andrews, or Mrs. Harry Payne Whitney, are relating directly to the photographer. They are accessible and at home, even if that home sometimes seems to be in the middle of a silvery cloud. De Meyer was not primarily interested in fashion photography—after all, the fashion industry as such did not exist in New York since all haute couture came from Paris, and many of the clothes photographed belonged to the wearers themselves. Nor was he intent on psychological revelations about his sitters, or even on getting a good likeness. He wanted to create an ideal of feminine beauty, of softness, luxury and high romance. He created a glamorous and elaborate world, gleaming with reflected light, a world of lush textures and silvery fabrics. His sittings took place in his own studio—furnished with lacquered screens and Empire furniture imported from Europe—and his women were objects of admiration, mysteriously feminine and luminous. Vanity Fair reported in 1923: "Practically every celebrity in the social and artistic worlds of Europe and America has been photographed by the Baron de Meyer, yet in spite of his tremendous output he has never repeated

himself, nor has his posing become stereotyped. Striking in composition, and delicately lighted, each photograph is as unlike the others as are the studies of a painter.''

Condé Nast regarded de Meyer's talent as *Vogue's* exclusive property, and it was with consternation that he heard that he was to join the Hearst magazine *Harper's Bazaar*, lured there by an increase in salary and a promise that he could live and work in Paris. De Meyer later regretted the decision and in 1937, eleven years before his death, he wrote to Edna Woolman Chase (*Vogue* editor, and later editor-in-chief, from 1914 to 1952): "Photography outside of movies may have its uses for magazines and newspapers but it is commercially dead. There is a general excellence in every country the world over. So what's the use of struggling for unusual angles which once seen are forgotten? If one has a glorious past it is stupid to jeopardize it in going on when interest is waning. I have new plans—putting photography aside. To talk, to become a *raconteur*, which is suitable to my grey hair.''

And in a way de Meyer had always been a raconteur, telling, through his camera, magical fables from the past, recreating a sensual world of kings and charmers; showing clothes that needed the care of a skilled lady's-maid, a way of life that presumed a massive substructure of servants to support it. His was a world in which women conformed to a mythology of femininity born out of the *Belle Epoque* of Europe. Cocooned in luxury, protected from care, swaddled in furs and satins, these creatures appeared to have nothing more to do than to wonder what fabric to choose for what fitting, or what gown to wear to what social event. There is no hint of activity in his photographs: his women did no work, played no sports;

E*dward Steichen/British Vogue, 1929/*
Marion Morehouse/Fashion: Chanel

they existed to be admired. And even when his subjects were actresses they never revealed the energy or power that went into their performances: they were shown as triumphant divas, surrounded by a nimbus of glory. De Meyer ceaselessly paid tribute to the world he had loved and left, the world in which he had been young. His photographs are imbued with the painterly traditions of the nineteenth century, and continue its taste for romantic chiaroscuro, for accepted artistic subjects, treated in the conventionally poetic way of a time when the artist-hero was a romantic fellow with an accepted place in society.

De Meyer was not interested in exploring the inherent potentials and possibilities of photography as such, the outer boundaries of the new medium— although he was extremely skilled and knowledgeable. The "new" woman, seeking emancipation, is conspicuous by her absence. His photographs are ravishing and timeless, because, even while he was taking them as contemporary documents of the 1920s, even when the women are in clothes by Paquin or Poiret or Lanvin, they are already removed from the slipstream of time. They are statements about a society which finally existed only in a nostalgic vision.

After de Meyer left *Vogue* to join Hearst, Condé Nast hired Edward Steichen, whom he heralded as "the greatest living photographer.'' There are early *Vogue* photographs in which Steichen is still seeking his own particular approach to this new—for him— subject of fashion; when he finds it, a new woman lives in the pages, a woman with a specific reality.

Steichen's route to becoming the chief fashion photographer for *Vogue* in 1923 is a parable of the development of photography in the early years of this century, when so many burning esthetic issues were being worked out, and when the ambiguities of the relationship between painting and photography were still controversial. Steichen did not wholly resolve these ambiguities in his own life until in about 1918, at the age of nearly forty, in an extraordinary symbolic act he burned all his canvases, the work of twenty years as a painter. Only then did he commit himself fully to photography as his life's work. Born in Luxembourg in 1880, Steichen was reared in the Midwest where from an early age he was fascinated by light and space. He was apprenticed at fifteen to a lithograph company in Milwaukee and began to take photographs and to paint. He came to New York in 1900, met Alfred Stieglitz, and became deeply involved with the Photo Secession movement and the establishment of the famous 291 Gallery at 291 Fifth Avenue. After visiting Europe he persuaded Stieglitz to show the work of contemporary European artists like Cézanne, Matisse, Rodin, and Picasso.

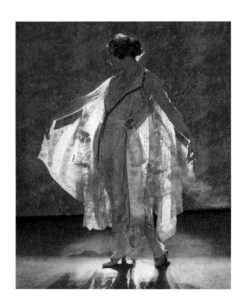

B*aron*
Adolphe de Meyer/
American Vogue,
April 1, 1922

When he joined *Vogue* (and an advertising agency) in 1923, he was attacked by votaries of the Stieglitz school for sullying the sacred profession of photography by such open capitulation to commercialism. Condé Nast had a somewhat similar, although more nervous, attitude to the question of "real" and "fashion" photography and suggested to Steichen that his name need not be put on fashion photographs. The artist was shocked: "I said that I would stand by fashion photography with my name."

Steichen, always pragmatic, saw that photography, by its very nature, could never be a jealous medium with aristocratic connotations, that there could be nothing élitist about its role in the future; it was a medium of the marketplace for him. This businesslike approach to the camera never precluded his astonishment at its capabilities. He knew little about the world of fashion and haute couture when he started to work for *Vogue*, and made no secret of the fact. He relied enormously on Carmel Snow, a fashion editor with a fabled sense of style (later editor of *Harper's Bazaar*), to help him. Their working relationship was the forerunner of many creative collaborations between photographers and fashion editors. He was grateful for her "infinite tact and patience in pointing out the essential fashion features in the pictures we were working on."

"She also taught me to appreciate the special aptitudes of the different French designers," he wrote in his autobiography, *My Life in Pictures*. "My favorite in the early days was Vionnet, and Snow, knowing it, always took special delight in bringing me a Vionnet gown to photograph. My first concern was to make it as realistic as possible I felt that when a great dressmaker like Vionnet created a gown, it was entitled to a presentation as dignified as the gown itself, and I selected models with that in mind."

His favorite was the inspiring Marion Morehouse, whose style emanated from every line of her elegant, humorous face and beautiful body. She was perhaps the first model to impress her personality on a photographer. "She was no more interested in fashion than I was," Steichen wrote, "but when she put on the clothes that were to be photographed she transformed herself into a woman who really could wear that gown."

Steichen saw fashion and women with a fresh eye. Instead of de Meyer's soft representatives of the old world, showing a hint of ankle, a rounded arm, Steichen's women are independent individuals standing relaxed and straight, heads high, casually watchful, dressed in clothes that other women could not only covet, but buy. In place of de Meyer's seamless drift of clothes, Steichen photographed a defined world of cut and texture. His models stood in doorways, sat crosslegged on sofas, leaned against pillars, looking out with total self-confidence. There was no sensual, soft shrinking away from the camera; they advanced to meet it, as they did to meet the world.

In de Meyer's heyday a photograph entitled *An Evening at the Theater* might have been a portrait of Miss X, after her triumph on stage, safely ensconced in his studio. For Steichen, it was a pair of shortskirted beautiful legs in glittering evening sandals, stepping lightly across a foyer towards what could have been any number of theatrical happenings—a jazz evening in Harlem, a performance of *Lady Be Good* starring Fred and Adèle Astaire, or a movie première.

The movies had an enormous influence on the idea of feminine beauty in the 1920s, and shifted the ideal away from the recherché, the individual, and the singular, towards a prototype with a face and form that would appeal to mass audiences. James Laver, the fashion historian, once called the camera "an engine for imposing types of beauty," and the new influential types included Mary Pickford, as the innocently girlish symbol of desirable womanhood, Theda Bara as the smoulderingly dangerous female, and Clara Bow as the demure girl with sex appeal. Gloria Swanson and Pola Negri aspired to combine the roles of movie star and society beauty, one by her marriage to the Marquis de Falaise de Coudray, the other by emphasizing her title of Countess Dombski. The anonymous model who could pattern herself on these prototype beauties became increasingly important in fashion photography. In California, John Robert Powers established the world's first model agency.

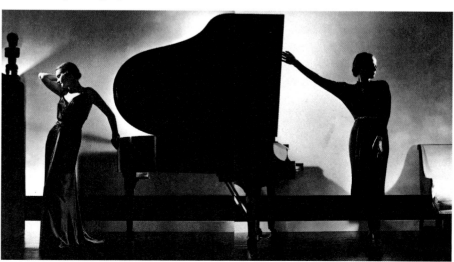

Edward Steichen/American Vogue, November 1, 1935/ "Black" L-R Frances Dovelin, Margaret Horan/Fashion: L-R Jay Thorpe, Bergdorf Goodman

But society beauties and leaders still dominated the smaller chic world of haute couture and of the international style.

The women in Steichen's photographs have boyish figures kept slender with pills, with new diets, with physical jerks, with tennis. They appear in revealing clothes—jodhpurs, sports clothes, tennis dresses, bathing suits—as well as in the new casually chic way of dressing invented by Chanel, a style that remained influential for decades. New artificial fabrics made clothes lighter, more fluid, and rayon stockings in flesh colors brought a new look to legs.

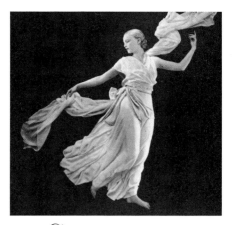

Georges Hoyningen-Huené/French *Vogue, November 1931/Fashion: Madeleine Vionnet*

Even when photographing inanimate objects, gloves, shoes, jewelry, without the animating presence of a model, and for the hundredth time, Steichen could produce new and striking images. His fashion work became more studied in the 1930s, and his quest for originality could lead him to excesses or absurdity—when, for instance, as a prop for white evening dresses, he introduced a white horse into his studio. He found photography a medium of formidable contradictions, "both ridiculously easy and almost impossibly difficult, because where the artist working in any other medium begins with a blank space and gradually brings his concept into being, the photographer is the only image maker who begins with the picture completed. His emotions, his knowledge and his natural talent are brought into focus and fixed beyond recall the moment the shutter of his camera has closed."

Steichen left *Vogue* in 1937. Condé Nast, perhaps romanticizing his own role slightly, wrote: "I remember, as if it were yesterday, our luncheon together at old Delmonico's when I first tried to seduce you into becoming a professional photographer at the expense of your career as a painter. What a fortunate thing for me that you were weak and surrendered to my solicitations! I believe that that luncheon did more to further the art and progress of photography in America than any other single event or agency in the past quarter century."

Steichen had an enormous influence on many of the new young photographers in the 1920s; and Cecil Beaton, who began work in 1926 as a contributor to British *Vogue* (which had existed since 1916), remembers how Condé Nast urged him to look at Steichen's work in order to learn about contrast and lighting. In Paris, where French *Vogue* had been published since 1920, the early work of another young photographer, Baron George Hoyningen-Huené, also shows Steichen's influence; but Hoyningen-Huené soon found his own inimitable style and for over a decade gave the pages of all editions of *Vogue* a brilliance and elegance that has rarely been surpassed. Like any other young man with an open mind and artistic aspirations living in Paris in the 1920s, this half-Estonian half-

American émigré was vividly aware of the culture movements and explosions going on around him. He saw the impassioned proponents of the different schools of art, the Dadaists, the Surrealists, the Cubists, the Expressionists, the Futurists, as fierce in their loyalties as the Guelphs and Ghibbelines, clashing and surging, and producing out of the heady ferment the sounds, shapes and movements that influenced the subsequent course of the twentieth century. In 1925, the International Decorative Arts Exhibition had an immediate effect on all design—and the resultant style, known as "Art Deco," is a constant in Hoyningen-Huené's work. Indeed his way of looking at things—his feeling for stance, for space, for placing, and for the effect of background—derived far more from what he saw in the theatrical and artistic circles in which he moved than from haute couture itself, although he found a perfect foil for his style in the peerless simplicity of Chanel and in the humors and conceits of Schiaparelli.

When Hoyningen-Huené first joined *Vogue* in Paris in 1923 it was, in one version of the story, as assistant to the staff photographer, who one day failed to turn up. Hoyningen-Huené, alone in the studio, surrounded by the elaborate sets, the models waiting, telephoned the *Vogue* editorial offices and was told to take the photographs himself. On the strength of the results he was appointed chief photographer. Mainbocher, fashion designer and fashion editor of French *Vogue* in the 1920s (he was later to be its editor), remembered it differently. Hoyningen-Huené visited his office to try and interest him in Man Ray as a possible fashion photographer: "But from George's conversation I felt very strongly that he himself had a great interest in photography and might be led into doing the pages I felt *Vogue* needed."

Mainbocher's instincts were right. "His work," wrote Mainbocher, "was new and absolutely practical." One can almost track his peregrinations around the world in the accessories of his photographs, yet they never look crowded. He was audacious in his use of pattern on pattern, his mixtures of shapes and angles; he rather enjoyed parodying other people's work, as if to show how easily he could plumb their trade secrets. But he had one secret that no one could copy, and that was his ability to suggest the pulsating quality of life in a still body. There is an extraordinary fluidity to the lines of his models as they stand in statuesque poses, or float clad in draperies to emulate a Greek frieze. He was intent on catching that spontaneous moment when the model reacted straight to his camera, and in that moment he also captured the essence of the look of the time. He used studio settings in a unique way to suggest the

outdoors. Location photography in available light was still not practicable, but his bathing beauties look as if they are glistening on a sunny beach; his skiers stand poised, as though the merest push will set them whizzing off down the hill.

The atmosphere of a Hoyningen-Huené sitting in the Paris *Vogue* studios was described in *Vogue* like this:

"The photographer, Baron George Hoyningen-Huené, very lightly clad in white linen trousers and a vest (for when the lights warm up the heat becomes intense), moves here and there shifting this and that, directing with a gesture robot-like men, clad from head to heels in dark overalls, their hands protected by heavy leather gloves, the eyes by enormous goggles, who noiselessly supervise the array of lamps. He says a word to the mannequin who moves into the circle of light, looking like a weird ethereal creature from another world. A shining silver pillar is put behind her, she takes an easy pose . . . a female figure slips forward from the surrounding shadows and adjusts a fold of drapery, a lock of hair, a voice says 'Hold that pose, please . . . again, please.' The silver screen is replaced by a black velvet screen, a big bowl of sweet white lilies placed on the floor. 'Do something different with your hands . . . there, hold that, don't move.' The figure in the circle of light moves as if hypnotized."

Yet from this hugely artificial setting came photographs crackling with energy, imbued with an impeccable, astonishing sense of the time. His women were sleek and elegant, glamorously whippetlike, suggesting coiled energy under the most languid of poses. Not that many of the poses were languid. For in the late 1920s the women in fashion photographs were, as in life, increasingly on the move. Dressed in little pleated skirts and blazers from Chanel, *trompe-l'oeil* sweaters from Schiaparelli, bias-cut dresses from Vionnet, they drove racing-cars, played golf and tug-of-war, and tore about from party to party.

1930s

The Wall Street crash of 1929 and the ensuing Depression affected life all over the world; and the world of fashion, inextricably linked with that of commerce, tottered. Not one American buyer visited the Collections in Paris in the 1930 seasons, and it was not until 1933 that they returned in force. The courtiers adapted quickly. They used cheaper fabrics and less of them: in 1933 Chanel showed evening dresses in cotton, organdie, piqué, and net.

In New York the ready-to-wear industry mushroomed, although much of the inspiration still came from Paris, by way of those chic sophisticates who could still afford couture clothes. In fact, many couturiers dressed their favorite clients free, to gain publicity —and sometimes inspiration. Schiaparelli dressed Gala Dali and Daisy Fellowes; the beautiful and stylish Princess Marina (later Duchess of Kent) was dressed by Molyneux. Mainbocher's most famous client was Mrs. Wallis Simpson, later Duchess of Windsor.

The movies were a potent influence; and in 1933 *Vogue* came to the conclusion that fashion ideas sprang from Hollywood and Paris by spontaneous combustion. Chanel had gone to Hollywood in 1929; but, although many of her costume designs were memorable, the timing was wrong. Hemlines dropped drastically and suddenly in 1930, and films featuring stars wearing the short hem length were outdated even before they were shown. The new length was greeted with mixed feelings. "Fashion," said *Vogue*, "is not controlled or prejudiced by screaming abuses or laws and rules of thumb, and, though for a time she may continue on her simple, practical path in the trend of modern life, she will suddenly become tired of being significant of the age—and will branch out into blossoming paths of her own whimsy."

Schiaparelli, Lanvin, Marcel Rochas, and Patou all worked in Hollywood during the 1930s, but the need to import European designers disappeared as creative indigenous designers like Howard Greer, Orry-Kelly, Travis Banton, and Adrian emerged. They were attuned both to the special demands of the mechanics of movie-making and to the more ambiguous demands of the mass audiences who sought escape from the bad times in the lavish dream-world of the screen, a world far removed from that of the socialites.

Designers like Adrian, who had his own couture house, as well as designing for Hollywood, helped bring these worlds together. The square-shouldered dress he made for Joan Crawford (originally intended to draw attention away from her hips) became a classic 1930s fashion. In 1932 Joan Crawford was voted "The most imitated woman in the world;" in 1934 it was Marlene Dietrich. The worlds contrasted most strongly, perhaps, in Gertrude Lawrence—whose chic, witty public image, as she appeared dressed by Molyneux for Noël Coward's comedy *Private Lives*, was matched by her private style—and Jean Harlow, the blonde bombshell, who wore much the same white satin bias-cut evening dresses in her movies as did Gertrude Lawrence on stage, but to quite different effect.

One thing in fashion was constant: to be a well-dressed woman in the 1930s was a time-consuming business involving serious dedication, endless fittings, and infinite changes of hat and costume.

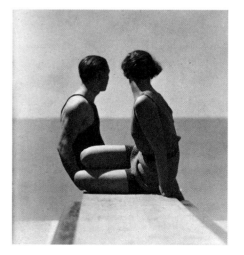

George Hoyningen-Huené/ American Vogue, July 5, 1930/ Fashion: A. J. Izod, Ltd./Vogue's Paris studio

Vogue itself was by now an important instrument and arbiter of fashion. Paris couturiers would jealously assess how much coverage had been given to rival houses, and the editor, Edna Woolman Chase, treated any subsequent hysteria with the same strong, calm, ladylike equanimity that appeared in her pages.

Those pages were changing radically in look and layout, as well as in content. A unique collaboration of talent, circumstance and opportunity lifted fashion

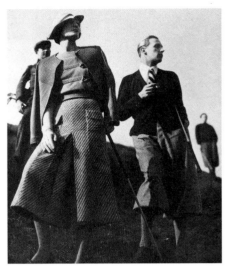

G*eorge*
Hoyningen-Huené/
French Vogue,
April 1934/
Fashion: Maggy
Rouff, Knize

photography in the 1930s into its distinctive place as a separate visual genre in the arts of the twentieth century. The development of the small, hand held camera made active outdoor shots both feasible and fashionable; the 1935 model of the Leica achieved a shutter speed of 1/1000 second. Once outside, the character of fashion naturally took on different allusive qualities. Martin Munkacsi, a Hungarian-born news photographer, took fashion photography into the natural world, using models who looked young, vivid, alive. He knew instinctively how to make elaborate artifice seem perfectly natural. The standard components had to be rearranged and re-grouped to produce a new assembly of illusions—the illusion of spontaneity, the illusion of movement, the illusion of reality. Women were photographed in situations that had an absolute relevance to the clothes in the picture. If the fashion story was "Clothes to Travel In," then the models stood in actual railway stations, about to board the trains; they no longer stood poised and exquisite by the side of swimming-pools, but plunged in; they went sightseeing in Paris (the Eiffel Tower was rarely out of sight), went shopping, walked the dog, climbed mountains, rode horses, went on cruises. The vast decks, curved rails and sweeping lines of the great transatlantic liners became a constant motif. Nature became a backdrop and monumental scenery a prop.

Running counter to these forerunners of the modern *paparazzi* shots (see p. 143) were the traditionally posed *grande dame* studio photographs of models still fixed into their clothes, and the dreamlike, surreal photographs that were a direct result of the first exhibition of Surrealist Art in New York and

London in 1936. To help construct these often elabo-rate fantasies the *Vogue* studios (established in New York in 1916, and in London and Paris some years later) had teams of skilled craftsmen, assistants, lighting experts and decorators who could supply the elements of almost any scene the photographers, who tended to be regarded as explosively temperamental maestros, had a whim for. This interior theatricality, this taste for employing the ingredients of other art forms, was used especially by European-based photo-graphers like André Barré. It drove many younger American photographers to look for a kind of no-frills outdoor naturalism with the image of a healthy, vivid American woman as its focal point: "Not for nothing is the American Beauty Rose as emblematic of America as the Stars and Stripes, for in no country in the world is feminine beauty more firmly entrenched as a national ideal. We talk about American looks with the same unaffected pride as we do our American highways or school systems. And every girl in her teens, taking her first serious appraisal of herself in her mirror and determining that she, too, can become a glamor girl, advances the credo just that much further."

Technical developments, as well as esthetic ones, continued to change the look of fashion photography, in its content as well as in how it looked on the page. The arrival of the German-invented Rolleiflex, with its fixed lens and its larger film producing larger negatives, resulted in extremely clear, high-definition photo-graphs. Some haute couture houses were made uneasy by this clarity and detail, in case ready-to-wear manu-facturers copied their clothes too exactly. New possibilities for magazine photography and reproduc-tion were opened up by the advent of color photo-graphy. Condé Nast was enthusiastic about the

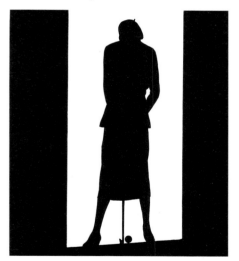

A*ndré*
Barré/American
Vogue, April 26,
1930/Mrs. Swynne
/Fashion: Jane
Régny, Marie-
Alphonsine/
Vogue's Paris
studio

prospect of color, and although it was initially compli-cated and expensive he set up his own color engraving plant on Long Island in 1929. Photographers who had mastered all the new color techniques were much in demand. In 1932, Anton Bruehl, an Australian of German parentage, became chief color photographer for Condé Nast publications, working in collaboration with Ferdinand Bourges, the chief technician at The Condé Nast Engravers. Bourges had developed a

process for creating color transparencies, and the Bruehl-Bourges partnership produced color reproductions which were without rival until in 1935 Eastman-Kodak introduced Kodachrome. But color printing remained a complicated process, and not until the advent of high-speed film did it seem a natural part of fashion photography.

Vogue itself began to look different in its design and layout, and in the way photographs were used for maximum effect and importance. The man behind the new visuals was Dr. Mehemed Fehmy Agha, who had come to New York in 1928 from Germany, where he was art director on the short-lived German edition. Until Dr. Agha's arrival the look, layout and

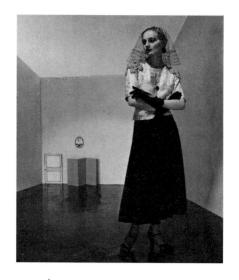

André Durst/American Vogue, October 1, 1936/Lyla Zelensky/Vogue's Paris studio

presentation of the pages were rooted in *Vogue's* beginnings as a society magazine, when text had been paramount and fashion drawings the only illustrations. Drawings and photographs alike were most often presented conventionally within frames. Words and pictures were not closely allied, and each page had the same wide margins. Agha removed the frames and sometimes the margins, and enlarged the photographs or filled whole pages with them, put together to tell one fashion story. He laced the pages with headlines, used bigger print, and gave them an enticing, accessible look. He matched content to layout, to give the unified look of a single unit of communication, with words and pictures matching up. Hitherto the copywriter had added words to the finished page; under Agha the copy department and the art director worked in close collaboration. He also turned the art director from a supporting character into a leading figure who could enormously influence a photographer's work and career. He could improve bad pictures, diminish great ones, and make average ones memorable, by the way he cropped them and positioned them in the magazine. Agha welcomed new talent and new ideas, and backed his hunches.

Despite the fact that Horst P. Horst, a protégé of Hoyningen-Huené, had never taken a photograph in his life, Agha told him he could have the studio twice a week for two hours—"just go ahead and try." Horst's first published picture was the result of that offer: "I went to the *Vogue* studios," he remembers, "and there was an assistant there who knew all about lighting and the exposures and all the techniques. I just posed the girl and bravely clicked the shutter."

His work has carried that distinctive stamp of confidence and bravura ever since. There is a paradox in his pictures: they spill over with life, color and occasionally with vulgarity, but, perhaps as a result of his work as a student under Le Corbusier, his forms have an architectural purity. His sets were often elabor-

ate, some designed by himself, others in Paris especially created for him by decorators like Emilio Terry or Jean-Michel Frank; and, although he often used only two or three lights out of the battery at his disposal in the *Vogue* studios, he created extraordinary lighting effects. Particularly striking was the way he photographed black, which had been supposed to look too heavy to be much used in fashion photography. He planned each of his pictures from beginning to end, so that the result should match the conception, and disliked the idea of the spontaneous improvisation, the happy accident. He made sure that the idea of what he wanted was there before he started, and almost always photographed indoors, in grand studio settings; but his model girls, no matter how elaborately coiffed and gowned, looked womanly, sexy, and individual.

They were a reflection of the women of the time. In 1934 *Vogue* heaved a sigh of relief: "From dolls, the women of fashion have become individual works of art. The creed of modern beauty is personality. And now, from the greenish or umber sheen of her eyelids to the flame or saffron of her lips and nails, the lady of today is a subtle and marvelous creation based on the entity that is—Herself."

The work of Hoyningen-Huené was reaching its apogee at this time. Each photograph carried his un-

Horst P. Horst/American Vogue, June 1, 1938/Mrs. Boissevani

mistakable sense of style and elegance; his economical graphic lines, which showed the influence of Art Deco as well as of the German design group of the Bauhaus, were wonderfully effective in pointing to the long flowing lines of current fashion. His work was glittering and polished: hard on the surface, but with a suggestion of softness and fluidity underneath. This was no more accidental than was the enduring beauty of the models he photographed:

"A lovely girl is an accident; a beautiful woman is an achievement. You may have heard words and music to this effect before, but we don't mean merely an achievement in the realms of clothes and grooming: rather, a monument to the art of living. Poets and people say that beauty is truth: it is more nearly the truth to sing that beauty is life. No woman, whatever her gifts of face and figure, can be really beautiful unless she has the quality of life. If a girl depends on her looks alone, she may be as beautifully perfect as a statue, but she will be equally chill and dumb. But every woman, however plain, can achieve the beauty inherent in vitality. If she goes out to meet life and enjoy it, she is possessed of the fundamental quality of enduring beauty." (*Vogue*, 1935.)

Edward Steichen, too, was continuing to produce striking fashion images. His final innovation for *Vogue* came about as the result of the perfecting of the high-speed color camera. His color spread of the Radio City Music Hall corps de ballet, caught in mid-step with a special 1/1,000-second shutter synchronized to flash bulbs, was published in 1935.

Other photographers who put their distinctive stamp on the fashion photographs of the decade include Man Ray, Cecil Beaton, and André Durst.

Man Ray was already established as an avant-garde painter, film-maker and photographer when he began his career in fashion; he did so as an expedient, a way of making money. But with his endlessly inventive and inqusitive manner of looking at things, his enchantment with new technologies, it was almost inevitable that he should photograph fashion in a new way. He brought an irreverent artistic sensibility to bear, ignoring fashion's social implications and approaching it instead as another branch of the arts: "I paint what I cannot photograph," he said, "and I photograph what I don't want to paint."

His fashion photographs, like Hoyningen-Huené's, have strength, purity, and a great emphasis on form and line. He contrasted model and background to create interesting tensions and patterns. When he was taking pictures for *Vogue*, and for *Harper's Bazaar*, in Paris and sending them back to New York via radio (utilizing the medium for the first time in fashion pictures), he realized that the very technology he employed would impose an extra distinctive image of its own, and thus planned and arranged the subject and content so that the lines would reconcile esthetically with the lines of the print-out image at the other end. Fashion photography seems the perfect subject for Man Ray's camera; its essential ephemerality appealed to him, and he liked the incongruity of the fact that the couture garments he photographed contained painstaking hours of hand labor, and were made to last long after their predicted life.

Cecil Beaton's first appearance in *Vogue* in 1926 was as a writer and illustrator, but it was his famous photograph of three young members of the literary Sitwell family that launched him on his unique collaboration with *Vogue*—one which spans more than fifty years. Beaton's love of photography stemmed

from childhood when he used to watch Alice Collard, nurse to his sisters Baba and Nancy—who were also his earliest models—produce pictures with her No. 2 Box Brownie. After his first attempt, he wrote in his diary in 1921: "The results looked awful, but I have wonderful plans and am going to do marvelous things in photography soon."

All through the 1920s he grappled with makeshift equipment, studied composition, applied himself to learn technique, experimented endlessly. When he began to take photographs especially for *Vogue* he clung to his original tiny camera.

"The word photography sounds so technical," says Diana Vreeland, editor of American *Vogue* from 1962 until 1971, and now fashion consultant to the Metropolitan Museum of Art, "that one can begin to think that a great deal depends on what camera one uses. But Condé Nast told me that when Cecil Beaton was photographing, say, the Duchess of Buccleuch, who has come down from the top of Scotland to be

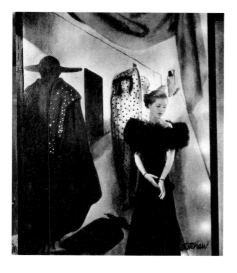

Cecil Beaton/American *Vogue*, July 1, 1935/Mary Taylor/Fashion. Bergdorf Goodman/Prince Matchabelli salon, painting by Tchelitchew

photographed, and is surrounded by so many roses and so much soap cloud she's practically afloat, he would put his finger on this tiny camera, and, although the noise would be so terrible—tw-aang—exactly like a rhinoceros coughing, that the duchess would fall apart, the pictures would be marvelous. Condé Nast, after watching two or three of his sittings, said to Beaton, 'I am going to buy you a camera. Because being photographed by you is too great a shock,' and he gave him a new camera, and at first Beaton hated it."

By degrees, Beaton recalls, "I reconciled myself to photographing on 10″×8″ plates. [In fact this size, insisted on by Nast, became one of his favorites and the one most associated with him.] It did lay out all sorts of interesting patterns and the lack of depth was fascinating. It was never a raffish camera."

Beaton's work has always had relevance to its times. More than any other photographer, he saw the relevance of the visual images of Surrealism to that other art of dreams which is fashion photography. He was deeply influenced by painters he admired, by contemporary movements and trends: when he fell under Pavel Tchelitchew's spell, his photographs

took on a neo-romantic look. Many of his photographs are based on the conventions of painting, partly due to his natural inclination towards that medium, partly to his love for stage design. His studio backdrops often looked like theater sets, as though he were photographing staged productions of clothes rather than fashion.

"I never got in a tizz about doing fashion pictures," he says, "but I enjoyed them tremendously. The complete falsehood, the artifice intrigued me." He was a master of the conceit, mixing real and artificial flowers, piling on all kinds of props and decorations. For decades, the pages of *Vogue* are filled with his fashion photographs, his portraits, his drawings, his writings, and through his pen as well as through his camera we get an inquisitive, unblinkered unique view of women—perhaps most significantly in the memos that passed between him, Mrs. Chase, and Dr. Agha.

These missives trace the evolution of the content of fashion photography in the 1930s, tellingly and often with rancorous humor:

"Dearest Edna,
I am sorry to say Julia is a tart!
I went to see her before lunch and she isn't a bit the smart woman you led me to expect! She's got no eyebrows, and her hair is really *very* blond—her back is nice and thin and knobbly *but*, and I know I'm right, she is an immoral woman and should *not* be encouraged in *Vogue*.
Some of the baroqueries of the window display are very effective, but don't you think we've overdone the baroque? What I *loved* and would like to borrow was a flock of little cupids playing violins, etc., carved in wood, which were slightly 1890-1900 in flavour and would be exquisite with bustle-dresses. Could we borrow them?

Yours,
Cecil."

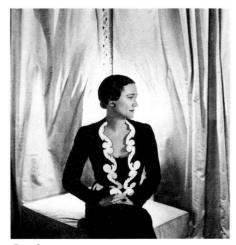

"My dear funny Cecil,
You gave me a good laugh! She isn't 'Julia'—she is 'Sylvie', and I didn't know she was a tart, but I am perfectly willing to take your word for it. Nevertheless, I do think she looks smart, and anyway, why should a dumb tart be barred from *Vogue* any more than some others we have known?
If you don't like her enough to want to photograph her, it's okay with me.
I'll get after the little cupids and the violins.
Edna."

In 1937 Beaton asked *Vogue* to be allowed to be more romantic in his pictures:

"I think the startling lighting and meticulously modern photographs now leave us as cold as the modern windows of the best fashion shops. Not even the people in the street are bouleversé by the white backgrounds and cubistic forms any more. The photographs that strike me as being most romantic are those taken in the early photographers' old masters style. Direct simple lighting, photographic background, by which I mean vaguely painted cloth which resembles nothing else in the world except a photographer's background. The photographs and the postcards that are sometimes reproduced in [the Surrealist magazine] *Minotaure* seem much more striking and extraordinary to me than anything that we do, though they are procurable at any quayside or Seventh Avenue shop.

"How important it is for *Vogue* to lead the tendency. There is such a surfeit of good photographers at the moment in the present fashionable tradition, that old-fashioned photographs, and I am convinced that I am not just led away by the dresses, are those that are most interesting. And although many people may not copy this particular feeling, I am certain it would add variety and a new note as well as a new look to an issue."

Dr. Agha responded in a revealing, sharp, and ambiguous memo:

"It really means denying everything *Vogue* stands for. *Vogue* readers want to see elegant backgrounds and furniture and smart ladies gracefully wearing smart dresses against these backgrounds. This is really the role of a fashion magazine. The technique of the presentation of this material can be changed—the ladies do not always have to have tea or be arranging flowers—but deliberate distortion of the posing, lighting and photographic printing in order to produce deliberately ugly, inelegant effects, I feel, is absolutely a wrong thing to do I think that what he is trying to do now is to deny everything *Vogue* has worshiped for so many years—to substitute ugliness for beauty, dowdiness for elegance, bad technique in photography for the good technique which we spent so many years trying to develop. Personally, I might be inclined to agree with him that a fashion magazine's conception of beauty, elegance and taste might be

insipid and nauseating, but I firmly believe that a fashion magazine is not the place to display our dislikes for these things."

Edna Woolman Chase backed Agha, and showed her editorial common sense: "I am perfectly willing to have a little caviar to the general in the magazine, and to do enough new and amusing stunts to keep you happy and to keep *Vogue* leading the band—but I don't want to be so damn far ahead of the band that we find ourselves with an isolated following of about five thousand sophisticates. You must believe that I know what I am talking about."

Undaunted, Cecil Beaton continued to chronicle the fashionable scene in all its aspects and as an intimate friend and participant—a gilder of the chronicle, perhaps, but one of its great image-makers. When he photographed Mrs. Wallis Simpson wearing Schiaparelli's white trouser suit, the fashion world was agog. Newspapers did not openly gossip about her affair with the Prince of Wales, but *Vogue* kept up a running chronicle of her clothes and general style, with her tacit agreement, and scooped the world at the time of her wedding with the publication of Beaton's exclusive portfolio of photographs of the Duchess dressed in her elegant Mainbocher trousseau. She was a symbol of the style of the 1930s, concerned with the precise, the modern; not for her the Winterhalter look popularized by the new Queen on the English throne, with its nostalgic message of bygone days.

In Paris—at the same time as Beaton, Horst and Hoyningen-Huené were working internationally for *Vogue*, travelling between the offices in New York, London, and Paris—the resident chief studio photographer was André Durst, a small frail man, extravagant and charming. All through the 1930s his precise photographs, particularly in French *Vogue*, showed clothes with care and attention to detail, but revealed also his exquisite imagination. He seemed to miniaturize things, assimilating and then using them in a manageable, disposable way. He deployed the images and ideas of Surrealism but stripped them of any sinister overtones. Lights and reflections gleam, as in de Meyer; models lean statuesquely against classical columns, as in Steichen; props with a hint of the surreal get in a tangle or go zooming off into space as they did in some of Beaton's work. But these pastiches have their own wry elegance, even the latest mood becoming something already evocative.

Durst's work reflects the unheeding frivolity which coexisted with the fear and poverty of the 1930s, and it was he who added the final punctuation mark to the gaudy days when *Vogue* used adjectives like beautiful, lavish,

spectacular, fabulous and brilliant, all in the same sentence, to describe a single event in Paris; and when an American *Vogue* editor could write:

"Where in America could you find the lady who made an entrance . . . as a Ghirlandaio, complete with chestnut horse (alive) and panther (stuffed), or the man who had Cardinal Richelieu's jewels copied to make his costume authentic? In Paris you'd find this at any one of any number of costume balls in the 1930s."

Durst's was the last. He gave it in his house outside Paris, near the park of Mortefontaine. The fireplace was set into a huge glass wall of the salon so that it looked as though the fire was burning in the middle of the forest, and *le tout Paris*, dressed as birds, as waterfalls, as leopards, came roaming in out of the wild. The dress designer Bébé Bérard came as a frolicking lion, Chanel as a tree faun, and Schiaparelli as the queen of the ants. Chanel danced with her and steered her into the candelabra, so that her antennae caught fire. It was the swansong of the season, the end of the decade, and the end of a way of life.

And in 1939 *Vogue* wrote of the last collections: "The couturiers, every one, made the grand gesture. They caught the spirit of the moment with martial scarlet and black; they cast that nostalgic backward glance, which people in troubled times bestow on a peaceful past."

1940s

In 1941 Edna Woolman Chase, the editor of *Vogue*, said in a speech to the Fashion Group of New York designers:

"When people speak to me about the war they ask me, 'Is it going to be incredibly difficult to edit a luxury magazine like *Vogue* in times like these? Do you think that you can hope to survive?' My answer is . . . what kind of a magazine do you think this is? Fashions would not be fashions if they did not conform to the spirit, the needs, and the restrictions of the current time."

Staff was drastically reduced as people joined the services; in 1943 price controls and restrictions on the amounts of fabrics and trimmings used in clothes were imposed. But these very restrictions inspired American designers to ingenuity. The cut and style of many American uniforms, like Mainbocher's designs for the *Waves*, were the envy of European services. Severe rationing had been introduced in the United Kingdom in 1941, the year of the "Sock-Shock" edict banning the use of artificial silks for anything but parachute-making. And when two years later the United States Government took over all nylon for military purposes

Cecil Beaton/British Vogue, September 1941/Fashion: Digby Morton

123

and rationed rayon, *Vogue*, with that fierce determination to make the best of things characteristic of its spirit all through the war, wrote "Socks can contrive to look charming." Bobby sox became a familiar sight and later a badge of the young.

As uniforms became standard dress, and rationing bit into clothing manufacturers' quotas, civilian fashion became square-shouldered, short-skirted, mannish-looking. Hair was cut short for ease, for safety's sake, for neatness; women, and fashion, looked practical.

The movies were hugely popular. *Vogue* said, "Today's woman has less time to imagine, and a good deal of her imagining is done for her in the cinema." But in fashion photography, on the whole, an attempt at realism prevailed. Models looked as though they drove jeeps rather than were chauffeured in limousines; as though actively contributing to the war effort.

Another kind of realism was achieved by Cecil Beaton, who often used the bomb-damaged buildings of London as a backdrop, with what some thought was a blithe disregard for public feeling. But often through the very incongruity of the images a poignant message was conveyed about the spirit of those behind fashion.

Vogue's readership soared during the war. Its photographs of women still managing to look marvelous while making do, the conviction that fashion was an essential part of life, war or not, the refusal of its editors to be disheartened by new restrictions and

T*oni
Frissell/British
Vogue, August
1942*

regulations, supplied not only guidance and glamor but also a reassuring sense of continuity and of civilized living.

For a short time after the declaration of war, Paris fashion appeared to operate normally, and with the help of dispatches from the French office, *Vogue* in New York published a series of articles about "What People Are Wearing in Air-raid Shelters" and "How the Couturiers Are Coping with War Conditions." But with the occupation of France, Michel de Brunhoff, the editor of French *Vogue*, could not continue to publish the magazine without having to compromise and collaborate, and it closed for the duration of the war.

Paris was isolated. A new American look in fashion was created, totally confident, self-contained, with a spirit of its own. New York and Los Angeles became independent centers. In 1942 the American garment-makers' union, the ILGWU, raised a million dollars to promote American fashion through an advertising campaign with *Vogue* at its center. And yet fashion, though much more accessible and easier to follow, was still rooted in the business of haute couture. Mass-produced ready-to-wear was still a poor relation, copied from custom-made garments. An editorial in 1943 advised women how to reach a compromise:

"Many women famous for their chic have all their clothes made to order. If your clothes appropriation is large, there is no more satisfying way of spending it. The peak of clothes pleasure is reached through the made-to-order salons, where you take your pick of new American designs, new Paris models; where you are measured and fitted with superlative skill. Such elegance, such excellence of workmanship, are costly, not only in money, but in thought, in time, in patience. If you lack any one or all of these, then consider other ways

"1. Have the *one* kind of costume most important in your life made to order; a forever sort of suit; a long-lived coat; an evening dress (in a quiet color to vary and renew with different accessories; in a calling-all-eyes color, an invitation to view perfection).

"2. Have your hats, even *a* hat, made to order, for hats are looked at as often as faces, and the right hat can carry a costume as a stamp carries a letter.

"3. Have the ready-to-wear clothes you buy expertly fitted to you. It takes time, costs money, is worth all it takes of both. (Tip: if you're a touch over size 14, buy size 16 and have it fitted *in*.)"

In 1943 a new annual award was instituted, sponsored by the parfumier Coty, to be presented to the designer-of-the-year in American fashion—"in recognition of past accomplishment and in the hope of inspiring more." Thirty-four editors made up the jury, and the first award (a bronze statuette of a naked lady nicknamed "Winnie", and a $1000 War Bond) went to the young designer Norman Norell. The other prizes and citations compose a roll-call of the most influential American designers of the time—Lilly Daché and John Frederics, hat designers, Adrian of Hollywood (for his V-line suit), Hattie Carnegie, Clare Potter, Charles Cooper, Mainbocher, Claire McCardell, and Valentina.

C*lifford Coffin/American Vogue, June 1949/Fashion: L–R Cole of California, Mabs, Caltex, Catalina/California*

Erwin Blumenfeld/American Vogue, March 15, 1947/Fashion: John Frederics

Horst P. Horst/American Vogue, February 1, 1943/New York studio

Irving Penn/American Vogue, July 1952/Lisa Fonssagrives/Huntington, Long Island

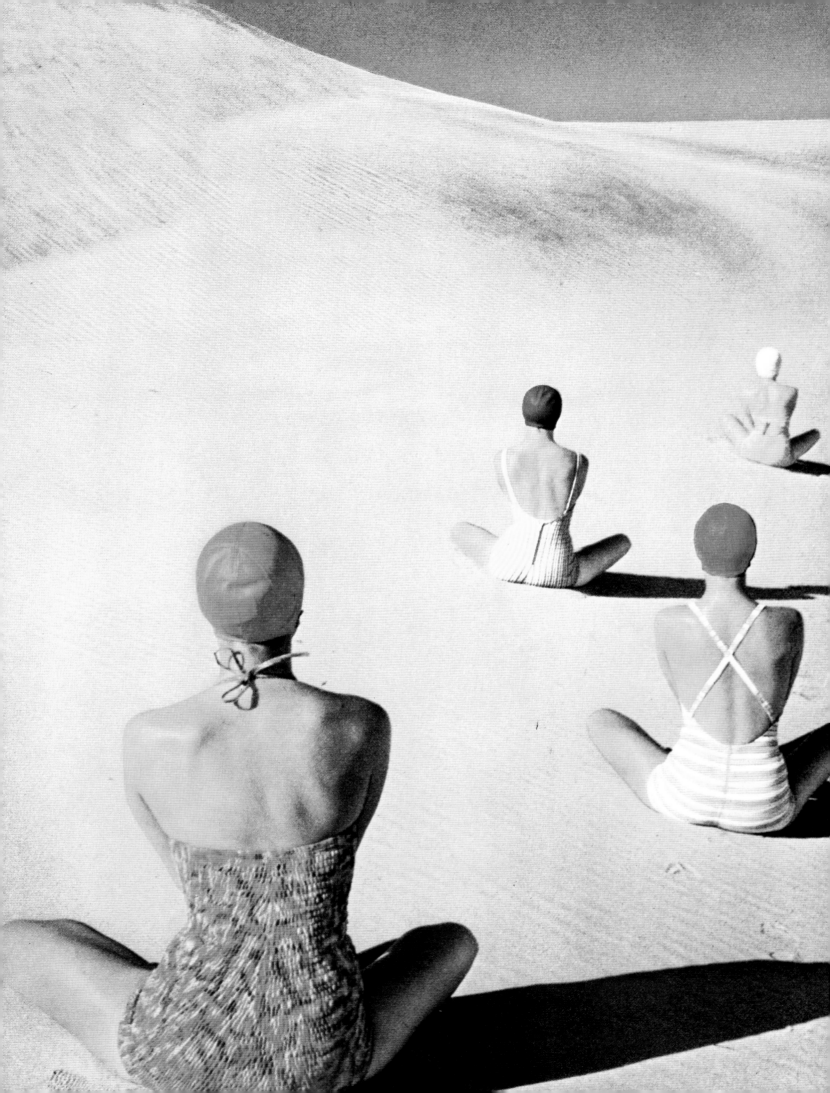

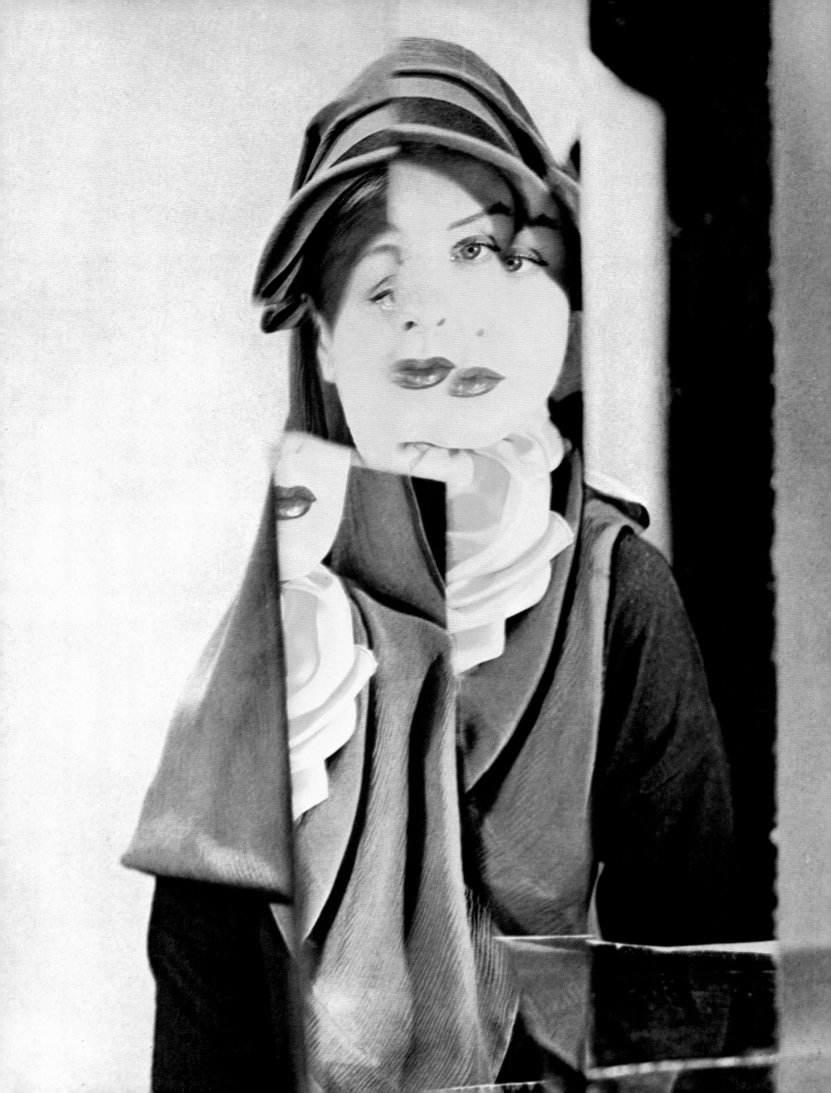

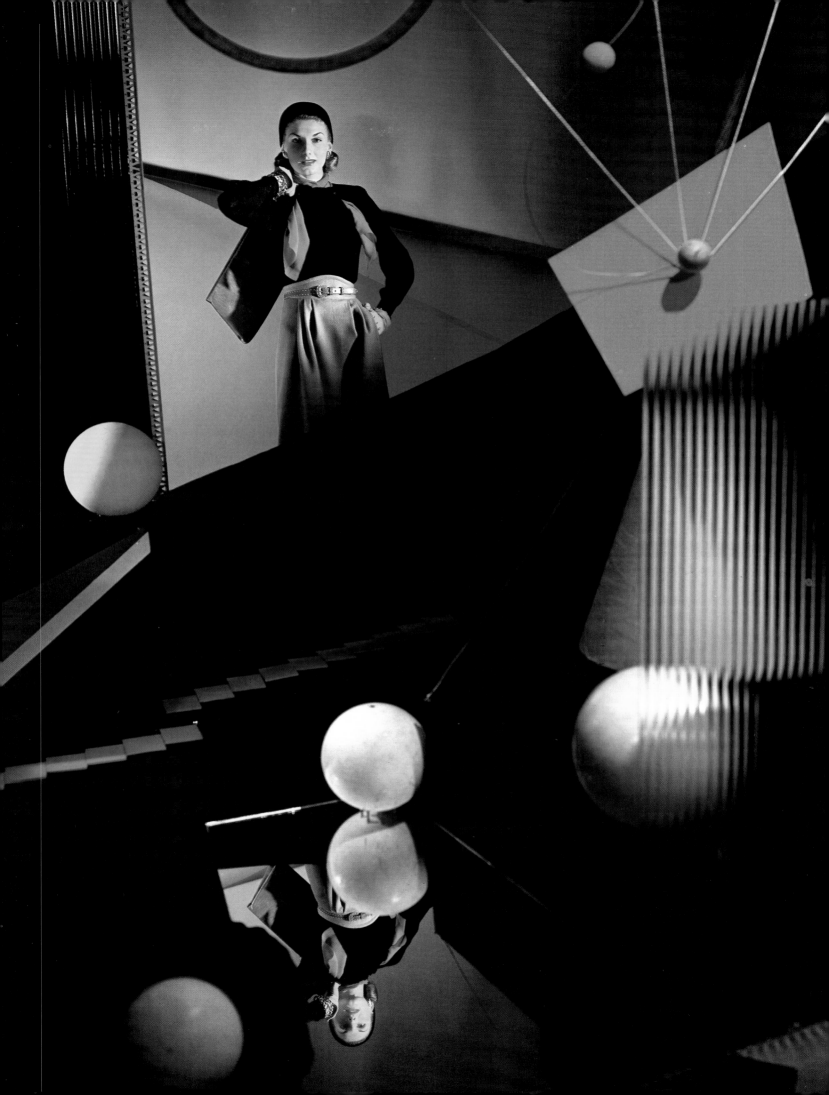

B ob Richardson
French Vogue, April 1967
Fashion: Claude de Coux
Rhodes

Bruce Davidson
American Vogue, October 15, 1962
Fashion: John Weitz for Leathermode
La Guardia Airport, New York

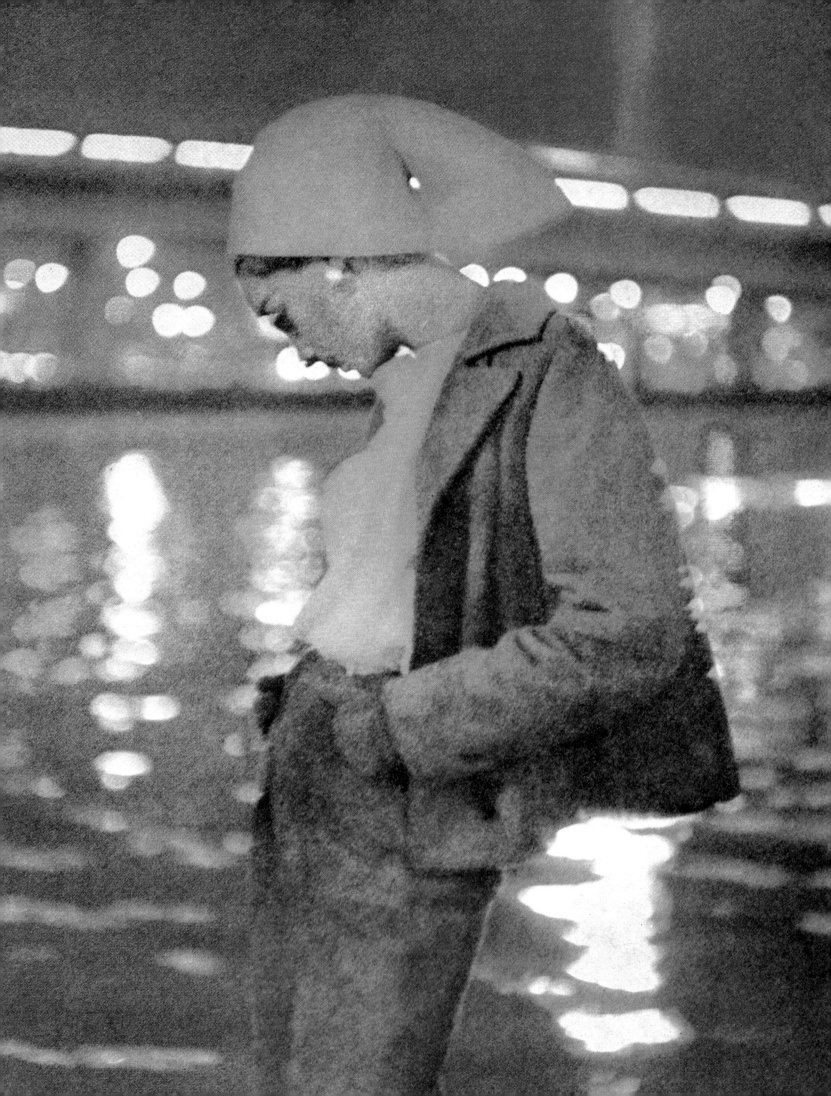

These last two were at the poles of American fashion. Valentina was a fully-fledged couturière interested only in using the most sumptuous of fabrics, in the exclusivity of fashion. Russian-born, tempestuous, beautiful, she often appeared in *Vogue* wearing her own creations; "She is one of her own most conclusive models for the fashion she makes," wrote *Vogue* under a photograph of her in décolleté, with a great strip of diamonds over her forehead.

Claire McCardell, by contrast, liked making high fashion available to everyone. Trained in a sportswear firm, she used materials like calico, ticking, seersucker and denim to unique effect, and she stamped American fashion with her distinctive, zesty, attractive way of dressing. It was a style absolutely suited to the times and outlook of the young American woman, who embraced her casual but beautifully groomed look—down to the flattie shoes she pioneered.

The open air became the natural setting for photographers like Clifford Coffin, John Rawlings, Frances McLaughlin, and especially Toni Frissell, who showed fashion in a high element—frisky, appealing, informal. In sleeveless dresses, shorts, small sweaters, their models swung, swam, gathered shells, gamboled with children, their hair often gathered into a turban, their eyes protected by the sunglasses which had become an essential accessory; and often the spontaneity captured in the photographs was genuine —the models actually were the women who lived these lives.

As the fashion editors of *Vogue* became more inventive, working with designers to produce the sort of clothes that *Vogue* wanted to promote and photograph, the magazine became a powerful fashion force. A number of fashion editors at this time personified their own versions of the American look. Barbara Cushing, who later became Mrs. William Paley, was always the impeccable epitome of chic, as much a visual delight in her crisp blouse and her handkerchief-linen skirts as in her haute couture extravaganzas. Sally Kirkland, later fashion editor of *Life*, with her loose-jointed, long-legged, limber figure, her shining pageboy bob, her flat shoes, her shift dresses with their big hip-slung belts, summed up the Claire McCardell look. Babs Rawlings, who before the war had been married to René Willaumez—one of the best-known fashion artists in *Vogue*—was a woman of inimitable style, of whom someone once said, as she fleetingly adopted a "gypsy" look with turbans, jewelry, layers of clothing and shawls, that when she undressed she just stood in the middle of the room and shook. She married John Rawlings, who had started as an assistant in the *Vogue* studios in New York, and had worked as a photographer in England. In New York he set up his own highly successful studio, and his wife was nearly always the fashion editor on his sittings. Their partnership is an example of those lasting associations which exist between a photographer and an art director, fashion editor, or model—partnerships which can give a unique direction and character to a photographer's work.

There was still a hallowed place for the elaborate sets, complicated lighting, and grand clothes of the big eye-stopping studio shots. But, as always, technical as well as social developments changed the look of photography. Color production was easier. Kodachrome was in everyday use; the new smaller cameras, notably the Leica, were an accepted part of photographic life. Stroboscopic or speed light was being used, most notably by Gjon Mili, an Albanian-born engineer. He had studied at the Massachusetts Institute of Technology and worked with Professor Harold Edgerton, who in 1931 had made the first experiments with high-speed flash and stroboscopic lighting.

Dr. Agha wrote after the death of *Vogue's* publisher in 1942: "Condé Nast believed that fashion photographers could aid in the development of American fashion by emphasizing those qualities which were its own—youth, gaiety, spontaneity, glamor . . . our pictures were to appear not remote, but friendly and direct, relaxed, almost off guard. To the uninitiated this would seem to simplify the photographer's task. Actually such a sitting required even more preparatory thought and infinitely greater concentration."

It also required a new look in layout to match its immediacy, urgency and vitality, and this emerged under the art direction of the young Alexander Liberman, who had arrived in 1941 from Paris, where he had been editorial director of the influential magazine *Vu*.

Irving Penn/American Vogue, October 1, 1943, and British Vogue, October 1, 1944

"I think," Liberman says with a tired smile, "that I have picked every photograph that has appeared in American *Vogue* for the past thirty-five years." He became art director in 1943, and so began one of those spontaneous cycles that are essential in the life of a magazine if it is to remain, to use a favorite word of his, "energizing." He changed the placing, pace, and settings of the photographs and text, and brought a vividly imaginative intelligence to the whole question of communicating through photography. His love of America and Americana was reflected in his encouragement of young American photographers like Irving Penn, whose exhilarating fashion images first

appeared in the same year in which Liberman became art director. These are sophisticated, startling, documentary evidences of their time.

The conglomeration of unique talents on the visual side of the magazine gave some of *Vogue*'s pages an almost futuristic look—a foretaste of the shapes and looks of the aggressive, optimistic decade ahead. Penn, Liberman, and the European photographer Erwin Blumenfeld seemed to be able, quick as a blink, to slip an image upstream into the flow of memory.

Blumenfeld's photographs in particular are characteristic of their time—unequivocal, strong, striking. Blumenfeld was introduced to Michel de Brunhoff by Cecil Beaton in Paris just before the war, and almost immediately began to work for *Vogue*. His early photographs of Lisa Fonssagrives (the famous model who later married Irving Penn), teetering from the topmost struts of the Eiffel Tower, with Paris stretching below in a panoramic backdrop, gave readers a memorable sense of shock and danger.

Blumenfeld had a keenly developed sense of the absurd, a satirical view of the world, and yet he never channeled his satirical outlook into his fashion photographs, never tried to invest them with his private obsessions. "Photography must be a clear statement," he once wrote, and that clarity was rendered with self-confident style and sustained invention.

When he photographed an eye and a mouth and a single beauty spot, he not only epitomized sophisticated womanhood but gave a startlingly beautiful image of one particular woman, and the fact that he could distil the essence of the girl and the fashion into one image was as much due to his darkroom technique as to his mastery of the camera itself. He was one of the first photographers to use the Hasselblad, which was developed in Sweden in 1947 from an aerial camera, and could be fitted with a wide angle lens to give wider variations in perspective and composition.

Erwin Blumenfeld/ American Vogue, January 1950, cover

In his autobiography—published in 1977, eight years after his death in Rome—Blumenfeld revealed that all the time he was so stylishly capturing segments of American life from his studio on Central Park South—as much through his advertising pictures for archetypal American firms like Ford or Elizabeth Arden as through his work in *Vogue*—he was hating the fashion and commercial world in which he worked with a productive, voluptuous hate.

In 1947, fashion was given an enormous, exciting jolt in a revolution that made headline news all over the world. Dior's New Look arrived, and a look that had been dormant for eight years burst on the world. Audrey Withers, then editor of British *Vogue*, remembered seeing in one of the last Collections in Paris just before the outbreak of war a dress with a full skirt and a pinched-in waist that was quite unlike anything that had gone before, and which would obviously have been the next step had not World War II intervened.

Even after the war, however, two years passed without a drastic change: rationing was still a limiting factor (in Britain and France there was an even more acute shortage of essentials than during the war), and Paris was painfully resurrecting itself. And then on February 12, 1947, the models of the new house of Dior came swishing onto the catwalks dressed in gloriously colored rustling dresses containing any-

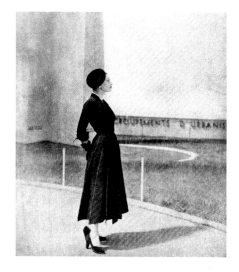

Horst P. Horst/British Vogue, October 1947/Fashion: Dior

thing from fifteen to fifty yards of fabric, their hems a scant twelve inches off the floor. Their stockings were sheer, their shoes high-heeled and pointed. The soignée women in the short, square-shouldered skimpy suits who watched the Collection felt elated, deprived and ill-dressed. It was the reaction of women all over the world. The new king of couturiers, Christian Dior, said, "I designed clothes for flowerlike women, with rounded shoulders, full, feminine busts, and handspan waists above enormous spreading skirts. I brought back the art of pleasing."

In one heady moment Paris reasserted itself as the leader of the fashion world. Its lost fashion demesnes were restored, and the courtiers of fashion came from all over the world happy to pay homage. (Not everyone was so happy. In Britain the President of the Board of Trade, struggling against the national discontent aroused by the continuing acute shortages of almost everything, declared there should be a law against it.)

Vogue was unequivocally delighted: "Fashion has moved decisively—Dior is the new name in Paris."

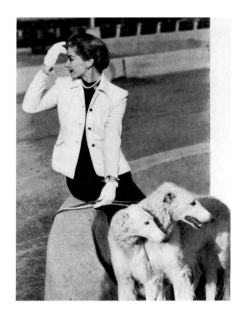

The New Look was the very stuff of dreams for its readers, hungry for sensation and avid for change. The first photographs stunned fashion-conscious America. Women clamored for the clothes, and Bergdorf Goodman, Henri Bendel, Marshall Field bought quantities of toiles (muslin prototypes for limited copying). The Dior staff worked eighteen hours a day to meet the demand. Soon there were copies in stores all over America, and the New Look was smoothly assimilated into American fashion, with a confidence that revealed the strength of the American fashion industry.

In 1949 a *Vogue* editorial summed up fashion at the end of a memorable decade:

"Good fashion is all across America in the clothes that belong where [women] live. It is a pale blue chiffon or white linen at the St. Louis Country Club dance or a slim dark crêpe in Chicago's Pump Room. It is a gray flannel suit, almost any day, anywhere—or Levis from Levi Strauss, in a million backyards. It is the bride in white cotton piqué and cap of white lilies; the pale green slippers she has dyed to wear the first time her wedding dress becomes a summer party dress. It is the biggest, spreadingest white tulle dress on the blondest debutante in New Orleans; or a linen skirt and sweater at a record-playing session in the white house on the corner. It is a satin suit for cocktails-and-on-to-dinner in New York, or for the bridge club afternoon in Marietta, Georgia. Good fashion is the gray jersey dress that goes shopping in Columbus, Ohio, or to Sunday luncheon at Lake Forest, Illinois; that sits behind a professor's desk at Bryn Mawr or in a lady vice-president's office at any one of a half-a-dozen banks across the country. It is the navy-blue coat that goes about in Denver every day, now with a taffeta scarf tied in a bow, now with a fat pink rose.

"Good fashion in America is clothes that look as if you meant them, and cared about your clothes enough to want them to be right for yourself and pleasing to your own particular public; that give no blatant evidence of price, but easily prove that you know where they were meant to be worn; clothes that know how much a given price should buy, and do not try to buy more. . . . They are clothes that can be bought in hundreds of cities, thousands of towns; . . . and the girls and women who wear them will be clothed not only in gray jersey and white tulle and blue denim and satin and cotton crash and handkerchief linen but in the perfectly visible idea that *everybody* should have a chance to choose, and should be able to buy some, at least, of the kinds of clothes she most particularly wants for herself."

1950 s

The 1950s were a time of new beginnings, of recovery and discovery. Years of rationing were over, and a deprived population, on both sides of the Atlantic, set about becoming consumers, reaching out eagerly towards a prodigal future. Many of the changes that the war had brought had become permanent. Aspirations to self-awareness and self-fulfillment, which were to become real quests in the following decades, were already evident, and traditional standards were being questioned and discarded.

In the fashion world, however, traditional standards died hard. The only kind of statement about women that could be made in fashion photography had a kind of absurd conventionality, and the model perpetuated an enshrined prewar image of the untouchable lady. Her horizons might be larger, geographically speaking, and her environment more exotic—she might entwine herself with the trunk of an elephant—but she would be elaborately coiffed and gowned while doing so.

Vogue was quietly confident about established conventions, sartorial and social. Its fashion features were directed more to society girls with an allowance

than to the vast mass of young earners and spenders who took their fashion influence where they found it. They found it among their peers: in the Paris existentialist look personified by Juliette Greco, in the new idols of music, in the new movie stars—the sweater-

I*rving*
*Penn/American
Vogue, April 1,
1950*

girl look of Lana Turner, the scrubbed girl-next-door image of June Allyson and Doris Day. In the obliging way that Nature has of evolving overnight to fit fashion requirements, a whole army of doe-eyed copies of Audrey Hepburn appeared, and an equal number of tousled blondes cast in the image of Brigitte Bardot.

The ladylike image was passé, especially among the new young class of teenagers. *Vogue* began to reflect the trend, but Edna Woolman Chase fought a strong rearguard action: "I have remonstrated when the editors have passed photographs of models who do not look like ladies and therefore are not *Vogue* material . . . but they contend that it is what ladies of today look like, and as journalists we should show them as they are, and not as we think they should be."

Jessica Davies (who had become editor in 1946 after Mrs. Chase had become editor-in-chief) refused to publish photographs she thought too *suggestive*: and this tended to happen more and more often, especially when lingerie began to have a specific place in fashion pages as new synthetic—and diaphanous—materials came on the market. She vetoed a Horst photograph of a girl in a nightdress lying on a bed, and was horrified by the immodesty of the new two-piece bathing suits.

The power that Paris had regained with the New Look was still absolute within the established fashion industry. No one was likely to forget the shock of the historic New Look Collection, when existing wardrobes had been declared obsolete at one man's dictate. Although that could hardly happen again, since the shock depended for its impact on the frozen conditions imposed on fashion by the war, the couturiers of Paris still played an enjoyably tyrannical game. The Collections were news, on a par with economic and political reports, and speculation raged before each season as to what arbitrary laws the dictators would impose. The reality was not quite like that. Clothes evolved, season by season: the waist shifted, the hemline lifted or dropped, and the famous lines of the 1950s—the envol line, the princess line, the tulip line, the A line, the H line, the Sack—were not the result of isolated radical changes, but rather showed the continuity inherent in a way of dressing where outline was all important and where one couturier naturally in-

fluenced another. Only the great, consummately stylish individuals like Chanel, Balenciaga, and, later in the decade, Yves Saint-Laurent (who at the age of twenty-one, on the death of Christian Dior in 1957, took over as designer for the House of Dior) pursued their own ideas and convictions regardless of anyone else.

Chanel was unique. She reopened her salon in 1954 to an unenthusiastic press, but a year later her tweed and wool cardigan suits, silk shirts, strings of beads and pearls had become staple classics in the wardrobe of women at every income level. Balenciaga, with his absolute mastery of cut and conception, was the doyen. His clothes were original, peerless, devastating, and although he is credited with great classic looks in fashion, he was always open to sudden inspiration, attuned to fashion from the young and from "the street", producing, for example, the first black vinyl "gendarme" raincoats to be shown in a Collection, the first elaborate stockings.

Then, almost overnight, as it seemed (although in retrospect one can clearly see the groundswell gathering), the 1950s became the decade of the affluent young. The discreet, allusive signals of wealth, good taste, and international chic meant nothing to them. Overall effect was more important than detail. Dress became an idiosyncratic affair, revealing the interests and allegiances of the wearer. Fashion taboos were broken with relish. To the purveyors and practitioners of traditional fashion and style, this new style appeared to have no style at all. It had energy and a furious pace, and it staked out a new fashion territory that expanded with alarming speed.

Among the new young photographers whose work was vital in extending and influencing the new fashion territory, and who redefined and invented the acceptable content of fashion photography, were Irving Penn,

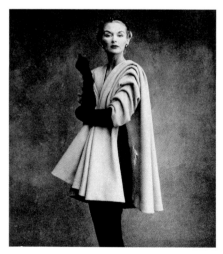

I*rving*
*Penn/American
Vogue, September
1, 1950/Lisa
Fonssagrives/
Fashion:
Balenciaga/
Vogue's Paris
studio*

Richard Avedon, Bert Stern, William Klein, and Norman Parkinson.

Penn had been a painter before becoming a photographer, and his intense interest in contemporary art movements is reflected throughout his work; Precisionism, for instance, that specifically American movement with its emphasis on sharpness, its simplifi-

cation of form, geometrical precision and mechanistic subjects, had a fundamental connection with his photography. He also admired the work of Paolo Uccello, the fifteenth-century Italian painter, and was influenced by his exploration of perspective and foreshortening.

His first *Vogue* cover appeared on the October 1, 1943, issue: a simple enough study of a handbag, a topaz, some citrus fruit, it was nevertheless a sensational new image, hard-edged and strong, of a kind hitherto more associated with avant-garde photographic magazines than with *Vogue*.

All his work had an immediacy and exploratory quality which was quite new. He made disclosures about the components of fashion photography: the fabrics, the textures, the weave of the wool, and the nubs on a bare back were scrutinized. His camera came in like a microscope, and the consequent images looked magnified.

Alexander Liberman exerted a significant influence over his work, and encouraged him in his quest for his own style. It was a uniquely creative relationship, a rare and intimate fusion of talents.

Penn's images are memorable, timeless; you feel that there is no yesterday and no today, only the now, anchored in the petrified shape of a shoe, the candid line of a shoulder. There is always a still quality that holds a Penn picture in the mind's eye. In his definition of his subject, he is the Dr. Johnson of the camera.

Penn's formal, accessible definitions often seemed shocking because they were uncompromising, free of the chilly flirtatiousness that marked so many other fashion photographs of the time. In fact, he found existing fashion conventions so restricting that he ignored them:

"When I started to work, it was important to make a document, to make pictures that were timeless, that would burn off the page. The ideal setting was the French drawing room. I didn't know what a French drawing room looked or felt like, and the ideal women were remote, with European overtones. They were beyond my experience, as was Huené's work, which was remarkable, but his aristocratic perfectionism was beyond my aspirations. I could photograph only what I knew and felt comfortable with. I made pictures in simple circumstances of women I could imagine and could want to possess. So at first I photographed simple uncultivated girls—the girls I went to school with. They seemed right for America in the postwar period."

"The girl has always been important in my pictures because she projects so much, and has so much projected on to her. The models I used were people, and I would have a favorite model with whom I might have more real emotional involvement, which sometimes meant I saw more in the ground glass than was there, and photographed with more objective power than I was going to get back. I was a young man with no knowledge of style, but I knew when an image had guts."

Penn's new all-American model brought gusts of fresh air into the still and rarefied atmosphere of fashion photography. His girls—still impeccably groomed, every hair in place—appeared in many guises. Feline and glittering, they slouched carelessly (although in wonderfully becoming postures), defying all rules about sitting up straight; fluffy as kittens, they giggled on telephones, or played intimate charming games. Sometimes they played the arrogant-model game extremely well and stood chin up in the famous model-girl stance, with the pelvis tilted, one knee behind the other to accommodate their pinned arrow-thin skirts.

The photographer who more than anyone was responsible for creating the new image of fashion and models in the 1950s—as well as for creating legends about himself—was the brilliant, peripatetic Richard Avedon, who from the beginning cultivated a special rapport with his models. He had started work on *Harper's Bazaar*, where the art director Alexey Brodovitch had seen in some blurred shots of children at play a hint of he young Avedon's extraordinary eye. Like Alexander Liberman, Brodovitch exerted enormous influence over the photographers who depended on him for suggestions, encouragement and direction in their work.

I rving Penn/American Vogue, September 1, 1950/Fashion: Molyneux/Paris

Avedon was and is the quintessential photographer of his time, and he created stunning effects, cropping photographs in a new way, often filling the whole frame with the angled body of the model, splashing the detail of a dress diagonally across the page. The models he used were memorable, and his way of working with the sisters, Dorian Leigh and Suzy Parker, illustrated how productive the relationship between a model and a photographer could be. He startled readers with his vivid pictures of these beautiful, energetic, punchy girls. Not at all aloof and haughty, they were actually doing glamorous but apparently spontaneous things: Dorian Leigh throwing her arms around the winner at a bicycle race, Suzy Parker running down the Champs-Elysées. Avedon caught fashion on the move, spinning through time. He made models seem the most ravishingly unpredictable, enormously stylish people in the world to be with. Suzy Parker, in particular, reacted to the camera as though she loved it: "In front of the camera I looked

like a grown woman. I was always big for a model, but I didn't care I never starved myself either. I remember all the models eating raw hamburgers and living on codeine to keep up their energy. You never met a skinnier, meaner bunch of people."

However skinny or mean, these women projected an aura of sleek self-confidence which many sought to emulate. This was difficult, as their looks were based on artifice: that easy confidence was achieved by an

enormous amount of concentration, preparation, and attention from a team of skilled people. Locations became ever more bizarre and more remote; and this only added to the models' glamor. They became romantic heroines, and couturiers talked of being inspired by a favorite model.

By the mid-1950s modeling was a highly paid profession. The hourly rate could be as much as the average weekly wage for girls in ordinary jobs, and, because it looked so easy and glamorous, it became the dream of a new generation of young hopefuls who knew little of the rigors or disciplines of the job, or the vagaries of photographers. Model schools and agencies pro-

liferated, although there have always been stories of models being discovered accidentally—like Lud, Horst's favourite model, spotted as she rushed into his studio to deliver some clothes; or Carmen, one of the most famous models of the early 1950s, discovered by Cecil Beaton, "a renaissance child with a heart-shaped face, enormous aquamarine eggs for eyes, and bad teeth," on top of a bus on Fifth Avenue. In the 1960s, Jean Shrimpton, on her way to lunch from modeling school, was excitedly accosted by a photographer who told her he could make her a top model.

As photographers and models began to make the news, newspaper editors realized that fashion could be urgent, fast, and interesting. Men as well as women looked at the fashion features in newspapers, and as a result the pictures became a little sexier and more sensational, the stance of the models more provocative.

This new image chimed with the ideas of William Klein, a young American photographer living in Paris, who brought an unusually acid and ironic attitude to fashion. Klein had an inventive, irreverent style which was wholly distinctive. The jumpy environment in which he placed his models seemed almost as important as his clothes: it loomed around them, electrifyingly modern. He managed to capture in his photographs the fast-moving, multi-imaged quality of movies and television; he used girls who looked independent, tough, with the kind of knowledgeable air that suggested they had been brought up in a tough urban area—an image much removed from the haughty, classic beauties of the early 1950s.

"I used semi-nuts," he said. "I liked the tough girls from New York and the back-streets rather than the upper-class socialites. In my photos the girls are always in trouble, always askew, or I play two girls off together. Helmut Newton's pictures come out of mine because I was the first to use hard girls."

In his own behavior and life-style Klein added to the legends already building up about photographers and their demands. One editor recalled:

"I went with him on a sitting to Petra, and although finally he produced wonderful photographs, there were dreadful moments. After I thought I had foreseen

everything, he said 'We need camels.' I was frantic, trying to get camels at five minutes' notice before the sun went down, but I managed it; they appeared, two moving brown masses. 'You might have known I wanted white ones,' Klein said. I burst into tears.''

Another key photographer who influenced how women looked was Bert Stern. Before Stern's advent, fashion photographers tended to be given advertising accounts only after their work had been seen in editorial pages. Stern reversed this by first establishing himself as the master of advertising. His Smirnoff vodka advertisements in the late 1950s not only made sales soar but gave the American consumers a new view of themselves and their desires. He brought to Vogue's editorial pages the technique that had made his advertising such a success, persuading the reader that what she was looking at was what she was looking for. His fashion photographs were made rather to whet desires than as statements about fashion. Stern's lavish life-style and way of working filtered into the public myth about how photographers lived. His studio was enormous, an old schoolhouse in the middle of Manhattan, and was always full of people; his turnover was reputed to be a million dollars a year.

Running counter to Klein's graphic vision of women as hard and uncompromisingly urban, and to Stern's images of them as sex objects, was the English photographer Norman Parkinson's idealized portrayal of women as gentle creatures who often looked as though they were happiest among green fields. Parkinson had started work for Vogue in 1948, and his fresh, glowing photographs reflected his double life as farmer and fashion photographer. This strange combination of violently disparate roles—the one so concerned with slow growth, roots and fruition, the other so geared to lightning changes, frivolities, ephemeralities—has given his work a balance which has remained remarkably unchanged: "I have been taking the same pictures for over thirty years. They have got a little bit sharper, a little better, a little more beautiful. I am not interested in anything that Nature has not smiled upon."

Antony Armstrong-Jones, later Earl of Snowdon, was one of the begetters of the dashing new English style which was beginning to influence fashion looks everywhere. He began work for Vogue in 1956 and captured the excitement of London's cultural and fashion revival, epitomized by the cult of the Angry Young Men and the amazing success of Mary Quant's newly opened small shop Bazaar in the King's Road. Its young customers were of much the same age, and shared the same background and interests, as Mary Quant herself. Like Chanel and Claire McCardell, she was a designer who both created and, by her own example, set the fashion—and this time it was all ready-to-wear, low-priced and immediately available.

Snowdon captured that atmosphere. His photographs are memorable for their wit, zest, and immediacy, and his young models look as if they are having a terrific time—in odd situations which, while not exactly real life, are close to their culture, the culture of the 1950s in whose making they had a hand.

1960s

An American woman," explained Vogue in 1960, "has to carry a purse and an umbrella under one arm, and swing on to the bus with the other She has to walk fast and if she's not busy she's probably ashamed of it. Hectic? Not really, but the clothes that lead this life are meant to move; to get on with the times, to wander continents and to keep their wits about them. They're made for women who drive cars, travel by plane or by jeep, and who love to look a little bit pampered and more than a little elegant by night; and often rise at six to pack energetic broods off to school. They can cook too. And if they have the brains of a goldfish they don't make an issue of all this."

It is an encapsulation of the image of the fashionable woman of the time, a competent femme d'intérieur, unaggressive, content in her role as homemaker and accessory; there is, too, the underlying implication that it is vaguely unfeminine to reveal cleverness or frustration. Her image in fashion photographs was impeccable. Even when being photographed in a mock-casual or supposedly secret moment, she was dressed in the height of fashion, immaculately groomed, and wore carefully coordinated accessories. Other more striking accessories were often introduced for flamboyant effect, and to induce the almost statutory mood of fantasy. She could find herself elegantly lunching opposite a bejeweled cheetah, for instance, without turning a hair, or be photographed among a host of historical waxworks while remaining socially poised. These pictures were still plugged into the world of haute couture—and photographers like Henry Clarke or Leombruno-Bodi could always make even ready-to-wear fashion look grand, their models cosseted, their surroundings opulent. Vogue's pages shone with glamor.

However, the underlying assumptions about woman's role in society were already being questioned, with significance and force. There was a certain anxiety revealed in editorial comment about what new standards the changes would bring—an anxiety held

somewhat at bay by a jaunty belief in the powers of traditional symbols of charm and femininity:

"The woman of our time stands directly in the light and faces up to it beautifully. No longer limited by the soft focus of private life, she moves often now in the full brilliance of her own town and city, perhaps in a national blaze. She lives more in history than any woman has ever done. However much she may want to retire into her own household, her own family, her own small community; however much she may consider these her true concerns, she cannot escape history. History in the making is funneled to her hourly, inexorably; by newspapers, transister radios, television and jet planes. She lives in the world of 1962 now and she has to like it—

*D*avid Bailey/British Vogue, September 15, 1965.

she's in it up to her neck—but around her neck can be, all the same, a becoming twist of brightly colored chiffon."

The woman in question sounds like Jacqueline Kennedy, who had become the epitome of the American woman for the rest of the world. Her thick, bouffant hairdo, sleeveless sculptured dresses worn just to the knee, Chanel-style suits, the small pillbox hat that almost became her trademark, her sumptuous evening dresses—all were discussed, admired, photographed and copied the world over. Her relative youth, style, and intentional chic, and her unembarrassed concern with her appearance, had a profound effect on the overall look of fashion-conscious women.

A new style was being forged out of many disparate sources. Tom Wolfe, the chronicler of the emergent culture, went in search of its roots: "Once it was power that created high style, but now high style comes from low places . . . from people who are marginal . . . who carve out worlds for themselves . . . out of the

*F*ranco Rubartelli/ American Vogue, July 1968/ Veruschka/ Fashion: Alimac, George Kaplan

other world of modern teenage life, out of what was for years the marginal outcast corner of the world of art, photography, populated by poor boys."

He quoted a New York photographer, Jerry Schatzberg: "The photographers are the modern-day equivalent of the Impressionists [*sic*] in Paris around 1910: the men with a sense of New Art, the excitement of the salon, the excitement of the artistic style of life."

This artistic style was an eclectic mingling of new influences, new movements, new trends and new visuals—from the rerendering of universal images into Pop art, to the eye-confusing intimacies of Op, to the kitsch appeal of High Camp. The new "culturati," artists, photographers, journalists, painters and writers, mixed with the stars of underground movies and off-Broadway theater, and the fashion and art worlds merged in a publicity-conscious whirl. Photographers like Helmut Newton, Bob Richardson, Frank Horvat, Franco Rubartelli, Penati, and David Bailey—young, energetic, irreverent, projecting their own youth and sexiness— were just as interested in influencing and being a part of this new style as they were in recording it. They dressed to suit their image, and with their small single-lens reflex (SLR) cameras they were as likely to snap fashion in a local street as to go to more exotic places.

The more established photographers did go further, to find the dazzlingly ostentatious ingredients still required for "high" fashion; and their models ran through Oriental temples, explored tropical jungles, or rode camels in the desert, with their customary insouciance. A Penn, Avedon, or Klein trip in the early 1960s could cost $20,000—but *Vogue* appeared in New York twenty times a year, so the results of a trip could be spread over many pages.

There was a curious contrast between these parallel themes and images of women: on the one hand, the glamorous, recherchée, poised lady; on the other, the free, freaky individualist dressing in whatever mood took her. Gradually the two images came together to make one amazing composite creature—or were drawn together by Diana Vreeland, who had become editor of American *Vogue* in 1962 and who loved the new style, especially in its more romantic and successful manifestations. She adored the young, embraced their ideas, endorsed their style, and coined the term "youth-quake" to describe the new movements and trends, as well as the people who instigated and followed them. In fact, she was famous for her metaphors and her fast descriptive labels, and *Vogue*'s use of the phrase "the beautiful people" became a password for a chic, rich style of life in the 1960s.

She had favourite models—including Veruschka, Marisa Berenson, Twiggy, and Jean Shrimpton—to whom she sometimes gave a free hand to construct their own fantasies (or, in the case of Penelope Tree, one of her discoveries, FantasTrees). She loved "a bit of romance, a bit of splendor, a little luxe in our lives . . . it's what we all crave, yes? One perfect jewel, one sumptuous fur to sink into languidly Some small delectable thing."

Mrs. Vreeland's wild imagination, her acquisitive eye for the near future, encouraged and defined the spirit of exaggeration in the air:

"The Greek-boy look will take the country by charm. And why not?—what could be more romantic than pretty girls prancing about like modern Ganymedes in golden thong sandals to the knee and blowy little dresses with tiny whirling skirts, their hair a crop of bouncing ringlets and careless tendrils."

She promoted the space-age white look of Courrèges with the same enthusiasm as she had the classic fashion

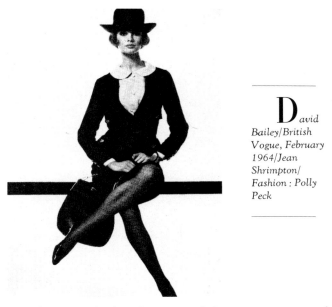

David Bailey/British Vogue, February 1964/Jean Shrimpton/ Fashion : Polly Peck

of Balenciaga; for her they carried the same message of vitality and excitement. The very vocabulary of fashion became extreme—a preview of summer looks in Vogue, April 1966, read like this: "Ready to name now: the next killer-diller looks . . . snap, crackle, glitter back at night, shiny and supple and wonderfully luxurious—as in a knee-dusting float of lacquered black lace: as in a short net cage."

The accoutrements of fashion became more outré. Body paint and enormous quantities of jewelry were used to decorate the newly revealed expanses of skin. Hairstyles became increasingly elaborate, as hairpieces and wigs were piled into edifices such as had not been seen since eighteenth-century France, and the hemlines of dresses and skirts rose higher and higher over printed and patterned tights. Trouser suits too, were fast becoming standard fashion.

For the first time, fashion in clothes began to come from the streets up, as the young began to dress to illustrate their roles and interests, using whatever was available, particularly antique clothes. Among certain

sections of the young the search for values led some to the Flower Power and Hippie movements, and to an interest in the occult, in astrology, Oriental philosophy, music and religion. The ethnic look became fashionable.

This evolving way of dressing was difficult to translate into conventional fashion terms. Haute couture in Paris still had a certain news value for the fashion establishment, but other influences were more powerful. The English look, in particular the miniskirt, had arrived through such diverse channels as the clothes of Mary Quant, movies like Darling with Julie Christie, the phenomenal prestige of the Beatles, and more directly the photographic partnership of David Bailey and Jean Shrimpton.

There was an engaging toughness about Bailey's work, a toughness far removed from the casual violence that manifested itself in fashion photography later. Shrimpton's freshness, candor, and natural look, her curved long-legged limber body which so gracefully collapsed into vulnerable postures, seemed a generation away from the static elegance of only a few years before. She opened the way for a school of new models who, as the decade got older, seemed to get younger, culminating in the success of seventeen-year-old Penelope Tree, and of Twiggy, a year younger. Their naive, adolescent image set a standard that was difficult for women to relate to—except, that is, in photographs by Richard Avedon, who could endow them with a touching and universal appeal.

Avedon's work, which had always had an extraordinary modernity and relevance, took on a new vitality, dash, and energy when he joined Vogue in 1966. Sensitive to approaching trends, vulnerable to mood, open to the possibility of the unpredictable happening in front of his camera, he had a questing temperament which suited the climate of the 1960s.

He seemed able to inspire his models to new inventiveness by the demands of his imagination, and produced images of women that are as emblematic of the 1960s as his earlier ones had been of their times yet which still carry the eternal appeal of the feminine. Veruschka, Shrimpton, Tree, Lauren Hutton, all seemed to gain new personas under his probing eye. Jean Shrimpton once confessed that only in front of his camera could she move unselfconsciously. He could make them idiosyncratic, sometimes hoydenish, individuals, or transmute them into universal symbols of womanhood. In his search for the latter he extended the acceptable standards of nudity so much that his 1966 portrait of Veruschka naked from the waist up aroused little of the shock that had greeted his similar portrait of Cristina Paolozzi only five years before.

In the March 1968 issue, fashion as a matter of dictate or decree from Paris seemed obsolete, as Avedon, Tree and Twiggy went off to cover the Collections. "Packed them off to Paris we did," ran the editorial. "Simply turned them loose to amuse themselves in the most amusing clothes we saw there. They played it by ear and played it to the hilt."

With apparent freedom, with new boundaries of acceptability established and almost simultaneously

crossed, it became harder to be inventive, to arrest or shock the eye. Fashion photography had exhausted, at least temporarily, the elaborate and explosive effect—perhaps only Penn could still produce a monumental effect from magnifying detail. A new young photographer, Bob Richardson, found a brilliant solution by casting the model as a heroine, and by adapting the techniques of *cinéma-vérité* to his sequences of linked photographs which related a story, or hinted at small tragedies—or celebrations—while making a fashion point. The adventures or tribulations of the model-heroine were often sited in beautiful, dramatic and earthbound surroundings—a Greek island, for example, or a Paris café—in scenarios of Richardson's own devising which suggested ambiguous hopes and desires.

The fashion editor who most influenced him, and with whom he enjoyed working, was Deborah Turbeville, who later became a photographer working in somewhat the same evocative mood and genre. Richardson's photographs involved and intrigued the woman who looked at them. They connected her significantly, emotively with the subject, and connected fashion with the elemental and sensual side of her nature. "Sex is one of the things that happened to fashion photography in the 1960s," Richardson said.

Sensuality of a different, tauter kind was beginning to be portrayed in the photographs of the German-born Helmut Newton, whose work had first appeared in the British and Australian editions of *Vogue* in the late 1950s. Many of his most telling images, in the 1960s, relied on external elements of drama for their impact. The swift whiplash quality of his work was beginning to surface, and in many of his photographs there was a feeling of lurking violence. A venomous humor, too, as in his version of the stock safari photograph: there is the Land Rover, the big-game hunter, and the leopard, curled up quietly. But it is the girl who is trussed up in the net, bound hand and foot, to be carried home. She is the prey and Newton's camera is the predator.

In the 1960s he used the paraphernalia of technology as his props. Later in the decade his images became lusher, his girls sexier. They sit on satin sofas or on tousled, inviting beds, staring sullenly out at the spectator. They look slightly decadent, restless and independent, sexually liberated.

H*elmut Newton/British Vogue, April 15, 1967/Fashion: Terence Sythes*

Vogue was ecstatic about the new freedom in fashion, which it linked to that restlessly sought by women in all spheres; and which it proclaimed in a 1968 article by Richard Goldstein:

"Now Beauty is free. Liberated from hang-ups over form and function, unencumbered by tradition or design. A freaky goddess surveying her ailanthus realm. Kite-high; moon-pure. Groovy, powerful and weird!

"The love goddess of the sixties works in para-reality. She is larger than fantasy and loftier than modesty . . . she walks a thin line between camp and revelation. She exhibits herself, and through the subtle seduction of style she makes you notice.

"Exhibitionism is the quiet side of violence: it aims to provoke if not to injure. No wonder it dominates the fashion of the sixties.

"It is impossible to talk about even something as insular as beauty without noting that the same turmoil and insurrection that provides the terror of our time also inspires its greatest achievements. The style of the sixties is creative anarchy."

1970s

The 1970s brought a more realistic mood altogether. In the first three months of 1971 there was a national economic recession in the USA which hit the fashion world hard. The fantasy fashion of the 1960s vanished, made obsolete by harsh economic realities. The outlook was sobering; the Vietnam War and its consequences had deeply affected the country, and the mood was no longer propitious for dreaming, extravagance, or anarchy.

Fashion became more practical, easier to wear, and less exhibitionist, and reflected a leveling-off process: the theme for style, in fashion and therefore in fashion photography, was democratic uniformity. An editorial in *Vogue* in 1971 was unequivocal: "The blue denim look—Levis, a pullover, belts—it's the uniform of the world, the way we all want to look when we're feeling easy, moving fast—a way of life. The all-time, all-American superfashion you see all over the world."

Ostensibly, blue denim bridged the generation gap and the class/money barriers—but status symbols in the form of special accessories and integrated designers' signatures appeared, bringing to an ultimate absurdity the idiosyncratic fashion launched by the Italian designer Emilio Pucci ten years earlier when he incorporated his scribbled signature into his fabric designs. Even individual fashion styles like "cheap chic" used the concept of uniformity, including old army uniforms and remnants from the 1930s, 1940s, and even 1950s. Yves Saint-Laurent, with his own couture firm, established in 1962, often gained his inspiration from the street chic of clothes already being worn by stylish individuals, although he adapted them in his own special way.

The foundation of the new fashion philosophy and style of photography in *Vogue* was what was seen by the eye and not the imagination: what was actually

worn by women going about their business, rather than what might be worn in pursuit of their dreams. Grace Mirabella, who became editor in New York in 1971, epitomized this new *Vogue* style, maintaining a balance between fantasy and reality, between visions and possibilities.

Arthur Elgort/British Vogue, February 1972/Fashion: John Craig, Baltrik

The very look of her *Vogue* changed. It was no longer an "album"—and it was competing with a great surge of other magazines, geared to the interests of woman in her wider world. The magazine's format was reduced to conform to new postal regulations. The pages began to look more charged, less concerned with esthetics and massive fashion statements. They were crowded, speedy and communicative, an intimate integration of words and pictures. The result was a communication of energy, transmitting a fast message to women. *Vogue* said in 1971: "Clothes must work for the woman who wears them. And that's what fashion is all about just now. Just another pretty look won't do. If it doesn't earn its keep, it's not fashion today!"

Clothes were put together, layered on, taken off. Accessories had always been important, but had been used as additions to an overall look, to emphasize, to point out, to modify a mood, an effect, or a function. Now everything became an accessory, and looks were put together to suit the mood, the time, the circumstances. Women might dress up for a special occasion in the evening; and occasional anachronisms, like the spectacular costumes of some of Yves Saint-Laurent's haute couture, still had a place in fashion. But these had no reality or connection with a daily life; they were the stuff of memories and dreams.

Photographers of the 1970s, like Duane Michals, Albert Watson, Arthur Elgort, Chris Von Wangenheim, and Barry Lategan, faced problems that earlier photographers, with autocratic attitudes and sensational clothes at their disposal, did not have. It required a new impact of reality to make the reader stop and look at a free-and-easy girl in a shirt-dress, or in jeans. The girl in the picture must communicate spontaneously with the reader, not by striking her with the overwhelming fact of her appearance, but by invitation, by conspiracy, by relation.

One of the ways photographers solved the problem was to adapt the quick-moving look of the *paparazzi* photograph to the fashion sitting, making it look as though the model had actually been spied on by a scurrilous Italian pressman (a *paparazzo*) as she wholeheartedly and stylishly lived through her day. The intensity of movement, the feeling of news-gathering, the element of drama about these photographs, was in itself arresting. But the model was at the core of these scenarios, and it took a special girl to play the part. She had to be a representative, an actress, an athlete; to look independent but not tough; to be marvelous and beautiful but not remote; to be accessible, hygienic and healthily sexy: and the girls who fitted these demands, like Janice Dickinson, Patti Hanson, Beverly Johnson, René Russo, and Roseanne Vela, projected an American look as distinctive and influential as the earlier pinups of Hollywood.

There were other movements in society, too, which affected both fashion and photography. Magazines and films catering for every sexual whim were widely available, and what seemed inadmissible explicitness one year became commonplace the next. Some fashion photographers were faced with a dilemma, others with a challenge: how to make people whose eyes had become inured to shocking and explicit images respond to a straightforward fashion picture. Some photographers began to take fashion pictures whose ideas and images seemed more connected with sexual fantasy than with the reality of the fashion, and the term "porno-chic" came into the vocabulary. But, says Jocelyn Kargère, the art director of French *Vogue*, "The trend for sexually orientated shots in fashion is a natural development and a reflection of the basic aims and instinct of fashion; after all, clothes are essentially designed to be appealing sexually."

A suggestion of violence, an atmosphere of menace, entered into some of the pictures which appeared in the various editions of *Vogue*. A stiletto heel pinned a man's black-slippered instep casually to the floor; a kick from a beautifully shod foot shattered a television screen; models appeared to fight over each other

Alberta Tiburzi/Italian Vogue, May 1973/ Fashion: Valentino

Bourdin has been photographing ever since, on military service in Dakar in the 1950s, he was impressed by the work of Edward Weston, the American master of photography. On his return to Paris he applied unsuccessfully to be an assistant to Man Ray, who was sufficiently impressed to let him spend time in his studio, listening and observing the artist at work. Even Bourdin's earliest fashion pictures show his extraordinary technique and his original way of looking.

In the 1960s he was photographing for a certain effect, to express ideas about fashion and women; now he uses models almost as props, as though to symbolize unfathomable imaginings. He seeks obsessively after a controlled perfection of his own. His models, who often look frantic, exhausted, and on occasion demented, are also sexy and impeccable.

Oliviero Toscani/British Vogue, September 1, 1977/Kirsty/ Fashion : Complice

tooth and nail; men were carried upside down over a woman's shoulder in a faintly humorous show of female power. The message seemed to be that violence had a kind of chic of its own.

One of the images that *Vogue* readers found most disturbing was that of Lisa Taylor sitting, legs apart, casually eyeing a man in much the same way that men have traditionally eyed passing women. She was conventionally, prettily dressed in ladylike clothes, and it was perhaps her total connection with reality that was so provoking. The photographer was Helmut Newton, whose photographs often convey a feeling of unease—of something sinister—about fashion. Provocation is at the core of his work: his models are cool, impeccably chic, and a little corrupt. "Under certain conditions," he once said, "every woman is available for love or something if paid . . . It would be sad if she did not have that kind of availability; I don't mean promiscuity."

Since the 1960s his fashion photographs have shown a steady elimination of props, and have—like his models—become barer, harder, edgier. His subjects are often variations on a sexual theme, his scenarios set amid the trappings of the bored and the rich.

"I think," he says, "that the greatest enemy of fashion is boredom. Big women fascinate me, muscular types—the Germanic woman—and I prefer to photograph blondes to brunettes because their hair produces a gleam. I often don't show their faces very much because I like to make women mysterious and anonymous. It is very hard to do erotic pictures—the less you show the better."

One of the most imaginative and controversial of all photographers working in fashion is Guy Bourdin, the grand master of the oblique, an original who takes pictures which astonish the eyes—and the brain— because the content and the message are out of kilter. The glossy surface is at war with the underlying messages; the de luxe atmosphere is full of aggression. His images often seem placed in the sultry stillness before an earthquake. His images have no parallels in fashion photography, and little in common but their source in his own head.

Albert Watson/American Vogue, January 1979/L-R Peggy Dillard and Linda Tonge/Fashion : L-R Mary McFaddon, Rodier, Paris/Marco Island

Tidy madness has a certain chill. No two of his pictures look alike, and he enjoys twisting conventional ideas and poses—but his style remains consistent even as he changes the idiom, pace and geography of his work. At his best he has a monolithic simplicity and originality.

Other new photographers, whose work both influences and suits the photography in *Vogue*, include Chris Von Wangenheim, whose inventive, glamorous and polished photography often contains insidious shock elements; Arthur Elgort, who makes the most ordinary clothes seem glossy; Mike Reinhardt; Steve Hiett; Toscani, an Italian who invests his photographs with a marvelous zest and gaiety, so that both his pictures and his girls seem to leap off the page bursting with health food and vitamins; Kourken Pakchanian, whose unequivocal recording of women and movement puts a different emphasis on fashion; Dick Ballarian whose clean, cool photographs emphasize the edges and outlines of fashion; Eric Boman who translates a *fin-de-siècle* sensibility into contemporary images. Stan Malinowski, Patrick Demarchelier, Francis Ing, François Lamy, Gian Paolo Barbiere, Uli Rose, and Guido Cegnani are among the artists who contribute their own idiosyncratic and electric images to the various editions of *Vogue* (including a new German edition, set up in 1979).

One of the most significant changes in the 1970s was the emergence of women as a numerically strong

and influential body of photographers. Although Louise Dahl-Wolfe, Toni Frissell, Frances McLaughlin, and Karen Radkai had taken fashion photographs since the 1940s and 1950s, they were distinguished exceptions. The new prominence of women photographers corresponded to what was happening to women's place in society, and to the way women looked at other women and at themselves. These photographers began to photograph fashion and women in a way that corresponded to their own realities, producing in general photographs that are sensuous and mood-oriented rather than conceived in terms of the graphic design of the page.

Deborah Turbeville, one of the most successful and imitated of the women photographers, says: "I am totally different from photographers like Newton and Bourdin. Their exciting and brilliant photographs put women down. They look pushed around in a hard way, totally vulnerable. For me there is no sensitivity in that. I don't feel the same way about eroticism and women. Women should be vulnerable and emotional; they can be insecure and alone; but it is the psychological tone and the mood that I work for."

Men photographing women often leave them as something only to be desired. Turbeville shows women with desires for something more than men can give. Her sense of how to place models in a setting is unequaled, and her groups of women look delicate and disturbing as they congregate in their odd environments. Their oblique glances have a certain enigmatic, intriguing quality, and sometimes they can look disturbed and isolated. Often their surroundings seem dreamlike and insubstantial, and their bodies say one thing, their clothes another. These ambivalences speak directly to many women.

Other women photographers include Eve Arnold, Elizabeth Novick, Anna Maria del Ponte, Carla Cerati, Alberta Tiburzi, Joyce Ravid, and Sarah Moon—a French model turned photographer, whose images are soft, nostalgic and evocative. "I always work with the same models, which creates a kind of friendship,"

Elizabeth Novick/British Vogue, February 1971/Fashion: Alice Pollock, John Craig

she says. Turbeville concurs: "I like to use real, natural people. If it were possible, I would much rather find my subjects on the streets than from an agency."

At one time or another many photographers have made serious attempts to avoid using the model as the central point in fashion photography. They have photographed clothes on hangers, on wax models, draped on furniture, in order to arrive at the essence of the clothes. But as long as fashion goes on being photographed the model girl will go on being an essential part of fashion. And in the 1970s, more than in any other decade, she was in herself both a celebrity and a nonperson. In her are brought together the different images of this century's fashionable women—the society beauty, the soubrette, the mannequin, the movie star—and the sum of these parts became the new American Heroine.

"These girls have the looks," wrote *Vogue* in 1978 of the top American models, "that are changing the whole meaning of beauty today. The glorious charge of health and vitality and fitness each of them has. The clear clean skin. The thick shiny hair. The strong wonderful bodies. The extraordinary sense of well-being. The 'high' of health. It's what American good looks are all about."

As fashion draws us along, we think we are acting of our own volition, ourselves choosing what we shall do and what we shall enjoy. But we are only going along with the intentions and inclinations of the age: we move in the current of the environment.

The best fashion photographers stopped the current for a moment, and produced immediate testimonies that also illustrate the meaning of fashion historian Quentin Bell's statement:

"Fashion for those who live within its empire is a force of tremendous and incalculable power. Fierce, and at times ruthless in its operation, it governs our behavior, informs our sexual appetites, colors our erotic imagination, makes possible, but also distorts, our conception of history, and determines our esthetic valuation."

In great fashion photography, originality is at a premium. Often originality is confused with sensationalism, and the desire to catch the eye becomes a need to outrage the sensibilities. The best photographers hardly need to shock at all, yet time after time their images intrigue and amaze the eye, and raise their subject to being a visual expression of what Thorstein Veblen called "the spiritual or higher need to dress." Our eyes, for all the sophisticated visual images that daily greet them, are always wonderfully innocent, and ready to respond.

The great fashion photographer removes the sense of *déjà vu* that is part of the legacy of overexposure to the images of photography and reminds us that the camera can show us something different, and can, above all, fashion for us the look of the times we live in.

1960s

PHOTOGRAPHERS FOR VOGUE

IN THE 1960S WERE ANTONY ARMSTRONG-JONES, RICHARD AVEDON,
DAVID BAILEY, CECIL BEATON, GUY BOURDIN,
HENRY CLARKE, JOHN COWAN, BRUCE DAVIDSON, TERENCE DONOVAN,
BRIAN DUFFY, HORST P. HORST, JUST JAECKIN, ART KANE,
WILLIAM KLEIN, BARRY LATEGAN, LEOMBRUNO-BODI,
DAVID MONTGOMERY, HELMUT NEWTON, NORMAN PARKINSON,
GORDON PARKS, IRVING PENN, JOHN RAWLINGS, BOB RICHARDSON,
FRANCO RUBARTELLI, JERRY SCHATZBERG, JEAN LOUP SIEFF,
VICTOR SKREBNESKI, BERT STERN, RONALD TRAEGER.

Richard Avedon
American Vogue, July 1967
Twiggy
Fashion: Emeric Partos
New York studio

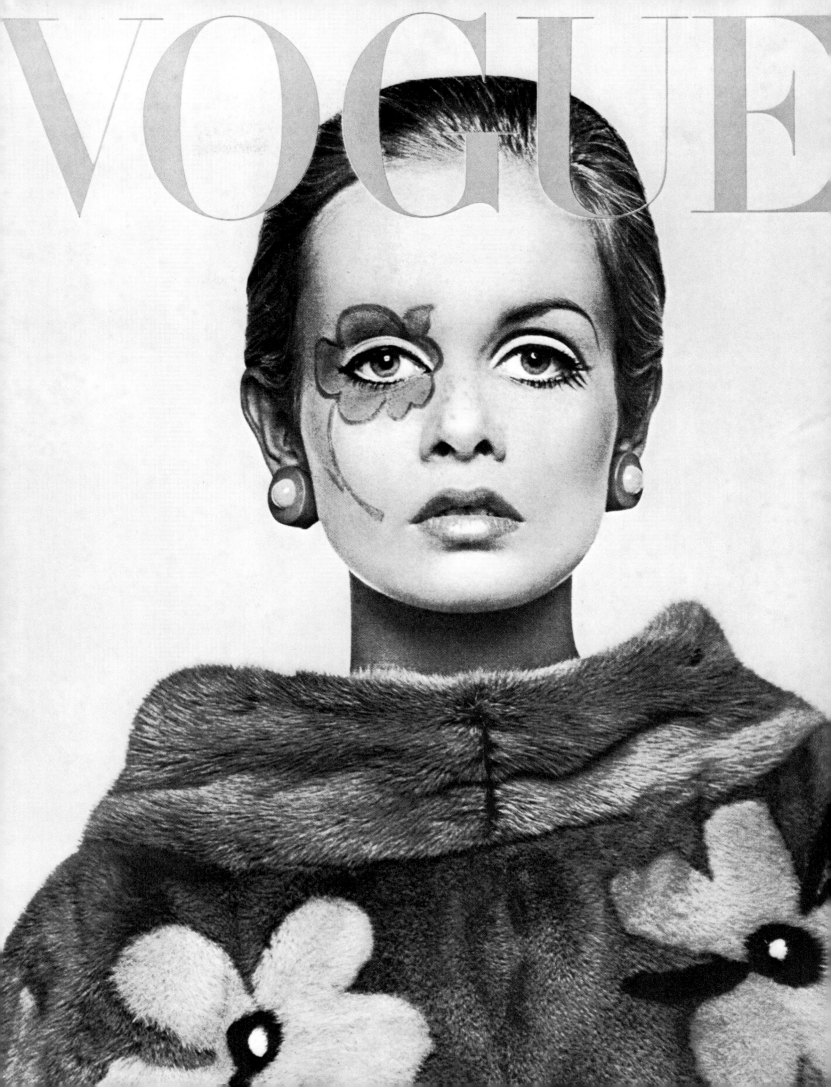

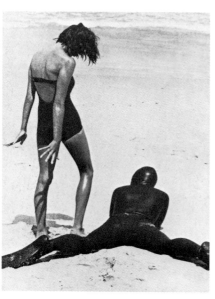

Irving Penn/American Vogue, October 15, 1965/Fashion: Emilio Pucci

William Klein/American Vogue, October 15, 1960/Fashion: Fontana/Roman Forum

Helmut Newton/American Vogue, May 1964/ Fashion: Brigance for Sinclair/Sydney

1960s

"Vogue's pages shone with glamor.
However, the underlying assumptions about woman's
role in society were already being questioned,
with significance and force. There was
a certain anxiety revealed in editorial comment about
what new standards the changes
would bring—an anxiety held somewhat at bay by a
jaunty belief in the powers of

Victor Skrebneski/American Vogue, September 15, 1967/Vanessa Redgrave

Henry Clarke/American Vogue, June 1964/ Fashion: Estévez/Villa Gamberaia, Florence

Rubartelli/American Vogue, February 1, 1968/Veruschka/Fashion: Sarff-Zumpano

John Rawlings/American Vogue, November 1, 1961/Fashion: Sarmi

David Bailey/American Vogue, September 1, 1964/Fashion: Harold Levine

traditional symbols of charm and femininity.
There was a curious contrast between the parallel
themes and images of women: on the one
hand, the glamorous, recherchée, poised lady;
on the other, the free, freaky
individualist dressing in whatever
mood took her. Gradually the two images came together to
make one amazing composite creature.''

Art Kane/American Vogue, July 1965/
Fashion: I. Miller/Turkey

Bert Stern/American Vogue, March 15, 1969/
Fashion: Courrèges

Bob Richardson/French Vogue, April 1967/
Rhodes

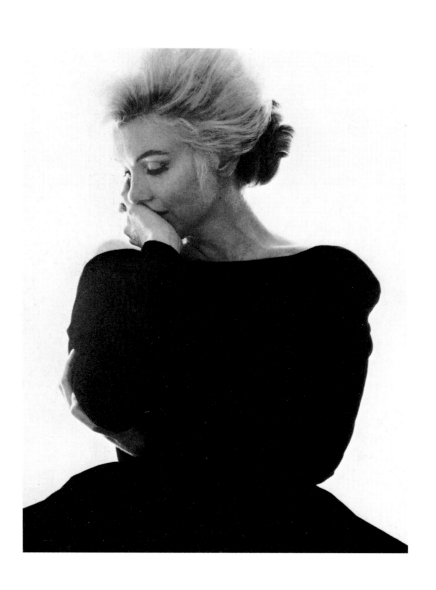

Bert Stern
American Vogue, September 1, 1962
Marilyn Monroe

William Klein
American Vogue, December 1962
L–R Princess Irene Galitzine, Madame
Hugo Gouthier, Marchesa Lisa di Bagno
Fashion: L–R Galitzine, Forquet, Galitzine

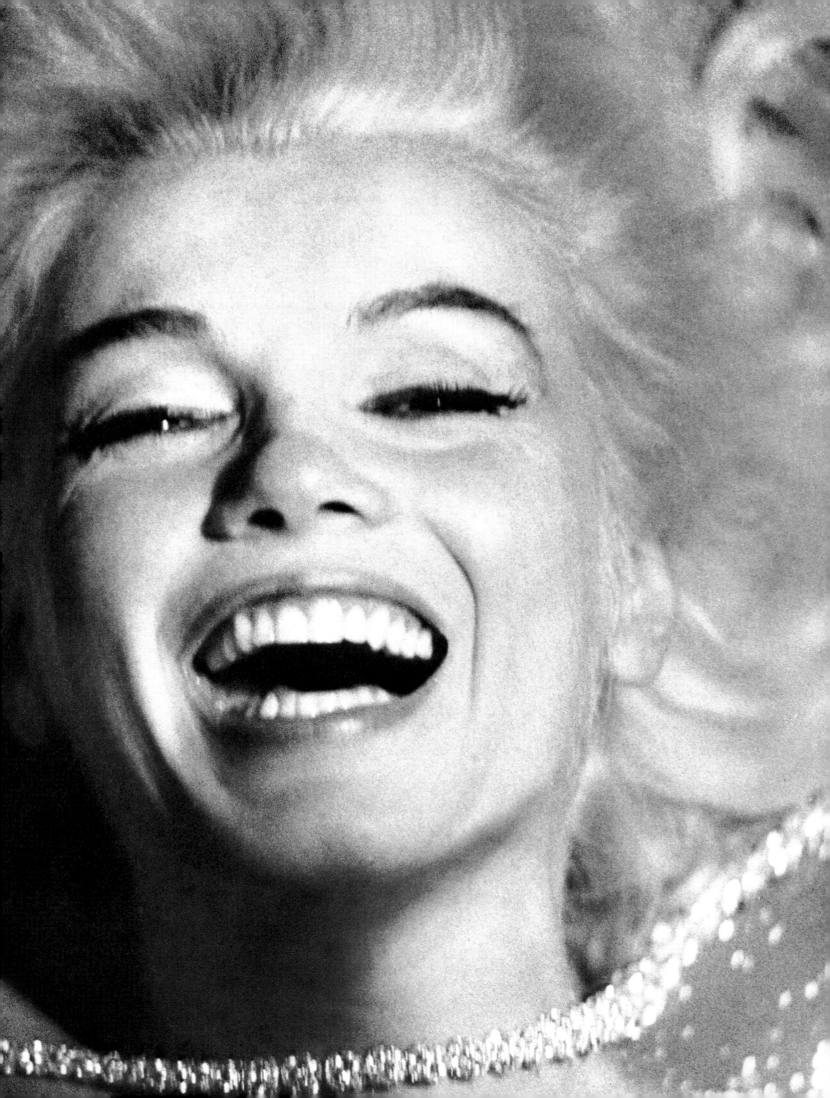

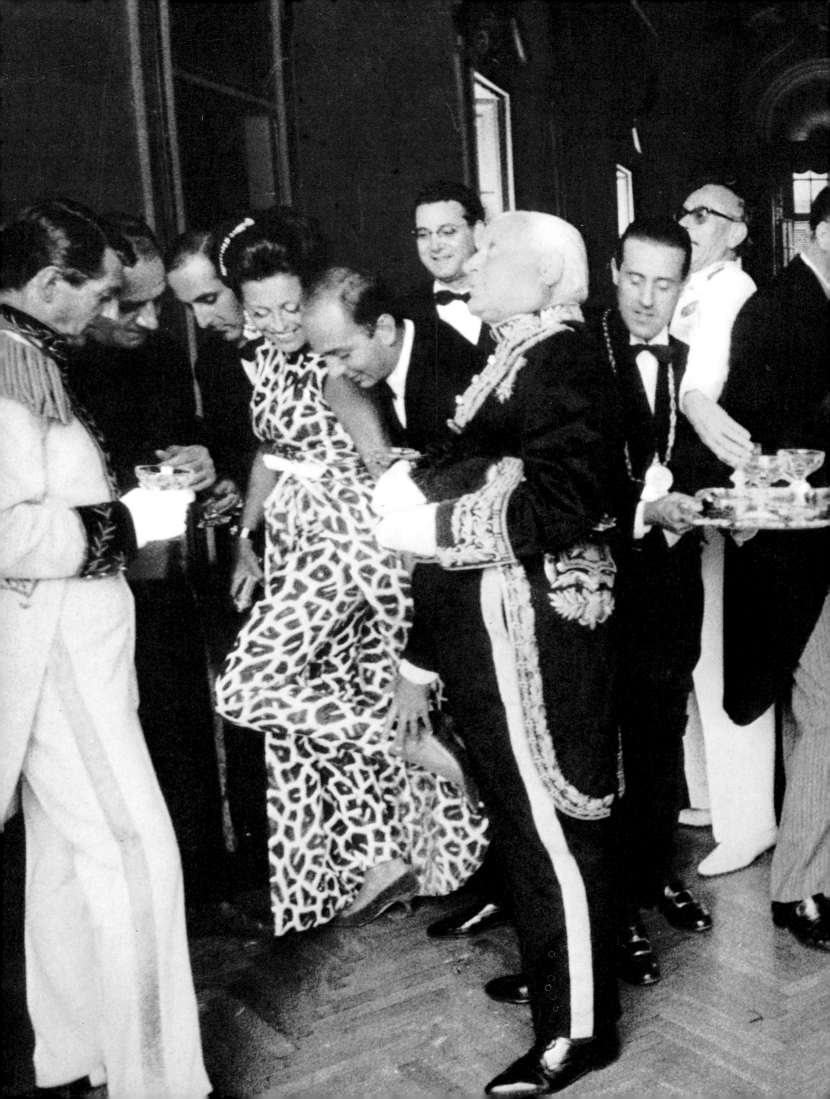

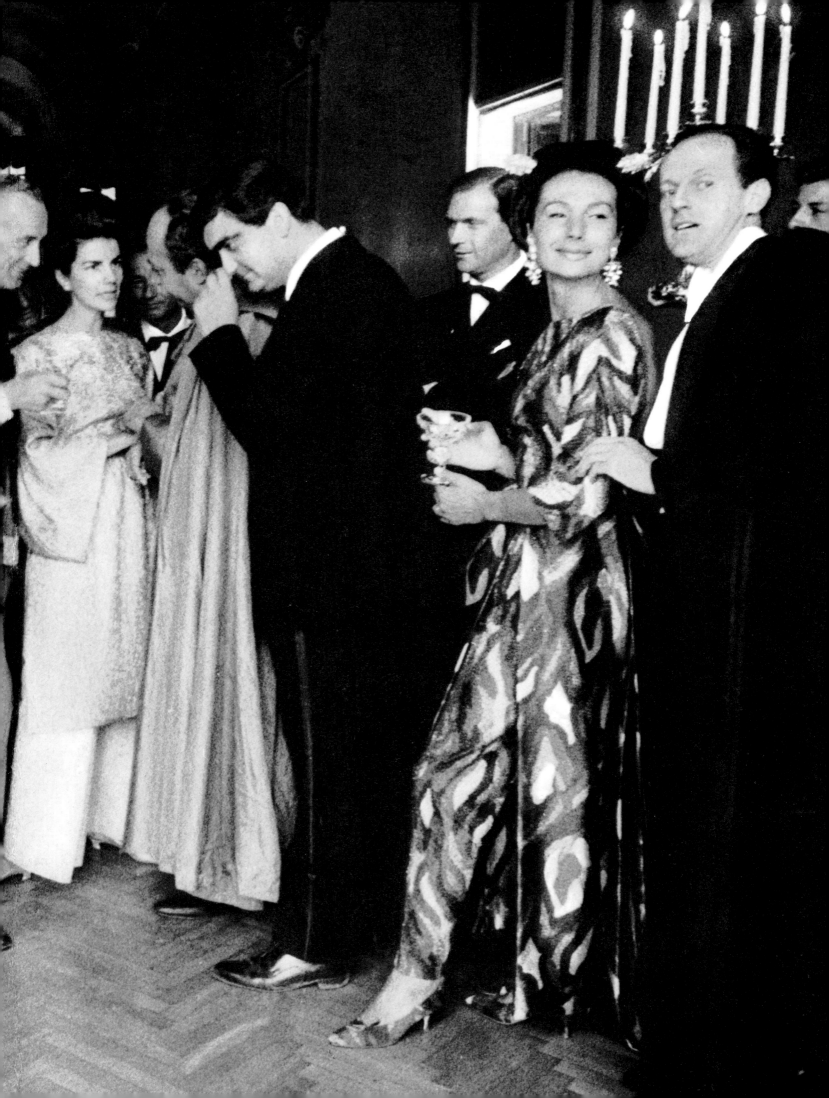

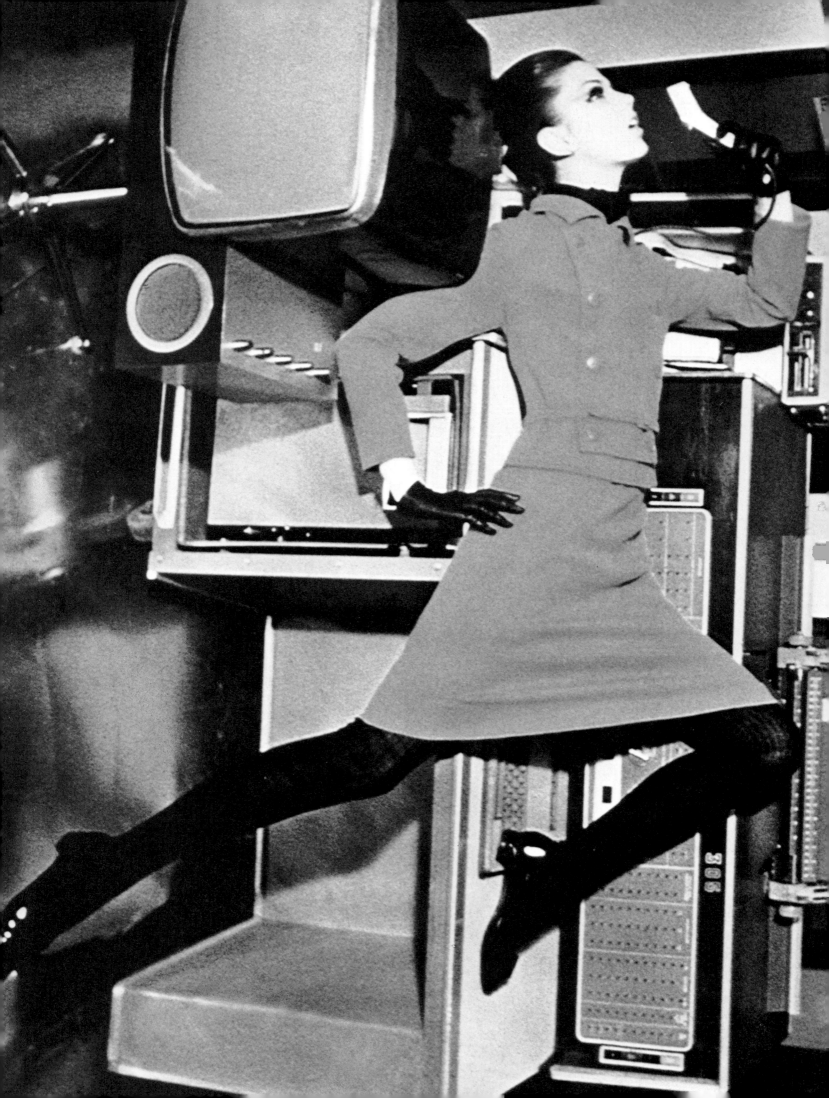

Helmut Newton
French Vogue, October 1965
Fashion: Christian Dior Boutique

Helmut Newton
French Vogue, October 1961
Fashion: Loden by Burberry
Franco-Belgian frontier at Baisieux-Route

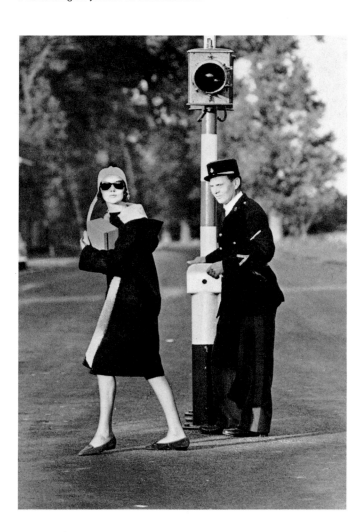

Henry Clarke
American Vogue, December 1965
Edita Dussler
Fashion: Stavropoulous
Palmyra, Syria

Bert Stern
American Vogue, January, 1965
Benedetta Barzini

Bert Stern
French Vogue, April 1967
Twiggy
Fashion: Grés

Helmut Newton
British Vogue, March 1, 1967
Twiggy
Fashion: Foale & Tuffin

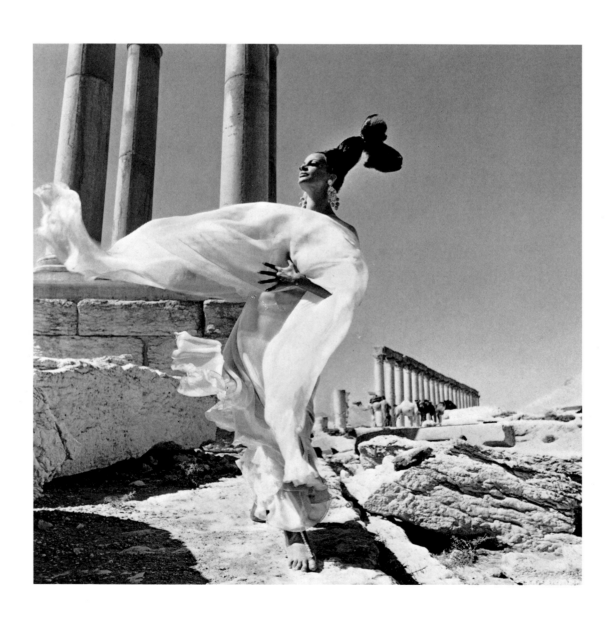

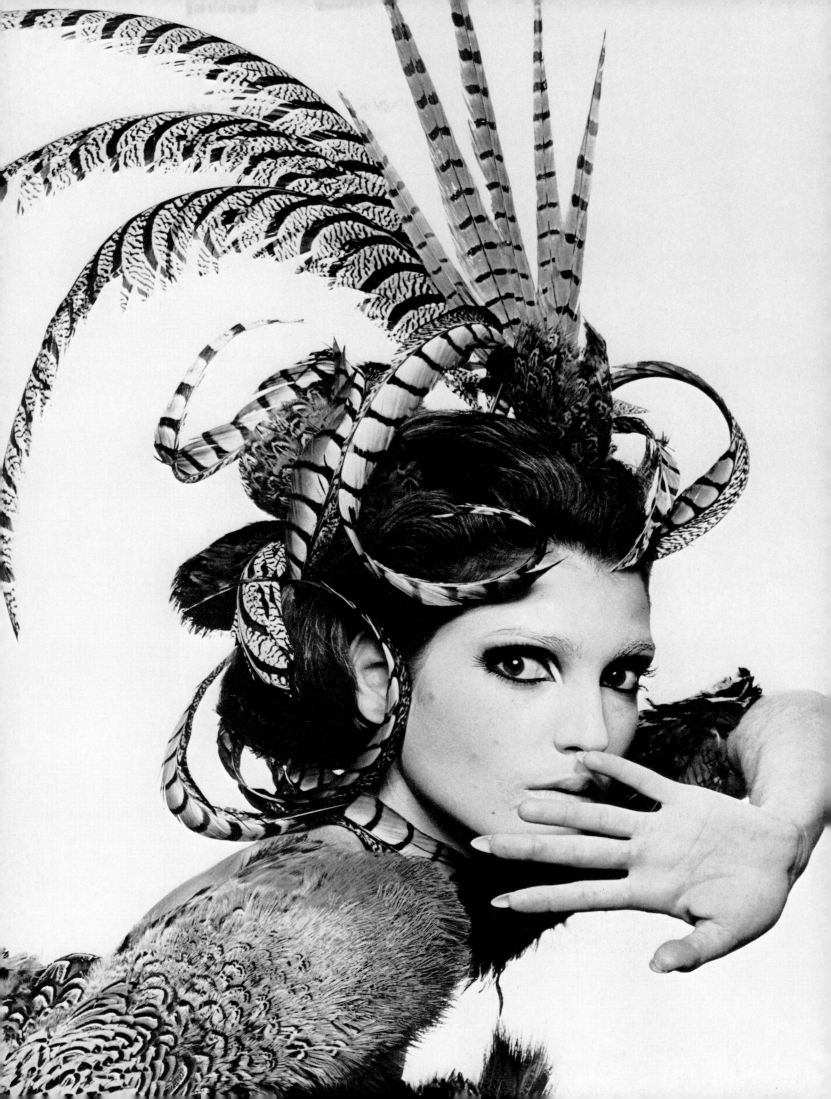

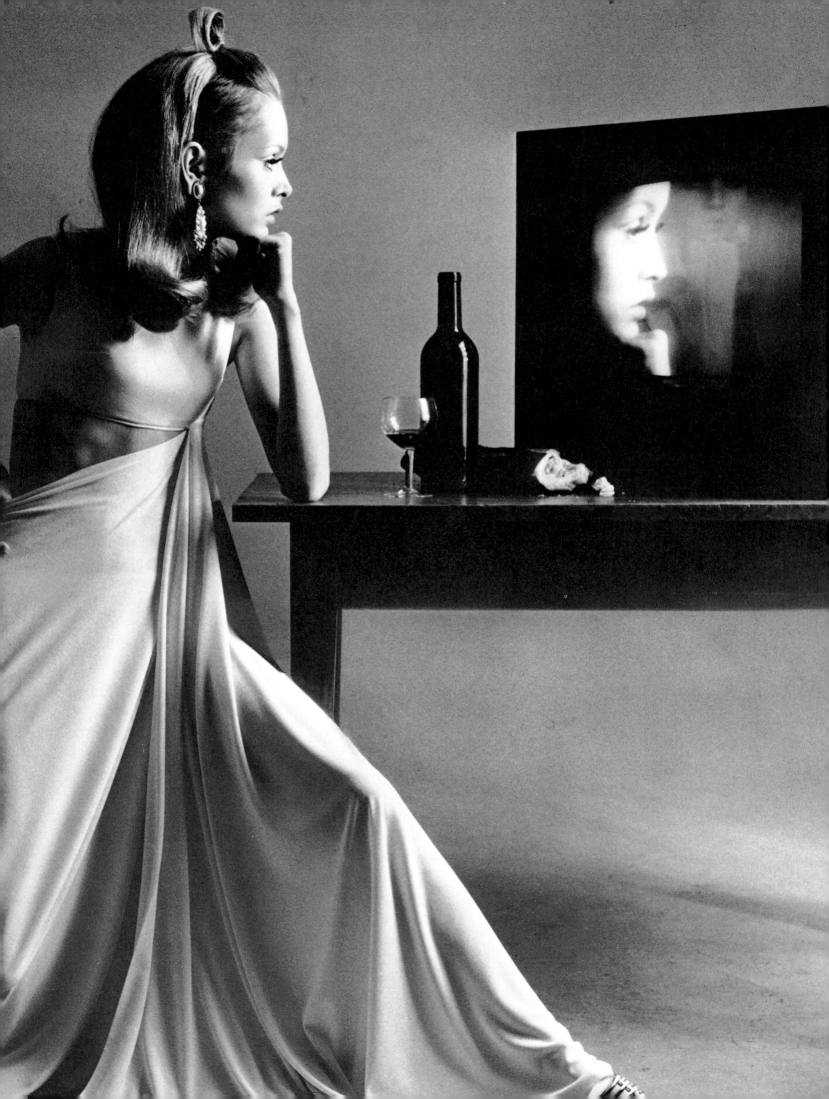

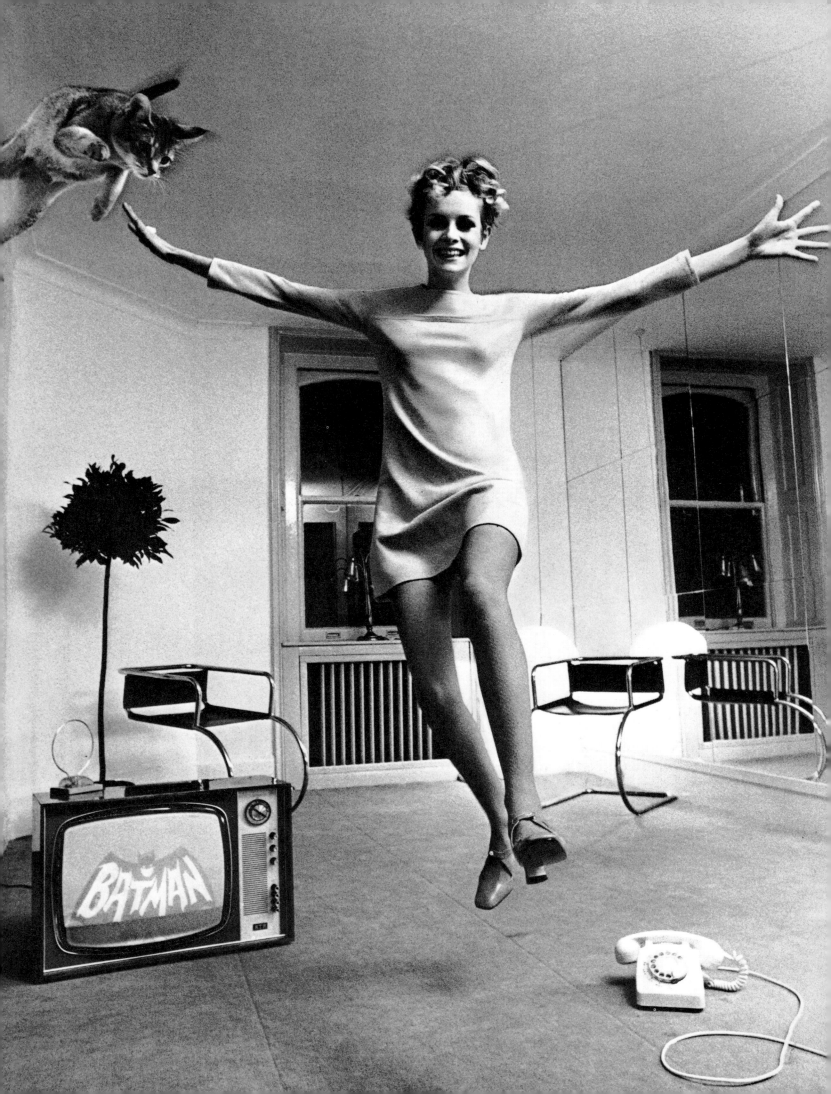

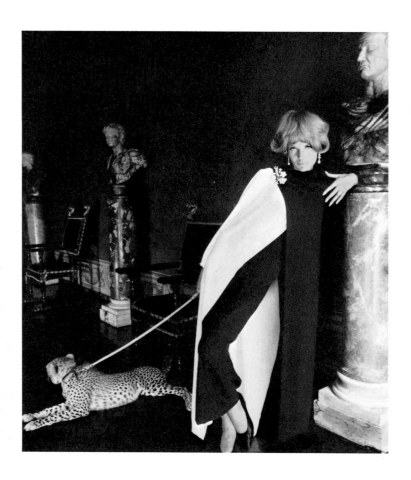

H*enry Clarke*
British Vogue, September 1, 1965
Fashion: Forquet
Countess Volpi di Misurata's Palazzo,
Rome

Leombruno-Bodi
American Vogue, November 1, 1960
"The Lady and the Cheetah"
Fashion: Lilly Daché

Irving Penn
American Vogue, April 1, 1970
Marisa Berenson
Fashion: José Maria Barrera
New York studio

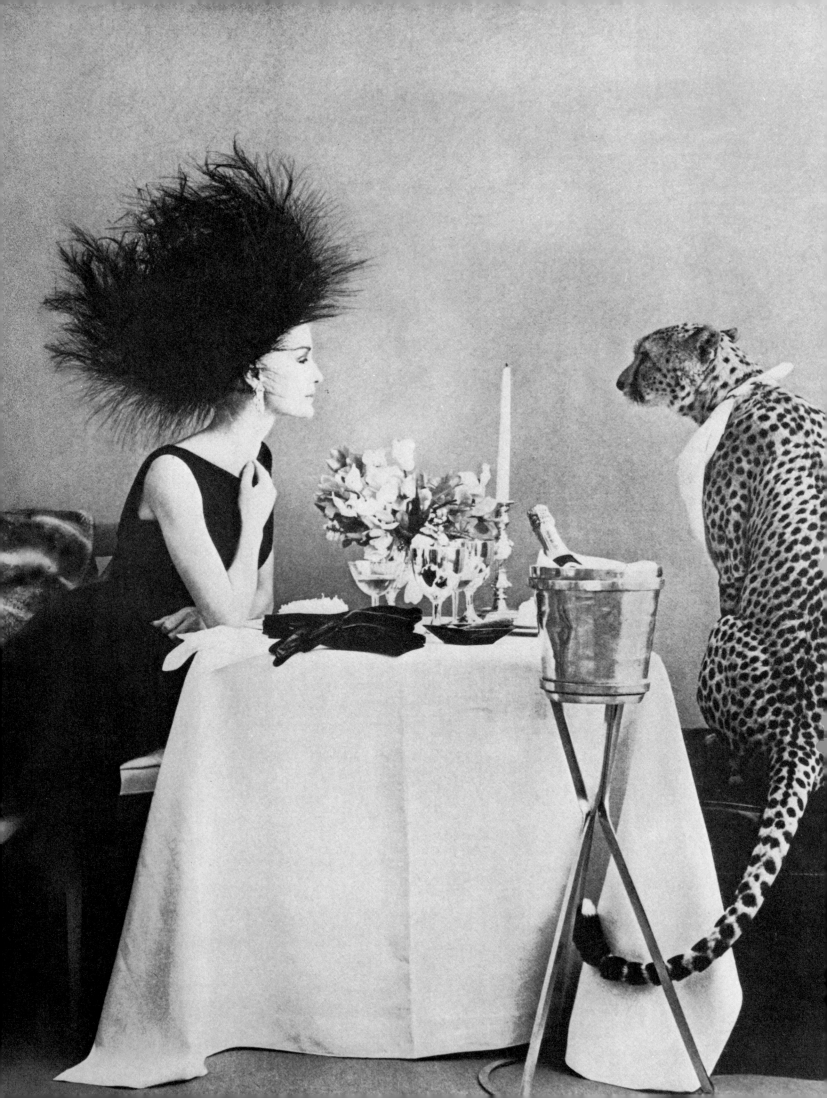

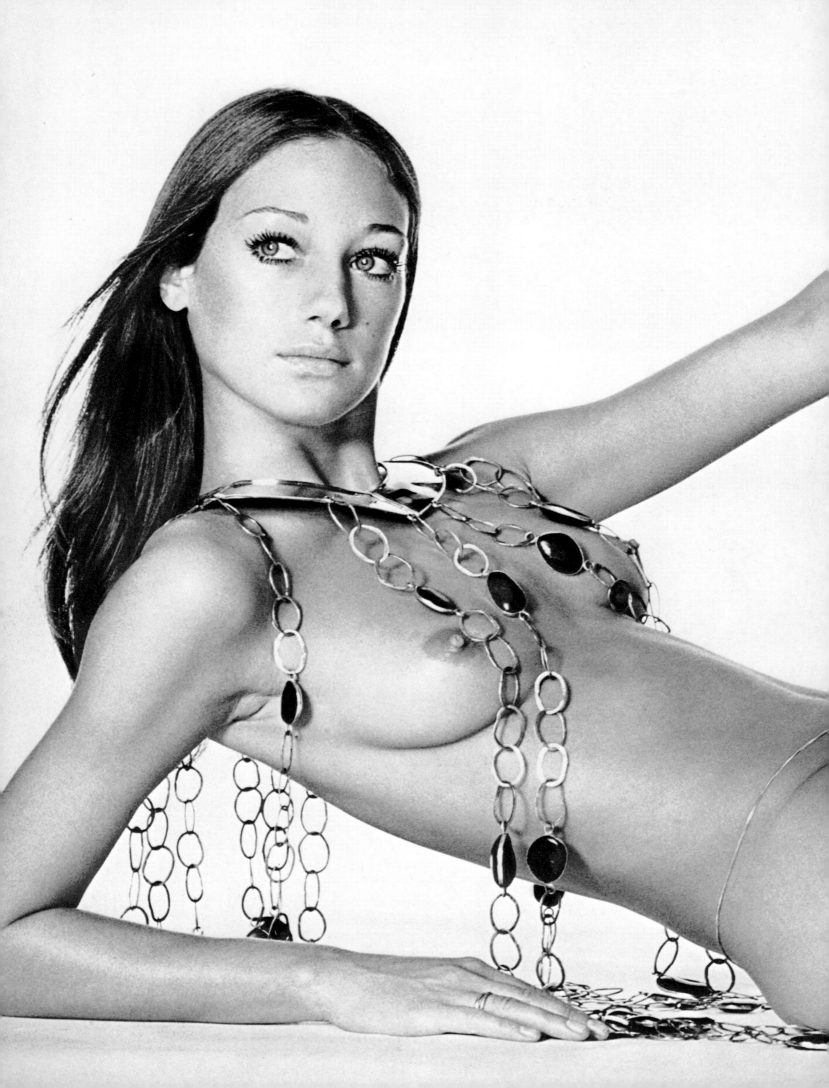

R‍ichard Avedon
American Vogue, March 15, 1970
Ingrid Boulting
Fashion: Dior/Paris studio

Richard Avedon
American Vogue, October 1, 1966
Maya Plisetskaya
Fashion: Halston/New York studio

Richard Avedon
American Vogue, January 1, 1969
Lauren Hutton
Fashion: Van Raalte
Great Exuma, Bahamas

Richard Avedon
American Vogue, January 15, 1968
Penelope Tree
Fashion: Dorcia Originals
New York studio

R̲ichard Avedon
American Vogue, August 1, 1967
Twiggy
Fashion: Roberto Rojas
New York studio

Richard Avedon
American Vogue, October 1, 1967
Penelope Tree
New York studio

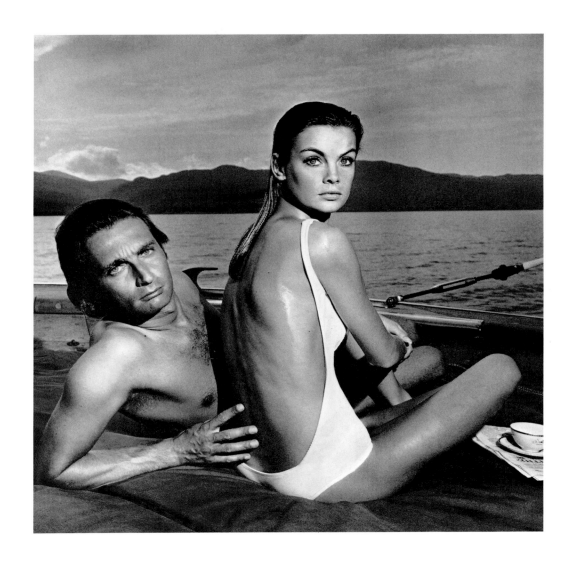

Richard Avedon
American Vogue, October 15, 1969
Anjelica Huston
Fashion: Melba Hobson for Tannerway,
M. Ferreras for Jones, New York
Ireland

Richard Avedon
American Vogue, January 15, 1967
Jean Shrimpton and Jean-Loup Sieff
Fashion: Rikki for Sport Trio
On Stavros Niarchos' yacht "Creole" in
the Greek islands

Richard Avedon
American Vogue, June 1968
Penelope Tree
Fashion: Lanvin
Paris studio

Richard Avedon
American Vogue, March 15, 1968
Penelope Tree
Fashion: Ungaro
Paris studio

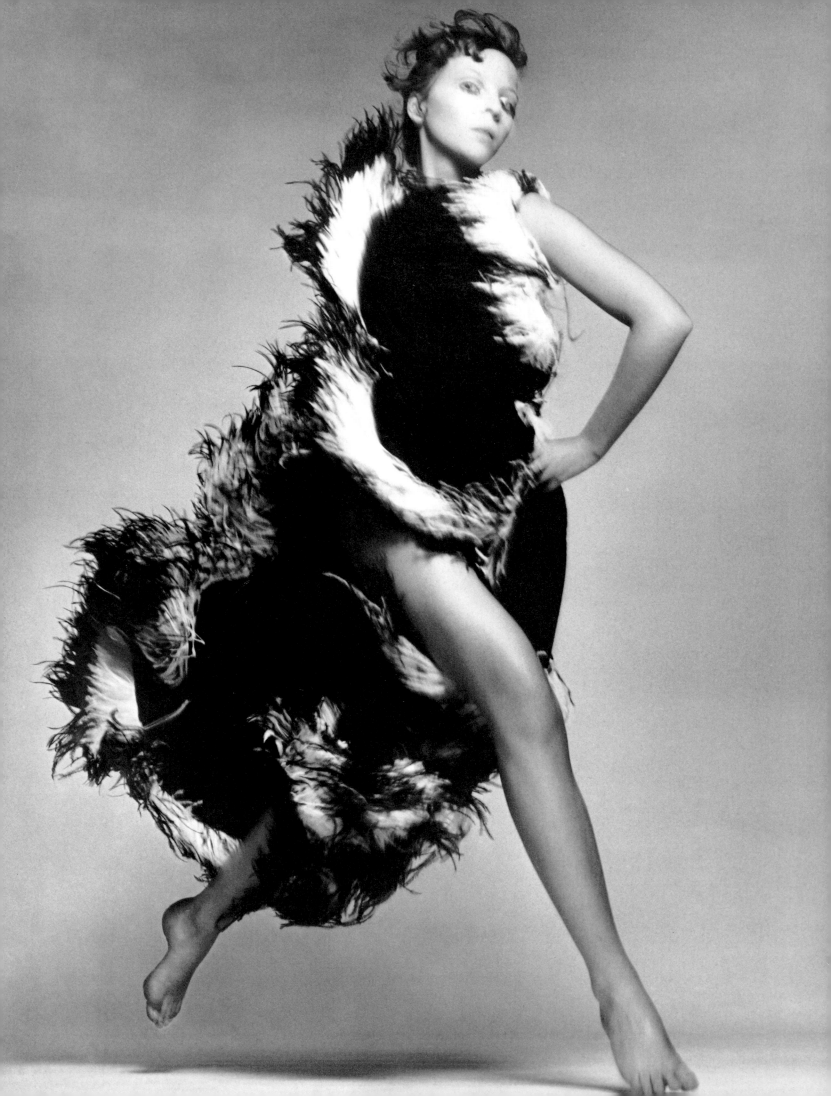

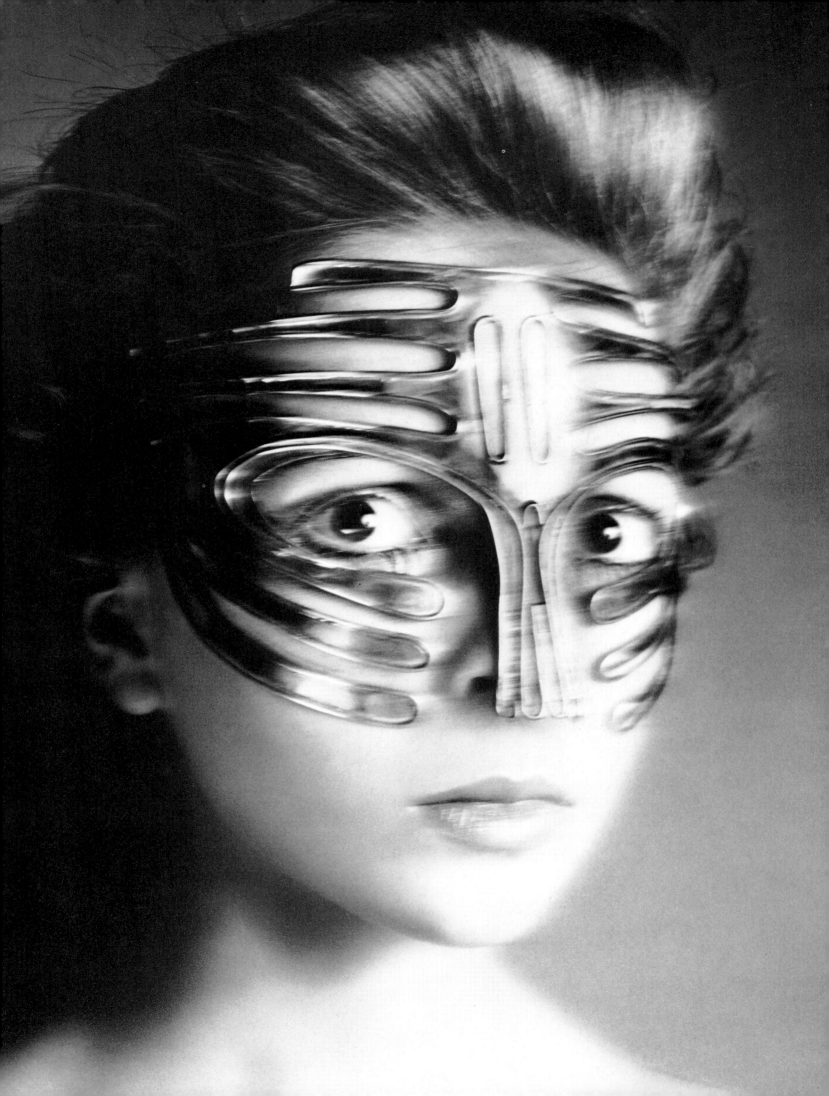

1970s

P

HOTOGRAPHERS FOR *VOGUE*
IN THE 1970S WERE CLIVE ARROWSMITH, RICHARD AVEDON,
DAVID BAILEY, BARBIERI, ANDREA BLANCH,
GUY BOURDIN, ERIC BOMAN, ALEX CHATELAIN,
WILLIE CHRISTIE, HENRY CLARKE,
PATRICK DEMARCHELIER, ARTHUR ELGORT, HANS FEUER,
STEVE HIETT, HORST P. HORST, FRANK HORVAT, DANIEL JOUANNEAU,
TONY KENT, PETER KNAPP, JACQUES-HENRI LARTIGUE,
BARRY LATEGAN, PATRICK LICHFIELD, STAN MALINOWSKI,
DUANE MICHALS, DAVID MONTGOMERY,
SARAH MOON, HELMUT NEWTON, KOURKEN PAKCHANIAN,
NORMAN PARKINSON, GIANNI PENATI,
IRVING PENN, MIKE REINHARDT, BOB RICHARDSON, ULI ROSE,
FRANCESCO SCAVULLO, TONY SNOWDON, OTTO STUPAKOFF,
OLIVIERO TOSCANI, DEBORAH TURBEVILLE,
CHRIS VON WANGENHEIM, ALEXIS WALDECK, ALBERT WATSON.

R ichard Avedon
American Vogue, June 1978
Roseanne Vela
New York studio

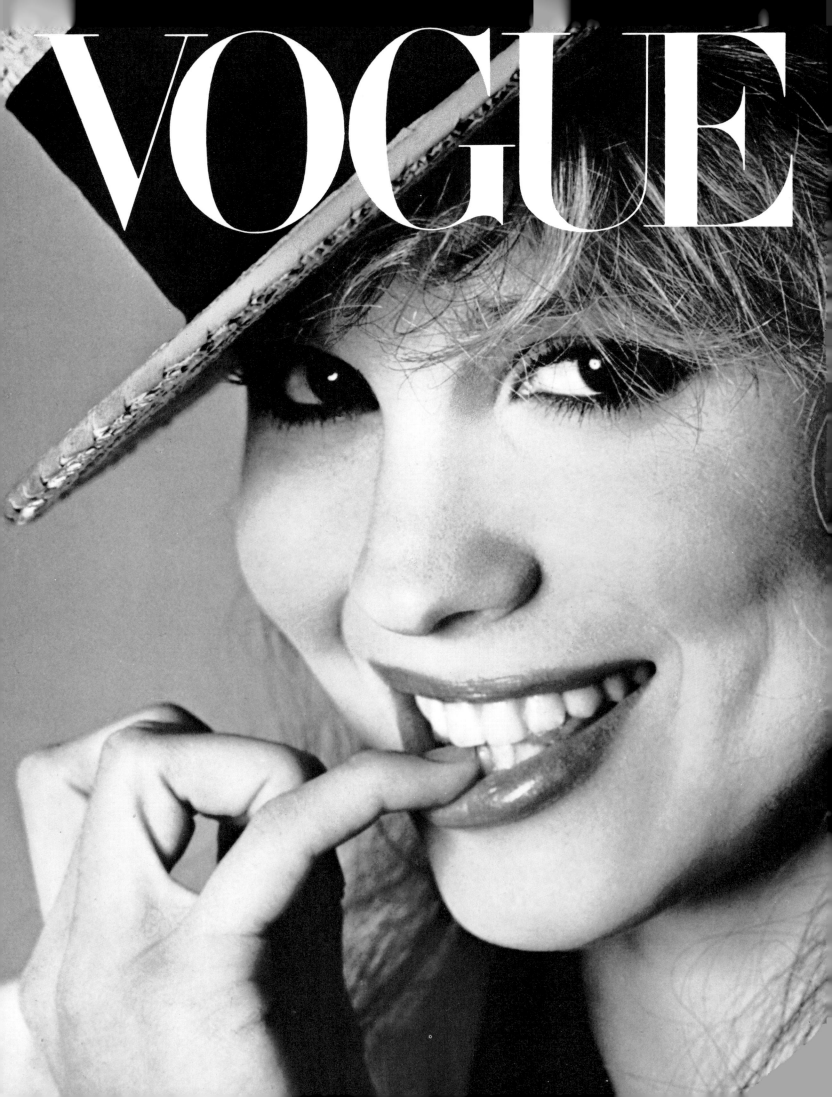

*Peter Knapp/British Vogue, May 1973/
Fashion: Sonia Rykiel/Bali*

*Clive Arrowsmith/British Vogue, January
1971/Fashion: Quant/Yale University Bowl,
New Haven*

1970s

"The 1970s brought a more realistic mood altogether.
In the first three months of 1971 there was a national economic
recession in the USA which hit the fashion world hard.
The fantasy fashion of the 1960s vanished,
made obsolete by harsh economic realities. Fashion
became more practical, easier to wear, and less exhibitionist,
and reflected a leveling-off process: the theme
for style, in fashion and therefore in

*Patrick Demarchelier/American Vogue, April
1978/Farrah Fawcett-Majors*

*Barbieri/French Vogue, March 1974/Fashion:
Rive Gauche Saint-Laurent*

*Stan Malinowski/American Vogue, January
1978/Juli Foster/Fashion: Daniel Hechter/
Florida*

Bob Richardson/French Vogue, April 1971
Fashion : Western House Francois Camus for
Sacoche

Barry Lategan/British Vogue, February 1976/
Fashion: John Bates

Eric Boman/British Vogue, September 1, 1977

fashion photography, was democratic uniformity.
It required a new impact of reality to
make the reader stop and look at a free-and-easy girl in a
shirt-dress, or in jeans. The girl in the
picture must communicate spontaneously
with the reader, not by striking her
with the overwhelming fact of her appearance,
but by invitation, by conspiracy, by relation.''

Andrea Blanch/American Vogue, January
1979/Lisa Vale/Fashion: Geoffrey Beene/New
York City

Oliviero Toscani/British Vogue, October 1,
1977/Fashion : Kati di Paura Phillips, Juliet
Dunn, Dorothée Bis/London

Irving Penn
American Vogue, September 1978
Kim Basinger
Fashion: Donna Karan and Louis
Dell'Olio for Anne Klein

Irving Penn
American Vogue, May 1976
Roseanne Vela
Fashion: Ralph Lauren

Helmut Newton
French Vogue, September 1975
Fashion: Saint-Laurent
Paris

Helmut Newton
American Vogue, November 1976
Winnie
The Negresco, Nice

Arthur Elgort
American Vogue, November 1976
Leslie Branner, Beverly Johnson, Lisa
Taylor, Patti Hansen
Fashion: (far right) Galanos
The Metropolitan Museum of Art,
New York

Helmut Newton
American Vogue, May 1975
Lisa Taylor
Fashion: L–R Flair, Calvin Klein

Deborah Turbeville
American Vogue, March 1979
Amy McCandless
Fashion: Calvin Klein
Radio City Music Hall, New York

Deborah Turbeville
American Vogue, March 1979
L R: Marley Crosby, Eva Voorhis,
Amy McCandless, Ann McCandless
Fashion: L-R Calvin Klein, Bonnie
August of Danskin
Radio City Music Hall, New York

Richard Avedon
American Vogue, July 1973
Polly Mellen, Karen Graham, Ara
Gallant, Lauren Hutton, and an assistant
Fashion: Adele Simpson and Hubert
Latimer for Mollie Parnis

Guy Bourdin
French Vogue, February 1973
Fashion: L-R Karl Lagerfeld for Chloé
Dorothée Bis

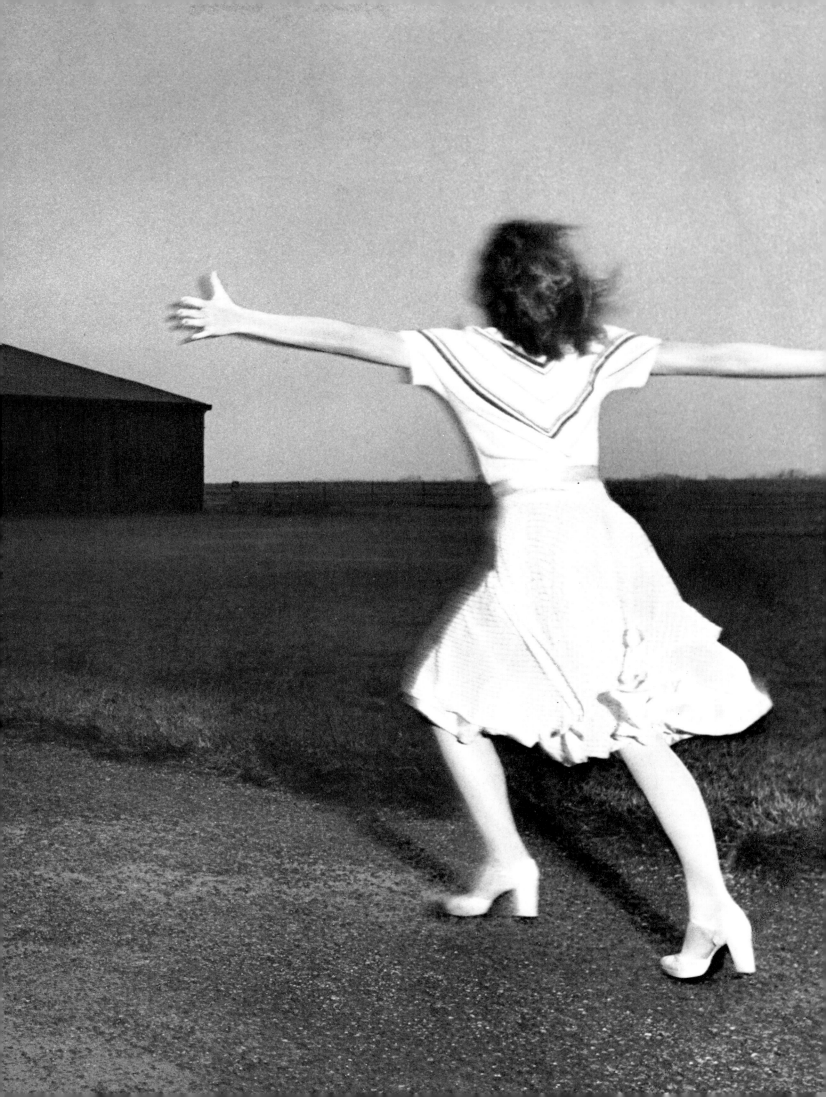

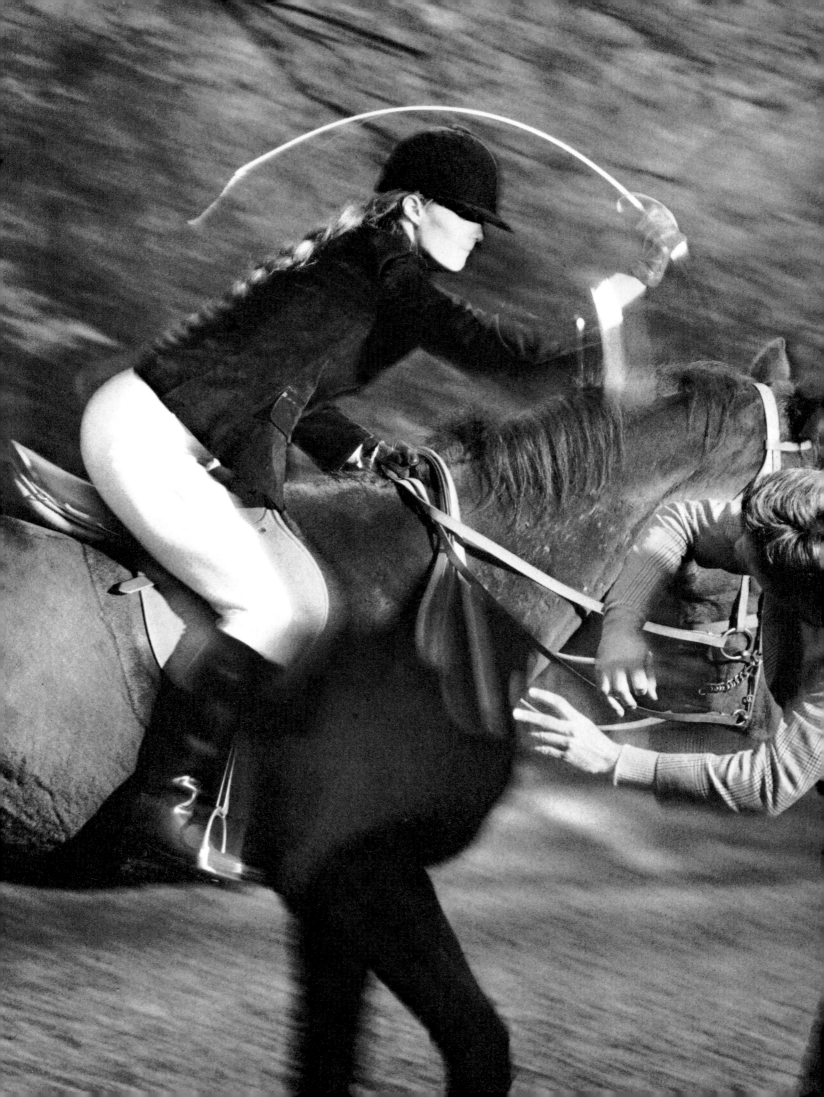

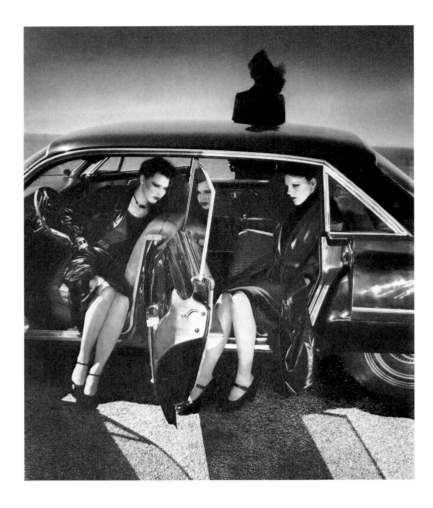

G*uy Bourdin*
French Vogue, December 1975/
January 1976
Natalie Delenn
Fashion: Hermès

Guy Bourdin
British Vogue, September 1, 1975
Fashion: Saint-Laurent

Chris Von Wangenheim
American Vogue, February 1979
L–R Gia, Donna Sexton, Matt Collins
Fashion: L–R Bill Blass, John Anthony
Lucerne Valley, California

Deborah Turbeville
American Vogue, May 1975
L–R Chris Royer, Sara Kapp, Marcia
Turnier, Yasmine
Fashion: L–R Jean-Louis Scherrer,
Stephen Burrows, Courrèges, Ungaro
New York public baths

Irving Penn
American Vogue, March 1978
Fashion: L-R Shoe Strings, Brooks
Brothers

Irving Penn
American Vogue, February 1978
Juli Foster

Deborah Turbeville
American Vogue, August 1977
Kathy Quirk
Fashion: Olga

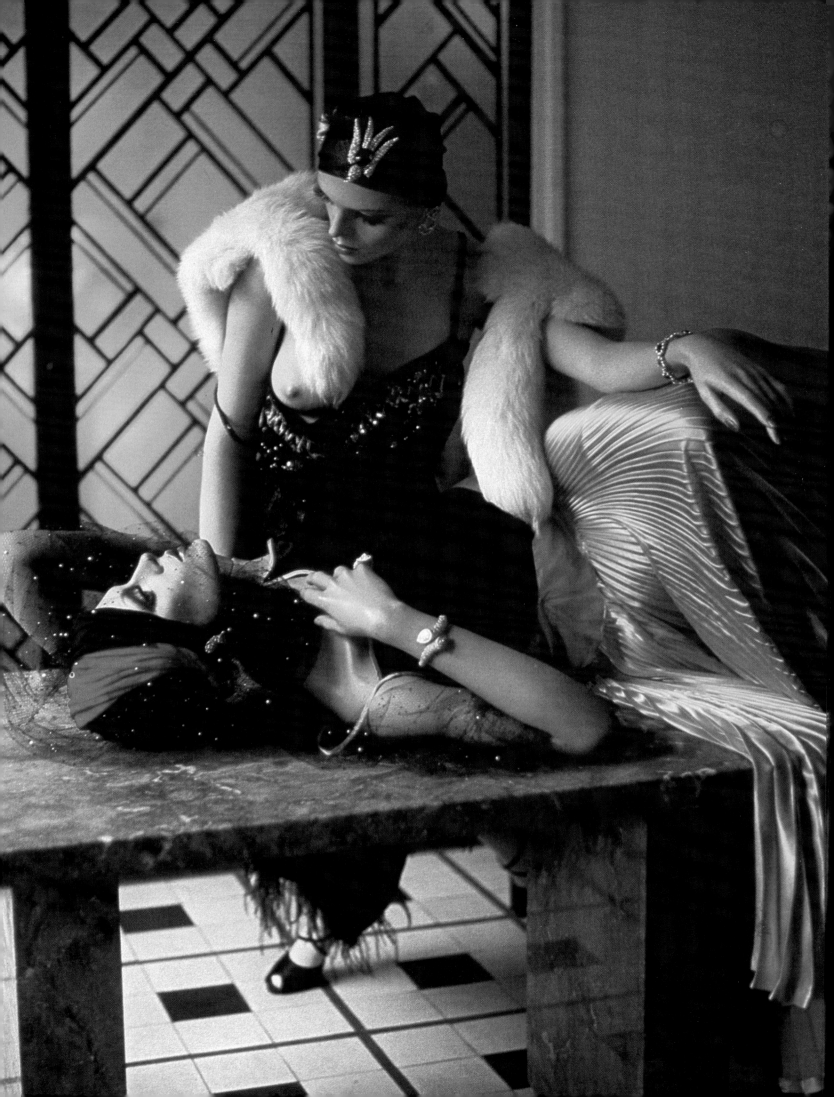

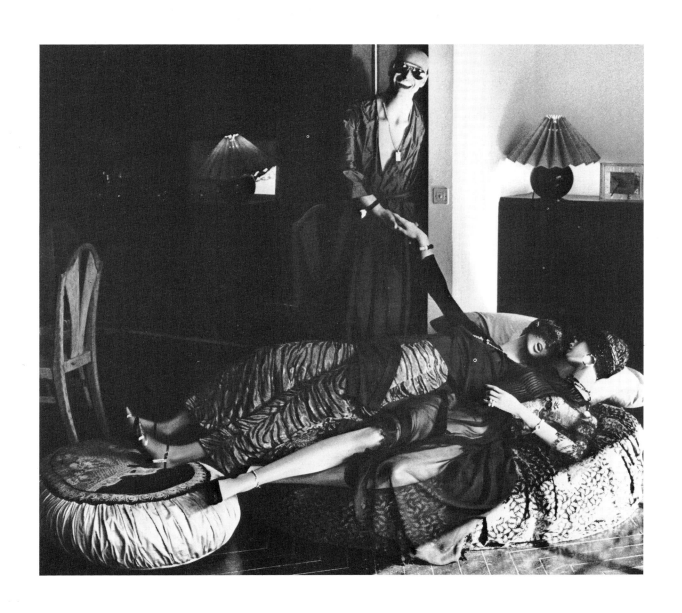

H*elmut Newton*
French Vogue, November 1976
Mannequins
Fashion: L-R Alexis de Fursac, Jean-
Claude de Luca; Chatillon,
Mouly Roussel, Veron, Maggy Rouff, Karl
Lagerfeld for Chloé

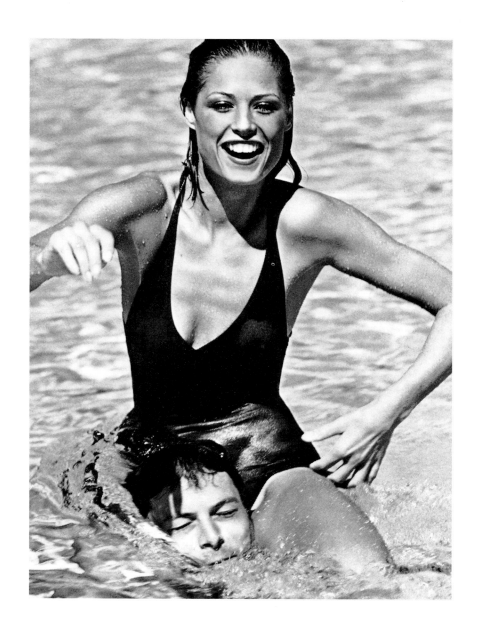

Arthur Elgort
American Vogue, January 1976
Mary Maciukas
Fashion: Catalina

Kourken Pakchanian
American Vogue, May 1972
Fashion: John Meyer, Ship'n Shore

A rthur Elgort
American Vogue, October 1976
Lisa Taylor

Arthur Elgort
American Vogue, November 1976
Roseanne Vela
Fashion: Saint-Laurent
New York

Albert Watson
American Vogue, February 1978
L–R Apollonia, Donna Palmer, Bill
Quateman, Helen Hogberg, Debbie
Dickinson, Iman
Fashion: L–R Kasper, Bill Kaiserman,
Stephen Burrows, Stephen Burrows,
Giorgio Sant'Angelo

Chris Von Wangenheim
American Vogue, December 1976
Lisa Taylor
Fashion: Maximilian, New York
Outside the U.S.A.R.I.E.M. climate
control chamber, Natick, Massachusetts

Duane Michals
American Vogue, December 1976
Fashion: Saint-Laurent
Paris

Guy Bourdin
French Vogue, May 1978
Fashion: Gianni Versace for Callaghan
The Fountainebleau-Hilton, Miami Beach

Deborah Turbeville
American Vogue, January 1977
Kirat, Yasmine
Fashion: Saint-Laurent
Paris

Deborah Turbeville
American Vogue, January 1977
L-R Vibeke, Lela, Yasmine, Diane
Fashion: Valentino
Paris

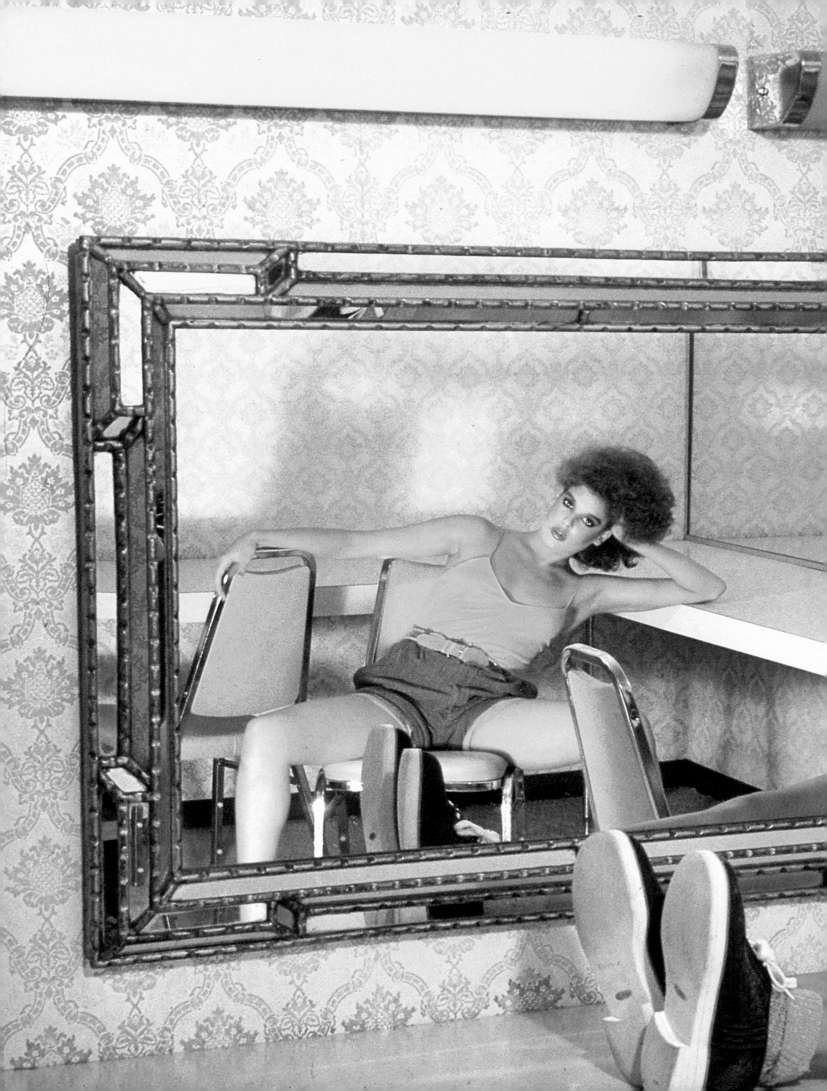

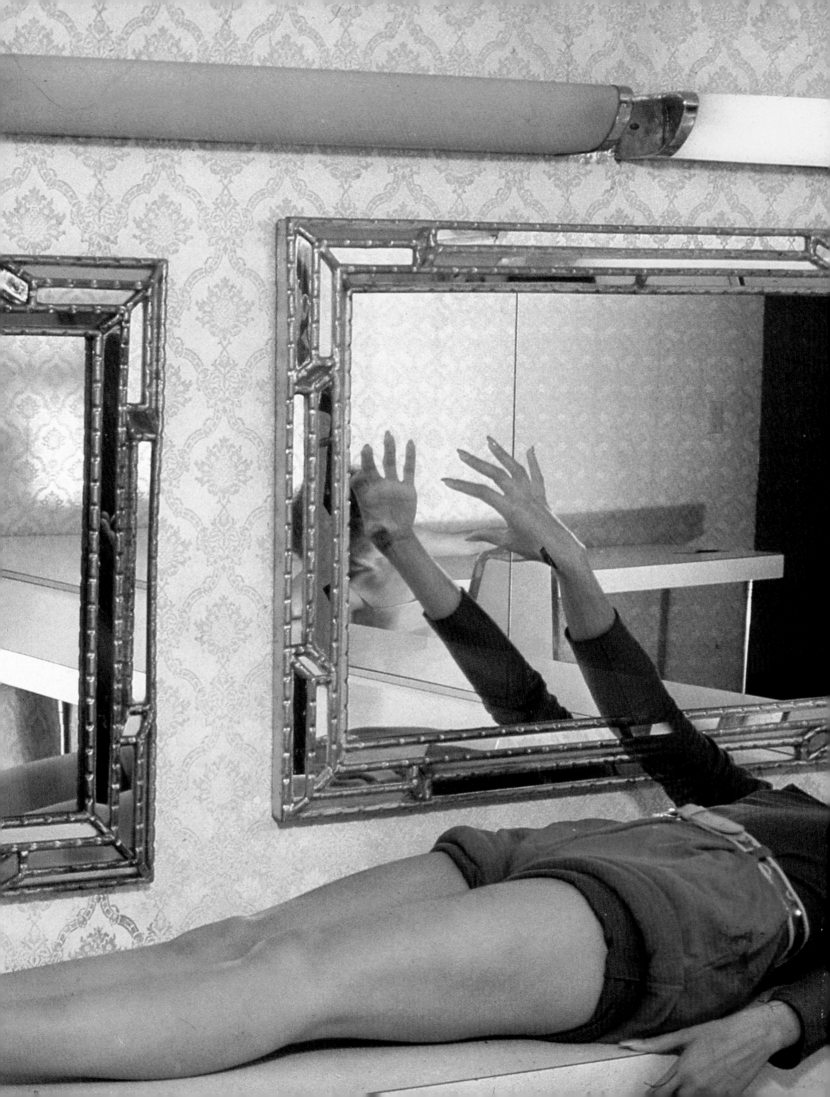

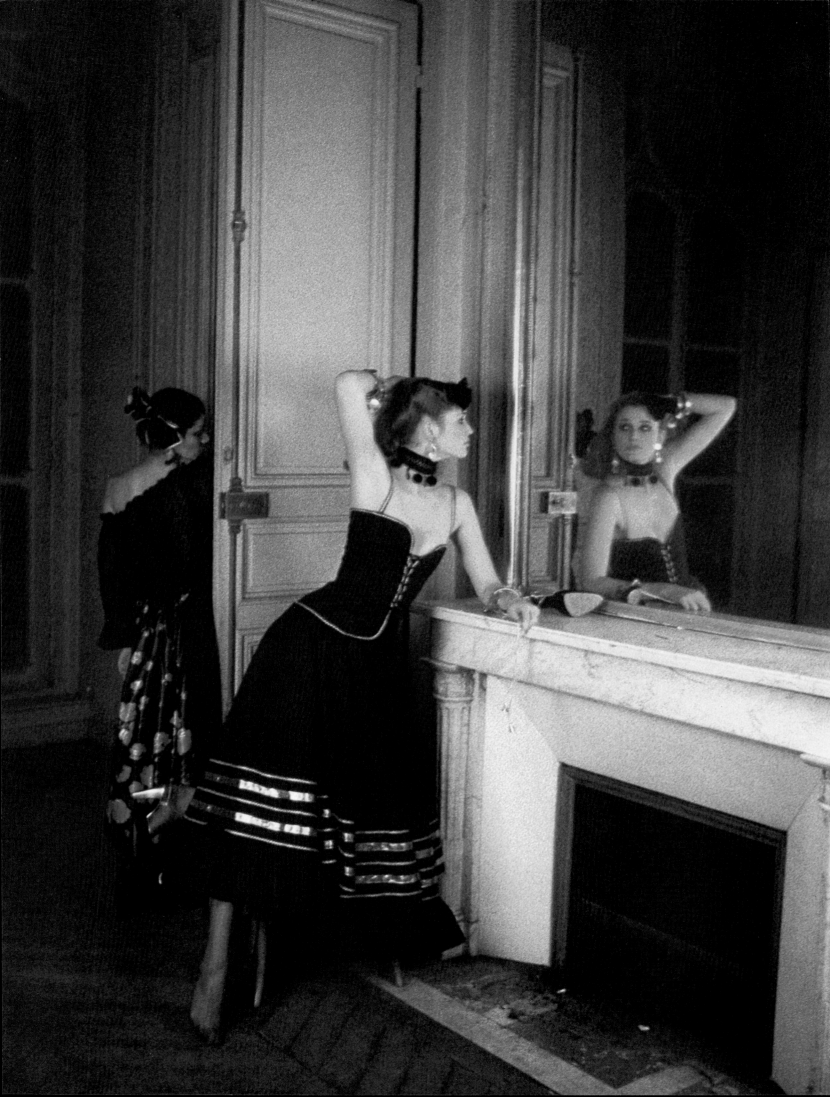

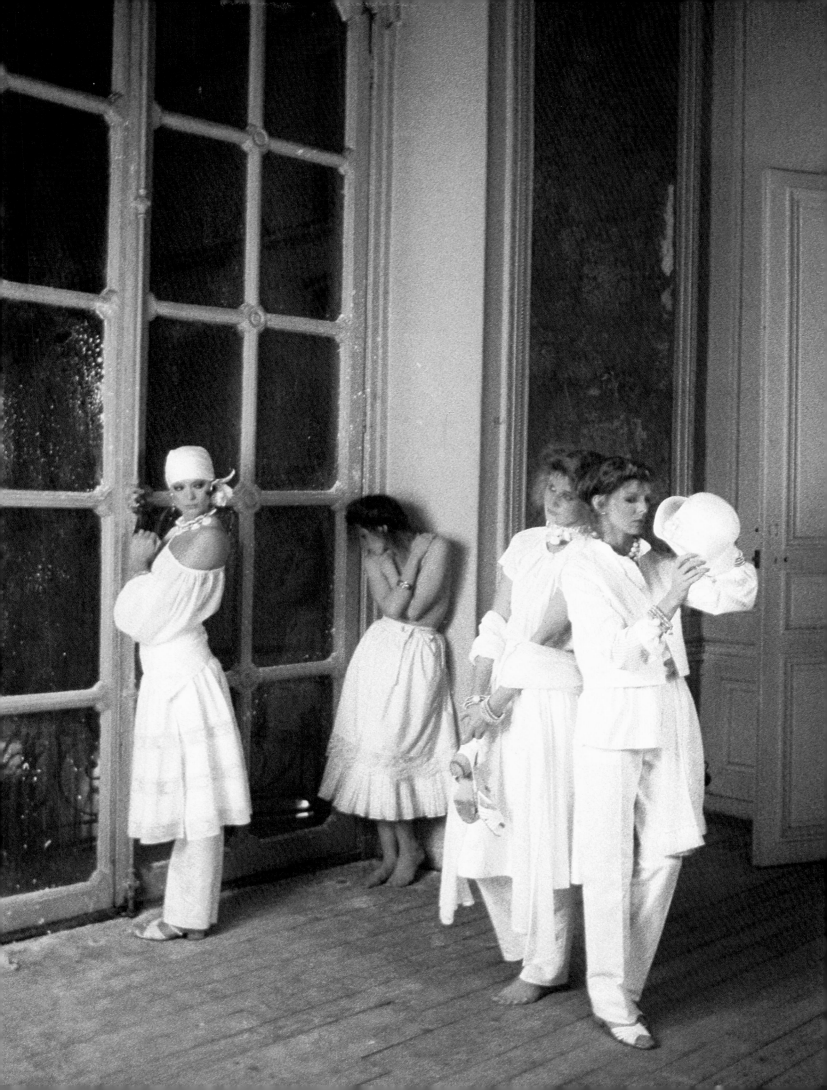

Arthur Elgort
American Vogue, October 1978
L-R Lisa Ryall, Juli Foster, Shaun Casey
Fashion: Saint-Laurent
Paris

Chris Von Wangenheim
American Vogue, March 1977
Fashion: Rossi

Chris Von Wangenheim
American Vogue, February 1977
Christie Brinkley

D avid Bailey
British Vogue, October 1, 1974
Fashion: Karl Lagerfeld for Chloé

David Bailey
British Vogue, July 1975
Fashion: Saint-Laurent

F rancesco Scavullo
American Vogue, July 1974
L-R Régine Jaffry, Ginella
Lindblad
Fashion: L-R Edith Imre, Fashion
Tress, Bill Blass

Helmut Newton
French Vogue, April 1978
Fashion: L-R Beatrix, Vanessa,
Livia
Hotel Sheraton, Paris

Richard Avedon
American Vogue, June 1973
Lauren Hutton
New York studio

Richard Avedon
American Vogue, December 1974
Aurore Clément
Fashion: Calvin Klein
New York studio

Richard Avedon
American Vogue, June 1978
Roseanne Vela
Fashion: Beene Bag, Sheila Davlin,
La Nacelle
New York studio

Richard Avedon
American Vogue, July 1978
Brooke Shields
Fashion: Karl Lagerfeld
New York studio

Richard Avedon
American Vogue, July 1977
Patti Hansen
Fashion: Bill Atkinson
New York studio

Richard Avedon
American Vogue, July 1977
Patti Hansen
Fashion: Versace
New York studio

Richard Avedon
American Vogue, June 1978
Roseanne Vela
Fashion: Dorothée Bis for Dianne B.,
Sara Mique
New York studio

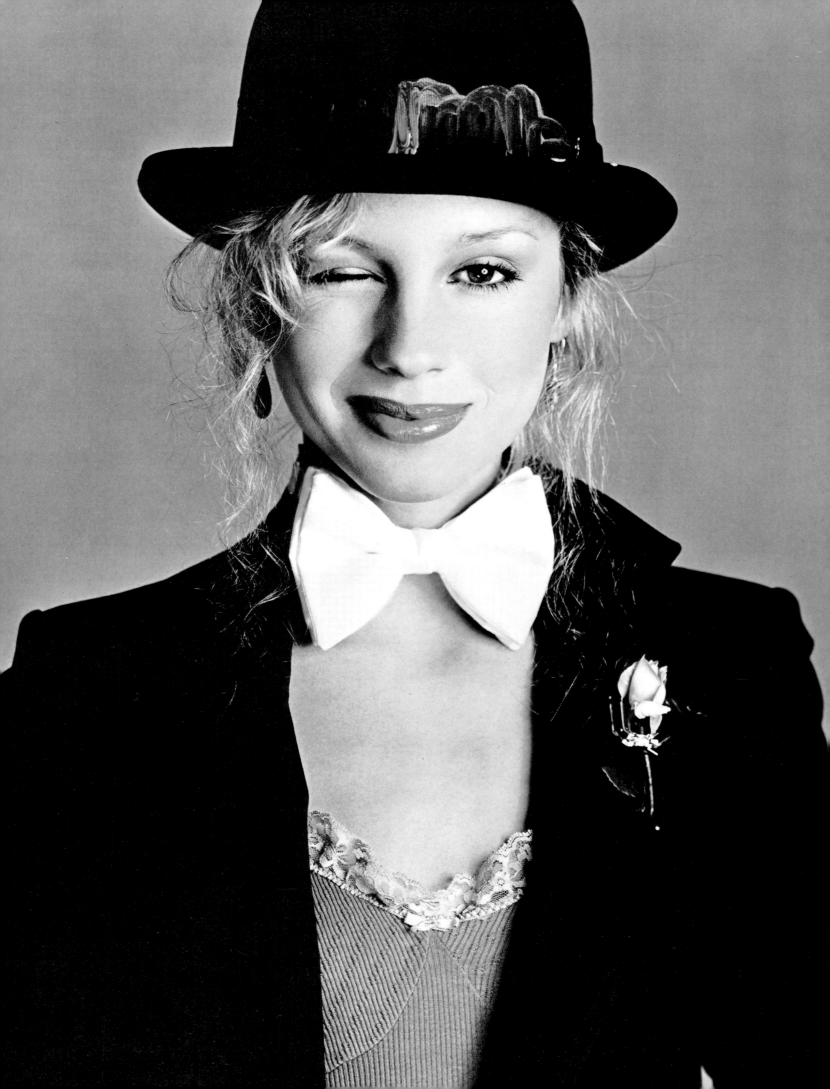

POSTSCRIPT

As we approach the 1980s, there is a new daring in photography. All fears and all constraints seem abandoned; a new self-assurance appears in the images of women, a fresh directness in an eye-to-eye contact. The model now dominates fashion photography; she creates the image.

Today, there are more *Vogues* (seven editions in seven countries, at last count), more pages, more photographs. This extraordinary visual flow enriches and amuses and sometimes makes one pause to consider the unexpected insights of these beautiful women caught in the web of fashion. The earlier photographs awaken our curiosity and bring the subtle joys of nostalgia. They are the link, the support for the magnificent outpouring of today's imagery.

Never in the long history of *Vogue* has fashion photography attempted such complex scenes. These images drawn from different countries, continents, and cultures create in one's mind a heady amalgam of sensuous and erotic experiences. One is struck by the wealth of these endeavors, desires and dreams all focused on the single purpose of portraying women in fashion with a simple clarity of statement that is the ultimate goal of the creative effort.

The resulting quality and richness of these photographs is the reward of a rare collaboration among dedicated beings who specialize in that unique creative effort, the fashion photograph. Designers, editors, models, hairdressers, makeup artists, art directors—a visible and invisible cast of characters who evoke and finally bring forth a materialization of the volatile spirit of fashion. The pages of all the *Vogues* are stages for this gala performance of the strange ongoing theater of the ever surprising human comedy.

ALEXANDER LIBERMAN

239

INDEX